BLACK

First published in the French language by Editions du Seuil, Paris, under the title *Noir, histoire d'une couleur* by Michel Pastoureau. Copyright © 2008 Editions du Seuil, Paris

English-language edition published by
Princeton University Press
41 William Street, Princeton, New Jersey 08540
In the United Kingdom: Princeton University Press, 6 Oxford Street, Woodstock, Oxfordshire OX20 1TW
press.princeton.edu

Translated from the French by Jody Gladding

Printed and bound in Italy
10 9 8 7 6 5 4 3 2 1

Library of Congress Cataloging-in-Publication Data
Pastoureau, Michel, 1947–
[Noir. English]
Black : the history of a color / Michel Pastoureau.
 p. cm.
Includes bibliographical references (p.).
ISBN 978-0-691-13930-2 (hardcover : alk. paper) 1. Black. 2. Color—Psychological aspects—History. 3. Color—Social aspects—History. 4. Symbolism of colors—History. 5. Black in art. I. Title.
BF789.C7P3813 2008
155.9'1145–dc22

2008025145

British Library Cataloging-in-Publication Data is available
Printed on acid-free paper. ∞

MICHEL PASTOUREAU

BLACK

THE HISTORY OF A COLOR

PRINCETON UNIVERSITY PRESS

PRINCETON AND OXFORD

THE BIRTH OF THE WORLD
IN BLACK AND WHITE
SIXTEENTH TO EIGHTEENTH CENTURIES
113

ALL THE COLORS OF BLACK
EIGHTEENTH TO TWENTY-FIRST CENTURIES
151

To answer the question, "What do the words red, blue, black, and white mean?" we can, of course, immediately point to things that are those colors. But our ability to explain the meaning of these words goes no further.

Auf die Frage: "Was bedeuten die Wörter rot, blau, schwarz, weiss?" Können wir freilich gleich auf die Dinge zeigen, die so gefärbt sind. Aber weiter geht unsere Fähigkeit die Bedeutungen dieser Wörter zu erklären nicht.

Ludwig Wittgenstein
Remarks on Colors/Bemerkungen über die Farben 1, 68

INTRODUCTION
FOR A HISTORY OF COLORS

Many decades ago, at the beginning of the last century, or even in the 1950s, the title of the present book might have surprised some readers unaccustomed to considering black a true color. That is certainly not the case today; it would be hard to find anyone anymore who does not grant it that distinction. Black has reclaimed the status it possessed for centuries, indeed even for millennia—that of a color in its own right and even a major pole in all the color systems. Like its counterpart, white, to which it has nevertheless not always been linked, black gradually lost its status as a color between the end of the Middle Ages and the seventeenth century: The advent of printing and the engraved image—black ink on white paper— gave these two colors a peculiar position, which first the Protestant Reformation and then the progress of science finally established to be outside the world of colors. When Isaac Newton discovered the spectrum in the years 1665–66, he presented a new order of colors in which henceforth there would no longer be a place for white or black. This marked a true chromatic revolution.

Thus for almost three centuries black and white were considered and experienced as "noncolors," even seeming to form their own universe as opposed to the one of colors: "in black and white" on one side, "in color" on the other. In Europe, a dozen generations were familiar with that opposition, and even if it is not really accepted anymore it also does not really surprise us. Nevertheless, our sensibilities have changed. Beginning in the second decade of the twentieth century, artists were the first to gradually return to black and white the status of authentic

colors that had been theirs until the late Middle Ages. Men of science followed, even if physicists long remained reluctant to attribute chromatic properties to black. The general public eventually joined in, so much so that today in our social codes and daily lives we have hardly any reason to oppose the world of color to the world of black and white. Here and there a few vestiges of the old distinction remain (photography, cinema, newspapers, publishing). Thus the title of this book is in no way a mistake or a provocation. Nor does it seek to echo the famous exhibition organized by the Maeght Gallery in Paris at the end of 1946, an exhibition that proclaimed with a kind of insolence that "black is a color." It was not only a matter of attracting public and media attention with a catchy slogan, but also an affirmation of a position different from the one taught in the fine arts schools and proclaimed in academic treatises on painting. Perhaps four and a half centuries after the fact, the featured painters wanted to respond to Leonardo da Vinci, the first artist to proclaim, as early as the late fifteenth century, that black was not truly a color.

"Black is a color": today such a claim has once again become an obvious fact, almost a platitude; the real provocation would be to affirm the opposite. But that is not the domain of the present work. Its title does not echo the 1946 exhibition or even the words of the illustrious Leonardo, but more modestly the title of a previous book, published in 2000 by the same publisher: *Blue: The History of a Color*. The good reception that it received, as much among the academic community as the general public, prompted me to devote a similar work to the color black. The furthest thing from my mind, however, is the idea of undertaking a complete series that would attempt, volume by volume, to trace the history of each of the six "basic" colors of Western culture (white, red, black, green, yellow, blue), and then the five "second rank" colors (gray, brown, purple, pink, orange). Such an enterprise, made up of parallel monographs, would have little significance. A color never occurs alone; it only takes on meaning, only fully "functions" from the social, artistic, and symbolic perspectives, insofar as it is associated with or opposed to one or many other colors. By the same token, it is impossible to consider a color in isolation. To speak of black, as you will read in the pages that follow, is also—necessarily—to speak of white, red, brown, purple, and even of blue. Hence the repetition with regard to the work I devoted to the history of that last color. I must be excused for what could not have been otherwise. For a long time, blue, an unobtrusive and unpopular color, remained a sort of "sub-black" in the West or a black of a particular kind. Thus the histories of these two colors can hardly be separated, no more than they can be separated from the history of other colors. If, as my publisher hopes, a third volume were to follow the first two (red? green?), undoubtedly it would be constructed around the same set of problems, and its inquiries would draw from the same documentary sources.

Such studies, which appear (but only *appear*) to be monographs, would ideally constitute the building blocks of an edifice that I have been busy constructing for nearly four decades: the history of colors in European societies from Roman antiquity to the eighteenth century. Even if I necessarily look beyond and before these two periods, that is the chronological segment— already very large—in which my core subject is located. Likewise, I will limit my remarks to European societies because for me the issues of color are, first of all, social issues. As a historian I am not competent to speak of the entire planet and have no taste for compiling, third- or fourthhand, studies conducted by other researchers on cultures outside Europe. So as not to write nonsense and not to plagiarize the works of others, I am restricting myself to what I know and have made the subject of my teaching at the École Pratique des Hautes Études and the École des Hautes Études en Sciences Sociales for a quarter century.

Attempting to construct a history of colors, even one limited to Europe, is not an easy exercise. In fact, it is a particularly

difficult task, which historians, archaeologists, and art historians (including those whose field is painting!) have refused to undertake until recently. The difficulties are myriad. It is worth mentioning them here because they are fully part of the subject and help to explain the inequalities that exist between what we know and do not know. Here more than elsewhere there is no real boundary between history and historiography. For the moment, let us stay with the history itself of the color black and consider a few of these difficulties. Despite their diversity, they can be grouped into three categories.

The first group involves documentation; on monuments, works of art, objects, and images transmitted to us from centuries past, we see colors not in their original state but as time has made them. This work of time—whether due to the chemical evolution of the colorant materials or to the actions of humans, who over the course of the centuries paint and repaint, modify, clean, varnish, or remove this or that layer of color set down by preceding generations—is in itself a historical document. That is why I am always suspicious of laboratories, now with very elaborate technical means and sometimes very flashy advertising, that offer to "restore" colors, or worse to return them to their original state. Inherent here is a scientific positivism that seems to me at once vain, dangerous, and at odds with the task of the historian. The work of time is an integral part of our research. Why renounce it, erase it, destroy it? The historical reality is not only what it was in its original state, but also what time has made of it. Let us not forget that and let us not restore rashly.

Also we must not forget that today we see the works, images, and colors of the past in lighting conditions very different from those experienced by the societies of antiquity, the Middle Ages, and the modern period. The torch, the oil lamp, the candle produce light different from what electricity provides. That is an obvious fact as well, and yet what historian takes it into account? Forgetting it sometimes leads to absurdities. Let us think, for example, of the recent restoration of the vaults of the Sistine Chapel and the considerable efforts on the part of the media as much as technicians to "rediscover the freshness and the original purity of the colors set down by Michelangelo." Such an exercise arouses curiosity, of course, even if it is a bit aggravating, but it becomes perfectly absurd and anachronistic if the layers of color thus redeemed are lit, viewed, or studied by electrical light. Can we really see Michelangelo's colors with our modern lighting? Is this not a greater treason than the one committed slowly by time and by humans since the sixteenth century? And it is a more disturbing one as well, when we think of the example of Lascaux or of other prehistoric sites destroyed or damaged by fateful encounters with past experiments and present curiosities.

To conclude our documentation difficulties we must recall as well that since the sixteenth century historians and archaeologists have been accustomed to working with black-and-white images, first engravings and then photographs. This will be discussed at length in the fourth and fifth chapters of the present book. But let us stress here that for nearly four centuries documentation "in black and white" was the only kind available for studying the figurative evidence from the past, including painting. By the same token, modes of thought and sensibility among historians seem themselves to have been converted into black and white. Having access largely to reproductions and books very much dominated by black and white, historians (and perhaps art historians more than others) have until recently thought about and studied the past either as a world composed of grays, blacks, and whites or as a universe from which color was totally absent.

Recent recourse to "color" photography has not really changed that situation, at least not yet. First, such habits of thought and sensibility were too firmly established to be transformed in a generation or two; and, second, access to photographic documents in color has long remained an

unaffordable luxury. For a young researcher, for a student, making simple slides in a museum, a library, or exhibition was for a long time a difficult or even impossible task. Institutional obstacles arose from all sides to discourage or exact a heavy price for it. Furthermore, for financial reasons, publishers and editors of journals and scholarly publications were obliged to prohibit color plates. Within the social sciences an immense gap long remained between what state-of-the-art technology offered and the primitive work of historians still confronting numerous obstacles—financial, institutional, legal—in studying the figurative documents that the past had left to them. What is more, these obstacles have not completely disappeared, unfortunately, and now there are daunting legal hurdles in addition to the technical and financial difficulties that earlier generations experienced.

The second set of difficulties is methodological in nature. The historian almost always feels helpless when attempting to understand the status and function of color in an image, on an object, on a work of art; all the problems—material, technical, chemical, iconographical, artistic, symbolic—present themselves at the same time. How to conduct an inquiry? Which questions to ask and in what order? No researcher, no research team has yet, to this day, proposed one or several pertinent analytical grids that could be used by the entire scholarly community. That is why, facing the abundance of questions and the multitude of parameters, every researcher—and no doubt I am especially guilty of this—has the tendency to consider only what seems suitable in relationship to the particulars of what he is in the process of demonstrating and, conversely, disregarding all else. That is obviously not a good way of working, even if it is the most common one.

Moreover, the documents produced by a society, whether written or figurative, are never neutral or univocal. Each document has its own specific nature and offers its own interpretation of reality. Like all historians, the historian of color

must take into account and maintain the rules of operation and encoding for each category of documentation. Texts and images, especially, employ different discourses and must be examined and used according to different methods. That is often forgotten, notably when instead of seeking information in the images themselves we project on them what we have been able to learn elsewhere, especially from texts. I confess that I sometimes envy the prehistorians who study figurative documents (the cave paintings) but who have no texts at their disposal; they are thus obliged to find their hypotheses, lines of thinking, and meanings in the internal analysis of the paintings without plastering over these images what texts may have taught them. Historians would do well to imitate prehistorians, at least in the first stages of analysis.

In any case, historians must abandon the search for some "realistic" meaning for colors in images and works of art. The figurative document, whether it is ancient, medieval, or modern, never "photographs" reality. It is not meant to do that, with regard to either form or color. To believe, for example, that a black door appearing in a thirteenth-century miniature or a seventeenth-century painting represents an actual door that really was black is both naive and anachronistic. Such thinking represents an error in method. In any image, a black door is black first of all because it appears in opposition to another door, or a window, or even another object, which is white, red, or some other black. That door or window may be found within that same image, or another image echoing or opposing the first. No image, no work of art reproduces reality with scrupulous exactitude with regard to color. That is just as true for ancient documents as for the most contemporary photograph. Let us think here of the historian of color who in two or three centuries seeks to study our chromatic environment of the year 2008. Beginning with the evidence of photography, fashion magazines, or cinema, the historian will probably observe a riot of vivid colors unrelated to the reality of

color as we experience it today, at least in western Europe. Moreover, the phenomena of luminosity, brilliance, and saturation will be accentuated, while the play of grays and monochromes that ordinarily organize our everyday space will be obscured if not absent.

What is true of images is also true of texts. Any written document gives a specific and unfaithful testimony of reality. If a chronicler of the Middle Ages tells us that the mantle of this or that king was black, it is not because that mantle was actually black. This is not to say that the mantle was not black, but that is not where the problems lie. Any description, any notation of color is cultural and ideological, even when it is a matter of the most insignificant inventory or the most stereotypical notarized document. The very fact of mentioning or not mentioning the color of an object was quite a significant choice reflecting the economic, political, social, or symbolic stakes relevant to a specific context. Equally significant is the choice of the word that, rather than some other word, serves to express the nature, quality, and function of that color. Sometimes the disparity between the actual color and the named color can be considerable or even simply constitute a label; thus we constantly say and have said for a long time "white wine" to characterize a liquid that has absolutely nothing to do with the color white.

The third set of difficulties is epistemological; it is impossible to project our present-day definitions, conceptions, and classifications of color onto the monuments, artworks, images, and objects produced by past centuries. They do not belong to the societies of the past (and no doubt will not belong to the societies of the future). The danger of anachronism awaits the historian at every documentary turn. But when it is a matter of color and of its definitions and classifications that danger seems even greater. Let us recall once again that for centuries black and white were considered colors in their own right; that the

spectrum and the spectral order of colors were unknown before the seventeenth century; that the distinction between primary and complementary colors emerged slowly over the course of that same century and did not become firmly established until the nineteenth century; that the opposition between warm and cool colors is purely a matter of convention and is experienced differently according to the time period and the society. In the Middle Ages and the Renaissance, for example, blue was considered a warm color in Europe, sometimes even the warmest of all the colors. That is why the historian of painting who wants to study the relation of warm colors to cool colors in a painting by Raphael or Titian and who naively believes that blue was a cool color in the sixteenth century, as it is today, will be completely misled.

The notions of warm and cool colors and primary and complementary colors, the classifications of the spectrum and the chromatic circle, the laws of perception and simultaneous contrast are not eternal truths but only stages in the fluid history of knowledge. Let us not wield them unthinkingly; let us not apply them heedlessly to societies of the past.

Consider a single example drawn from the spectrum. For us, following Newton's experiments and the spectral classification of colors, it is indisputable that green is located somewhere between yellow and blue. Many social customs, scientific calculations, "natural" proofs (the rainbow, for example), and everyday practices of all kinds are constantly present to remind or convince us of this. Now, for men of antiquity or the Middle Ages, that idea hardly made sense. In no ancient or medieval color system is green located between yellow and blue. The latter two colors are not present in the same ranges or along the same axes; thus they cannot have an intermediary stage, a "middle" that would be green. Green maintains direct relations with blue but has no relationship with yellow. Moreover, with regard to painting and dyeing, no recipe before the fifteenth century taught

us that it was necessary to mix yellow and blue to obtain green. Painters and dyers knew how to make the color green, but they did not mix these two colors to create it. Neither did they did mix blue and red to obtain purple; they mixed blue and black. Ancient and medieval purple is a demi-black, a sub-black, and it remained so for a long time in the Catholic liturgy and in the dress practices for mourning.

Thus the historian must distrust all anachronistic reasoning. Not only must he not project onto the past his own knowledge of the physics and chemistry of colors, but he must not take as absolute immutable truth the spectral organization of colors and all the theories that follow from it. For the historian, as for the ethnologist, the spectrum must be viewed only as one system among many for classifying colors, a system now known and recognized by everyone, "proven" by experience, dissected and demonstrated by science, but a system that may in two, five, or ten centuries make people smile or may be definitively obsolete. The notion of scientific proof is itself strictly cultural as well; it has its history, its reasons, its ideological and social stakes. Aristotle, who did not classify colors according to the spectral order at all, nevertheless "scientifically" demonstrated the physical and optical—not to mention ontological—justness of his classification in relationship to the knowledge of his time and with supporting evidence. That was the fourth century B.C., and black and white were fully part of this classification. They even constituted its two poles.

Without appealing to the notion of evidence, what are we to think of the men and women of antiquity and the Middle Ages—whose visual apparatus was no different from our own—who did not perceive color contrasts at all as we do today? Two juxtaposed colors that constitute a strong contrast for us could form a relatively weak contrast for them, and vice versa. Let us stay with the example of green. In the Middle Ages, to juxtapose red and green (the most common color combination for clothing between the time of Charlemagne and Louis IX) represented a weak contrast, almost a monochrome. Now for us it represents a violent contrast, opposing a primary color and its complementary color. Conversely, to juxtapose yellow and green, two neighboring colors in the spectrum, forms hardly a noticeable contrast for us. Yet in the Middle Ages it was the strongest contrast that could be created; lunatics were dressed in it and it served to indicate dangerous, transgressive, or diabolical behavior!

These documentary, methodological, and epistemological difficulties highlight the cultural relativism of all questions concerning color. They cannot be studied outside of time and place, outside of a specific cultural context. By the same token, any history of colors must first of all be a social history. For the historian—as well as for the sociologist and the anthropologist—color is defined first of all as a social phenomenon. It is the society that "makes" the color, that gives it its definitions and meanings, that constructs its codes and values, that organizes its customs and determines its stakes. It is not the artist or the scholar; neither is it biological apparatus or the spectacle of nature. The problems of color are always social problems because humans do not live alone but in societies. Without admitting this, we would tend toward a reductionist neurobiologism or a dangerous scientism, and any effort to attempt to construct a history of colors would be in vain.

To undertake this history, the work of the historian is twofold. First, he must try to define what the universe of colors might have been for the various societies that preceded our own, taking into account all the components of that universe: the lexicon and phenomena of naming, the chemistry of pigments and colorants, the techniques of painting and dyeing, the systems of dress and the codes underlying them, the place of color in daily life and in material culture, the regulations issued by authorities, the moral standards of the church, the speculations of science, the creations of artists. The grounds for inquiry and reflection are vast

and present multifaceted questions. Additionally, in diachronic analysis, in limiting himself to one given cultural area, the historian must study mutations, disappearances, and innovations that affect all historically observable aspects of the color.

In this dual process all documents must be examined; color is essentially a multimedia and interdisciplinary field. But certain fields of inquiry have proved more fruitful than others. That is true of the lexicon; here as elsewhere the history of words contributes much pertinent information to our knowledge of the past. In the domain of color it demonstrates how in every society color's first function is to classify, mark, proclaim, combine, or contrast. Once again, that is true especially in the area of dyes, fabric, and clothing. More so than in painting and artistic creations, this is probably where we find issues of chemistry, technology, and materials most inextricably bound with social, ideological, and symbolic stakes.

In this regard, the history of the color black in Europe, to which the present book is devoted, seems exemplary.

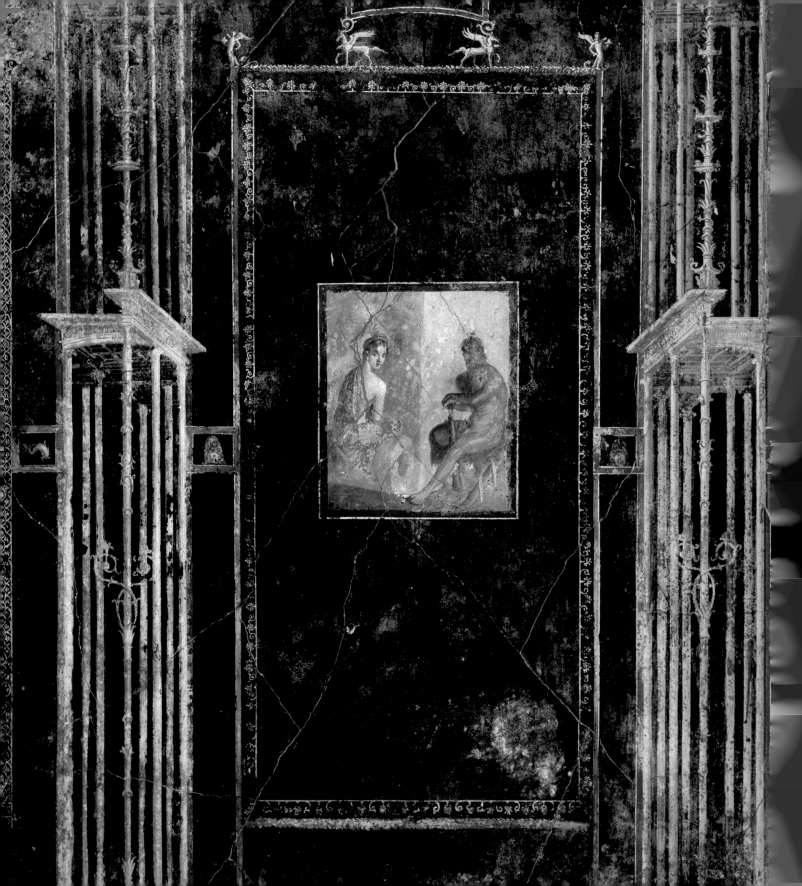

IN THE BEGINNING WAS BLACK

WAS BLACK

FROM THE BEGINNING TO THE YEAR 1000

"In the beginning, God created the heavens and the earth. The earth was without form and void: darkness was upon the face of the deep, and the spirit of God was moving over the waters. God said, 'Let there be light,' and there was light. God saw that the light was good; and God separated the light from the darkness."[1] If we are to believe the first verses of Genesis, darkness preceded light; it enveloped the earth when the earth was still without any living being. The appearance of light was a necessary condition for life to begin on the earth: *Fiat lux!* For the Bible, or at least for the first account of Creation, black thus preceded all other colors. It is the primordial color, but also the one that from the beginning possessed a negative status. In black no life is possible; light is good, darkness is not. For the symbolism of colors black already appears as void and deathly after only five biblical verses.

The picture hardly changes if divine creation is replaced with the big bang and if it is moved from the theological to the astrophysical plane. Here as well darkness precedes light and a kind of "dark matter" passes for having been the first site of the expansion of the universe.[2] At least that is true in a simplified version of the big-bang theory, which holds that the big bang was the explosion of an atom or a primitive mass. Of course now, after hardly having its hour of glory, that idea has been abandoned by most physicists; undoubtedly there never was a first moment. However, even if we admit that history has no beginning and that the universe is eternal and infinite, a primal image of a world made of darkness asserts itself nonetheless—that is to say, a world made of a material that absorbs all the electromagnetic energy it could receive: a world perfectly black, matrix on the one hand, terrifying on the other. A dual symbolism will accompany the color black throughout its history.

MYTHOLOGIES OF DARKNESS

Neither the Bible nor astrophysics has a monopoly on this kind of image. Most mythologies evoke it to describe or explain the origin of the world. In the beginning was the night, the vast originary night, and it was by emerging from darkness that life took form. Greek mythology, for example, made Nyx, goddess of the night, the daughter of Chaos, the primordial void, and the mother of Uranus and Gaia, the sky and earth.[3] Her dwelling place was a cave located far in the west; she withdrew there during the day before crossing the sky, clothed in black and mounted on a chariot drawn by four horses of the same color. In certain traditions the horses had black wings; in others Nyx's dark appearance was so frightening she scared Zeus himself. In the archaic period, throughout Greece, entirely black ewes or female lambs were sacrificed to her. Beyond heaven and earth, Nyx, a chthonic divinity, gave birth to numerous entities, the list varying according to the source, but all of whom were more or less closely associated with the color black: sleep, dreams, anguish, secrets, discord, distress, old age, misfortune, and death. Some authors even present the Furies and the Fates, those mistresses of human destiny, as daughters of the night, as well as the strange Nemesis, a complex personification of divine vengeance, responsible for punishing crimes and all that could disrupt the orderly world. Her principal sanctuary was found in Rhamnonte, a small city in Attica where a giant statue of the goddess stood, carved in the fifth century B.C. by the great Phidias from a block of black marble.

This originary black is also found in other mythologies, not only in Europe but also in Asia and Africa. It is often fertile and fecund, as the Egyptian black that symbolizes the silt deposited by the waters of the Nile, with its beneficial floods that are anticipated hopefully each year; it is the opposite of the sterile red of the desert sand. Elsewhere, fertile black is simply represented by big dark clouds, heavy with rain, ready to fall upon the earth to make it fruitful. In still other places it either graces the statuettes of the protohistorical mother-goddesses or adorns certain divinities associated with fertility (Cybele, Demeter, Ceres, Hecate, Isis, Kali); they may have dark skin, hold or receive black objects, and demand that animals of that color be sacrificed to them. Fertile black leaves its marks until the middle of the Christian Middle Ages by means of the symbolic

Pompeian Painting (page 18)
In Roman painting in the illusionist style, red and black tones are dominant. For the most part, these were obtained from charred plant (wood, woody vines) or animal (bone, more rarely ivory) materials.
Pompeii, villa of Fabius Rufus, cubiculum. Wall painting, 1st century.

color system associated with the four elements. This system itself constitutes one of the most durable of legacies: fire is red, water is green, air is white, and earth is black. Endorsed by Aristotle in the fourth century B.C., this symbolic system was readopted by the great Latin encyclopedists of the thirteenth century, notably Bartholomew the Englishman.[4] It was still appearing in books of emblems and iconology treatises printed at the end of the sixteenth century.[5] This earthly black is a fertile black; it is often associated with the vital power of red, which can be either fire or blood. Neither color is negative or destructive in this case. On the contrary, these two colors constitute the sources of life, and their combination sometimes increases their value exponentially.

The fertile nature of primordial black also leaves its mark in the tripartite organization of many ancient and medieval societies: white is generally the color of priests; red the color of warriors; black the color of artisans. In early Rome the association of these three colors with the three social classes was particularly pronounced.[6] But we also encounter it in many Greek works describing the ideal city.[7] Later, at the height of the Middle Ages during the feudal period, it appears in chronicles and literary texts, sometimes in images: white for those who pray (*oratores*); red for those who fight (*bellatores*); black for those who work (*laboratores*).[8] Clothing, furs, emblems, and attributes testify to this division, although obviously not systematically.[9] Certain scholars have identified the social function of this color triad as Indo-European in origin.[10] That seems credible, but simply considering black as it relates to production and fertility we may certainly go back even further.

Over the long term originary fecund black has consistently been associated with the symbolism of certain places, such as caves and all natural sites seemingly in contact with the bowels of the earth: caverns, grottos, chasms, underground passageways. Even though they are deprived of light, these are fertile crucibles, places of birth or metamorphosis, receptacles of energy and, by the same token, sacred spaces that must certainly have constituted the oldest sites for human worship.[11] From the Paleolithic to the historical periods they sheltered nearly all religious and magic ceremonies. Subsequently, grottos and caves became the favorite birthplaces for gods and heroes, then places of refuge or metamorphosis; one went there to hide, to be restored, to perform some rite of passage. Later, perhaps under the influence of Nordic mythologies, forests took over the role of caves, but continued the tradition of making dark or private spaces sacred ground.

Nevertheless, as is always true with mythology and religion, the symbolism of such spaces is ambivalent and includes a powerful negative dimension. All obscure matrices are also places of suffering and misfortune, inhabited by monsters, confining prisoners, harboring all sorts of dangers, increasingly disturbing the darker they are. The most famous passage from Plato's *Republic*—one of the great foundational texts of Western culture—presents such a cave, a place of pain and punishment where human souls are locked up and chained by the gods. On one wall they perceive a display of shadows symbolizing the deceptive world of appearances; they must break their chains and leave the cave to contemplate the true world, the world of Ideas, but they cannot do so.[12] Far from being the source of life and energy, here darkness makes the cave into a prison, a place of punishment and torture, a sepulcher or veritable hell. Here black is deathly.

Greek Vase with Black Figures
On Greek vases, black figures, standing out against a white, red, or yellow background, preceded the red figures belonging to the classical style. The pigment is a simple carbon black; its quality depended as much upon the potter and his mastery of the various phases of firing as the paint itself. *Circe the Sorceress.* Lekythos with black figures, c. 490 B.C., National Archaeological Museum, Athens.

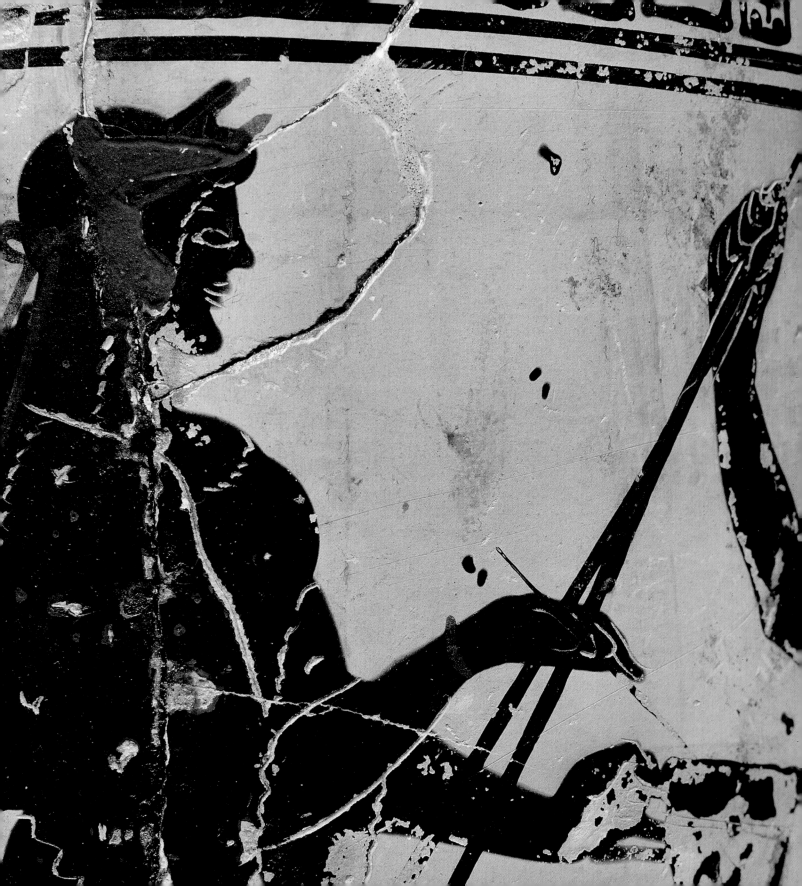

FROM DARKNESS TO COLORS

Humans have always been afraid of the dark. They are not nocturnal animals, they never have been, and even if over the course of centuries they have more or less domesticated night and darkness, they remain diurnal creatures, comforted by light, brightness, and vivid colors.[13] Of course, since antiquity, the poets, in the image of Orpheus, have sung night's praises, "mother of gods and of men, origin of all creation," but ordinary mortals have long feared it. They have feared darkness and its dangers, creatures who live and lurk there, animals with dark fur or feathers, and night itself, the source of nightmares and perdition. There is no need to be an expert on archetypes to understand that these fears come from far, very far back—from periods when humans had not yet mastered fire or, in part, light. I confess that I have never believed in a universal symbolic system of colors independent of time and place and shared by all civilizations. On the contrary, I have always stressed that the problems and stakes related to color are cultural, strictly cultural, and prohibited the historian from disregarding eras and geographical areas. Nevertheless, I am forced to acknowledge that a few chromatic referents are encountered in almost every society. They are not numerous: fire and blood for red; vegetation for green; light for white; night for black—an ambivalent, even ambiguous night, yes, but always, everywhere, more disturbing or destructive than fertile or comforting.

We will never know what essential turning point the mastery of fire constituted in human history, approximately five hundred thousand years ago. It was the control of fire by *Homo erectus* that definitively distinguished human beings from animals. Subdued, domesticated, produced at will, fire not only allowed humans to warm themselves, to cook their food, and build their first altars, but also and most importantly to produce light. The immense fear of darkness began to retreat and with it the terror of night and dark or underground places. Blackness was no longer totally black.

Later, beginning in the Upper Paleolithic, when the uses of fire diversified, it even became possible to make artificial pigments by burning to a cinder plants or minerals. The oldest of these pigments was probably carbon black, obtained by the controlled combustion of various woods, barks, roots, shells, or pits. Depending on the original material and the degree of

calcination, the shade of black obtained was more or less brilliant and more or less dense. Such processes allowed Paleolithic artists to enrich their palettes, limited until then to only the colorants provided directly by nature. Within the range of blacks, these artists knew henceforth how to produce their own pigments and vary their shades. Later they learned to burn bone in a similar fashion, as well as ivory and deer antlers, to obtain even more beautiful blacks. Then they took up minerals—scraped, ground, oxidized, mixed with binders, these minerals provided them with new colorants, more solid if not more luminous. For the blacks, manganese oxide tended to replace or supplement plant carbons. It was used abundantly, for example, at Lascaux (some fifteen thousand years ago) to paint most of the animals in the splendid and prolific bestiary, the star of which is the famous black bull. But carbon blacks did not disappear. Consider the excellently preserved cave paintings from a few millennia later in the Niaux (Ariège) grotto in the famous "black salon" located more than seven hundred meters from the entrance. A great number of black animals are represented: bison, horses, ibex, deer, and even fish. The pigment used was almost exclusively wood carbon, although these paintings, dating from about twelve or thirteen thousand years ago, are more recent than those at Lascaux.[14]

Over the course of the millennia, the palette of colors and number of pigments never stopped growing. Egyptian civilization produced a great number of them, and many were new. With regard to blacks, however, manganese oxide and especially the carbon blacks continued to occupy the primary position. Even ink, a recent invention, used a solution of carbon black or lampblack in water, with the addition of animal glue or gum arabic. The grays, practically unknown until then, made their appearance in Egypt, where they played an important part in funerary painting. They were obtained through mixing plant carbon and white lead.

In certain parts of the Near East bituminous black, a very thick pigment emanating from the oil-rich soils, was added to these various materials. Farther west, in Greece and Rome, painters used lampblack abundantly, especially for small surfaces, and produced magnificent blacks from certain wood carbons. The most prized, and particularly valued by the Romans,

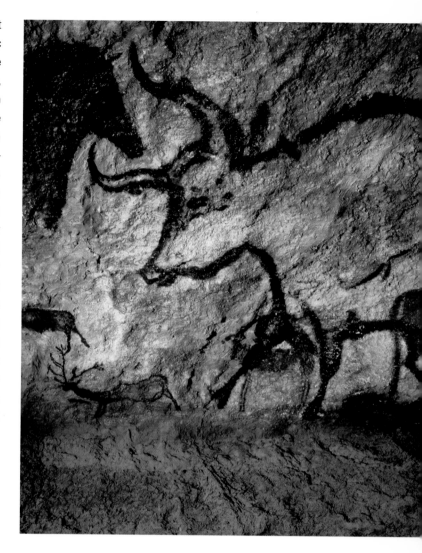

The Great Bull of Lascaux
Black pigments are most abundant in the Paleolithic cave paintings. The oldest ones came from charred plant (wood) or animal (bone, ivory, antlers) materials, but in some caves with more recent paintings, mineral pigments are found as well, notably, as here in Lascaux, manganese oxide.
Great Black Bull. Lascaux cave, c. – 15,000.

was the black from vines, obtained through the calcination of very dry vine shoots that gave the color much depth and blue highlights. Of course, ivory black was considered even more beautiful, but its exorbitant price restricted its use. Natural brown or black soils, rich in manganese oxide, continued to provide painters with most of the principal mineral pigments used in the range of blacks and browns. They were relatively expensive because they often had to come from far away (Spain or Gaul, for example), and the coloring effects they produced were more matte than those of plants and lampblack.

Technology was less advanced with regard to dyes. Even though they appeared quite early, they did not generate actual activity until the Neolithic, when human populations became sedentary and developed textile production on a large scale. Dyeing required specialized expertise. The colorant materials derived from plants and animals were never usable as such. It was necessary to isolate them, remove their impurities, and make them react chemically. Then they had to penetrate the cloth fibers and be permanently fixed there. All these operations were long and complex. It was in the range of reds (madder, kermes, murex) that dyers were most successful early on, and that remained the case for many millennia. Dyeing in black, on the other hand, long remained an extremely difficult exercise, at least in the West.

The first dyes with a wood carbon or lampblack base were volatile and colored fabrics irregularly. Although never completely abandoned—even in the late Middle Ages there were legal proceedings against dyers who claimed to be using a true colorant material, expensive but permanent, when it was a matter of simple lampblack—they were gradually replaced by dyes with bark or root bases, rich in tannins: alder, walnut, chestnut, certain oaks. But these plant dyes held up poorly to the effects of the sun and washing or even to prolonged use. In some regions dyers learned early on to combine them with mud or silt rich in iron salts, which worked as a mordant. But that was not possible everywhere. In other places some dyers resorted to oak apple, a very expensive colorant material, extracted from a small spherical growth found on the leaves of certain oaks. Various insects lay their eggs on these leaves; after the eggs are laid, the sap of the tree exudes a material that gradually surrounds the larva and encloses it in a kind of shell; that is the oak gall, or oak apple. They had to be collected before summer, when the larva had not yet hatched, and then dried slowly. Thus they were rich in tannins and possessed remarkable colorant qualities in the black range. But their high price limited their use.

All these difficulties explain why for a very long time in Europe, from earliest antiquity to the late Middle Ages, the blacks produced by dyers were rarely beautiful, true blacks. Often more brown than black, indeed even gray or dark blue, they covered the fabric unevenly, were poorly fixed, and gave cloth and clothing a soiled, drab, displeasing look. Little prized, these black clothes were reserved for the lowest social classes, for dirty or degrading tasks, and for certain specific circumstances like mourning or penitence. Only the black of animal furs was valued, especially the sable fur, the most beautiful black to come from the animal kingdom.

FROM PALETTE TO LEXICON

Ancient cultures had a more developed and nuanced awareness of the color black than contemporary societies do. In all domains, there was not one black, but many blacks. The struggle against darkness, the fear of night, and the quest for light gradually led prehistoric and then ancient peoples to distinguish degrees and qualities of dark, and having done so, to construct for themselves a relatively wide range of blacks. Painting provides early evidence of this. Beginning in the Paleolithic era, artists used many pigments to produce this color, and their number would increase over the course of the millennia. The result was an already well-diversified palette of black in the Roman period: matte blacks and glossy blacks, light blacks and dark blacks, intense blacks and delicate blacks, blacks tending toward gray, brown, and even blue. Painters, unlike dyers, knew how to employ them in subtle ways according to the materials involved, the techniques used, and the coloring effects desired.[15]

The lexicon offers more evidence of this diversity in black tones as perceived by ancient peoples. It was used to capture the various shades used by the artists but also and especially to name all the qualities of black present in nature. That is why in most ancient languages the vocabulary for blacks is often richer than it is in modern languages. But for black, as for all other colors except perhaps red, that vocabulary is unstable, imprecise, and elusive. It seems more closely related to the properties of materials and the value of coloring effects than to coloration itself. Emphasis is given first to the texture, density, brilliance, or luminosity of the color, and only afterward to its tonality. Moreover, the same term can serve to name several colors: for example, blue and black (*kuanos* in Greek; *caeruleus* in Latin) or even green and black (*viridis* in Latin); conversely, many words can be used to express the same nuance.[16] Hence irresolvable difficulties for translation arise, of which biblical Hebrew and classical Greek offer innumerable examples.[17]

Latin comes a little closer to our modern conception of color vocabulary. But through the inflective play of prefixes and suffixes it sometimes continues to emphasize the expression of light (bright/dark, matte/glossy), material (saturated/unsaturated), or surface (uniform/composite, smooth/rough) over the expression of coloration. With regard to black, it does not always completely

isolate its chromatic field from that of other colors (brown, blue, purple) and most importantly it clearly distinguishes two large groups: matte black (*ater*) and glossy black (*niger*). Therein lies black's essential characteristic; while red (*ruber*)[18] and green (*viridis*) are expressed by a single base term, as opposed to blue and yellow, which have no such term and are named through recourse to an uncertain, changing vocabulary—proof of the Romans' lack of interest in these two colors?—black and white each benefit from two commonly used words, two terms with a solid base and semantic field rich enough to cover the whole chromatic and symbolic palette of these two colors: *ater* and *niger* for black; *albus* and *candidus* for white.

Ater, perhaps of Etruscan origin, long remained the most frequently used word for black in Latin. Relatively neutral at first, it became progressively specialized as the matte or dull shade of the color, and then, about the second century B.C., took on a negative connotation. It became the bad black, ugly, dirty, sad, even "atrocious" (this adjective has lost its chromatic meaning, retaining the affective meaning only). On the other hand, *niger*, its etymology unknown, was less commonly used than *ater* for a long time and at first possessed only the single meaning of "glossy black." Subsequently it was used to characterize all blacks taken as a whole, notably the beautiful blacks in nature. At the beginning of the imperial period it had already become more common than *ater* and spawned a whole family of frequently used words: *perniger* (very black), *subniger* (blackish, purple), *nigritia* (blackness), *denigrare* (to blacken, to denigrate), and so on.[19]

As is true for black, classical Latin also possesses two basic terms for white: *albus* and *candidus*. The first long remained the most frequently used, before taking on the specific meaning of "matte white" or "neutral white." The second, on the other hand, was first used only to indicate glossy white, until its usage was extended to all luminous whites and to all whites of enhanced value on the religious, social, or symbolic plane.[20] A similar duality for both black and white is found in the lexicon of ancient Germanic languages. It underlines the importance of these two colors for "barbarian" peoples and, as was true for the Romans, seems to affirm their preeminence (with red) over all other colors. Over the course of the centuries, however, the vocabulary was

reduced, and one of the two words disappeared. Today, German, English, Dutch, and all the languages in the Germanic family possess only a single base term in everyday use, to say "black" and to say "white": *schwarz* and *weiss* in German, and *black* and *white* in English, to limit ourselves to just these two languages. But that was not the case in Proto-Germanic, nor later in Frankish, Saxon, Old or Middle English, Middle High German, or Middle Dutch. Until the height of the Middle Ages, and sometimes well beyond, the various Germanic languages, like Latin, used two simultaneous terms to name black and white. Let us stay with the examples of German and English. Old High German distinguishes *swarz* (dull black) from *blach* ("luminous" black), and *wiz* (matte white) from *blank* (glossy white). Likewise, Old and Middle English oppose *swart* (dull black) to *blaek* ("luminous" black) and *wite* (matte white) to *blank* (glossy white). Over the course of the centuries the lexicon was reduced to a single word for each of the two colors: *schwarz* and *weiss* in German, *black* and *white* in English. This occurred slowly, following different rhythms depending upon the language. Luther, for example, knew only a single common word for black (*schwarz*), whereas a few decades later Shakespeare still used two words to name that color: *black* and *swart*. In the eighteenth century, *swart*, although an old term, was still used in certain counties in the north and west of England.

The lexicon of ancient Germanic languages teaches us not only that two terms existed for naming "black" and for naming "white," but also that two of the four words used, one meaning black and one meaning white (*blaek* and *blank*), have a shared etymology found in a verb belonging to Proto-Germanic: **blik-an* (to shine). Thus these two words express especially the brilliant aspect of the color, whether it is black or white. By the same token, they confirm what the vocabulary of other ancient languages (Hebrew, Greek, and even Latin) has already taught us: to name the color, the parameter of luminosity is more important than that of coloration. The lexicon seeks above all to say if the color is matte or glossy, light or dark, dense or thin, and only then to determine if it belongs to the range of whites, blacks, reds, greens, yellows, or blues. That is a phenomenon of language and sensibility of considerable importance, which the historian must constantly keep in mind when studying not only

texts but also images and works of art left to us by antiquity. In the domain of colors the relationship to light takes precedence over everything else. That is why, even though black is the color of darkness, "luminous" blacks exist, that is to say, blacks that brighten before darkening, blacks that are more light than dark.

Over the centuries this awareness of light, so important to ancient European peoples, diminished, and with it the lexical palette of blacks and whites became impoverished. The languages that possessed two basic terms to name each of these colors retained only one of them.[21] Old French, for example, abandoned the Latin word *ater* (although it was still attested in medieval Latin) and used only the single word in common use: *noir* (*neir*), from the Latin *niger*. By the same token, the word became extremely rich and took on the whole symbolic range of the color (sad, grievous, ugly, hideous, cruel, evil, diabolic, and so on). But to express the nuances of chromatic quality or intensity (matte, glossy, dense, saturated, and so on) it was necessary to resort to comparisons: black as pitch, black as blackberry, black as a crow, black as ink.[22] Modern French does the same thing but to a lesser degree, because modern sensibilities are less attentive to the various shades of black. It is as if the fact of no longer being considered a true color, beginning from the fifteenth or sixteenth century, had deprived black of a portion of its nuances.

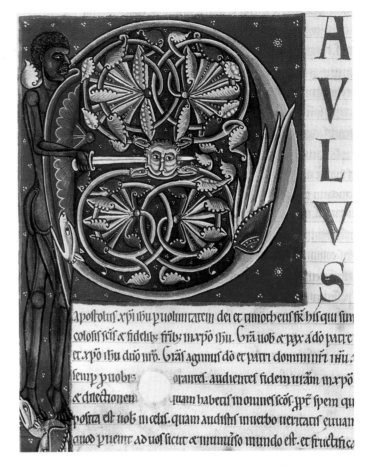

The Two Latin Blacks

Classical Latin possessed two commonly used words to designate the color black: *ater*, a dull, disturbing black; *niger*, a brilliant and sometimes esteemed black. In medieval Latin, the first became rare, while the second took over most of the meanings of black.
Decorated letter in a manuscript from the Corbie Abbey (Florus, *Commentaries on the Letters of Paul*), 1164. Paris, Bibliothèque Nationale de France, Latin ms. 11576, fol. 67v.

DEATH AND ITS COLOR

Anubis

In pharaonic Egypt, black was linked to the fecund aspect of the earth. During funerals, it ensured the passage of the deceased to the beyond. It was a beneficial black, the sign or promise of rebirth. Most of the divinities related to death were often painted black, like Anubis here, the jackal-god embalmer, who accompanied the dead to the tomb. *Anubis*. Painting and hieroglyphs from the interior of Inherka's tomb. Thebes, 12th century B.C.

As the color of night and darkness, as the color of the bowels of the earth and the underground world, black is also the color of death. From the Neolithic, black stones were associated with funeral rites, sometimes accompanied with statuettes and objects very dark in color. The same is true in the historical periods throughout the Near East and in pharaonic Egypt. Yet this chthonic black is neither diabolical nor harmful. On the contrary, it is linked to the fertile aspect of the earth; for the dead, whose passage to the beyond it ensures, it is a beneficial black, the sign or promise of rebirth. That is why among the Egyptians the divinities related to death were nearly always painted black, like Anubis, the jackal-god who accompanies the dead to the tomb; Anubis is the embalmer-god and his flesh is black. Similarly, the deified kings and queens, ancestors of the pharaoh, were generally represented with black skin, a color that was not the least bit depreciatory. In Egypt the negative, suspect color was red rather than black: not the admirable red of the solar disc as it rose or set, but the red of the forces of evil and the god Seth, murderer of his son Osiris and a great destructive force.[23]

In the Bible this was not the case. Even if it is sometimes ambivalent, as all colors are, even if the fiancée in the Song of Songs proclaims "I am black but I am beautiful," biblical blacks—and all other dark colors as well—are frequently considered bad.[24] This is the color of evildoers and the impious, the color of the enemies of Israel and divine malediction. It is also the color of primordial chaos, dangerous, harmful night, and especially death. Light alone is the source of life and manifestation of the presence of God. It is opposed to the "darkness"—one of the words that appears most frequently in the biblical text—always associated with evil, impiety, punishment, error, and suffering. In the New Testament, this theophanic aspect of light becomes ubiquitous; Christ is the light of the world.[25] He snatches the righteous from the empire of evil and the "prince of darkness" (the devil); he helps them ascend to celestial Jerusalem, where they will see God face to face and will be illuminated forever.[26] By the same token, white, the color of Christ and light, is also the color of glory and resurrection; in contrast, black appears as the color of Satan, sin, and death. Of course, the image of hell is still obscure and imprecise, but it is already different from the *shéol*

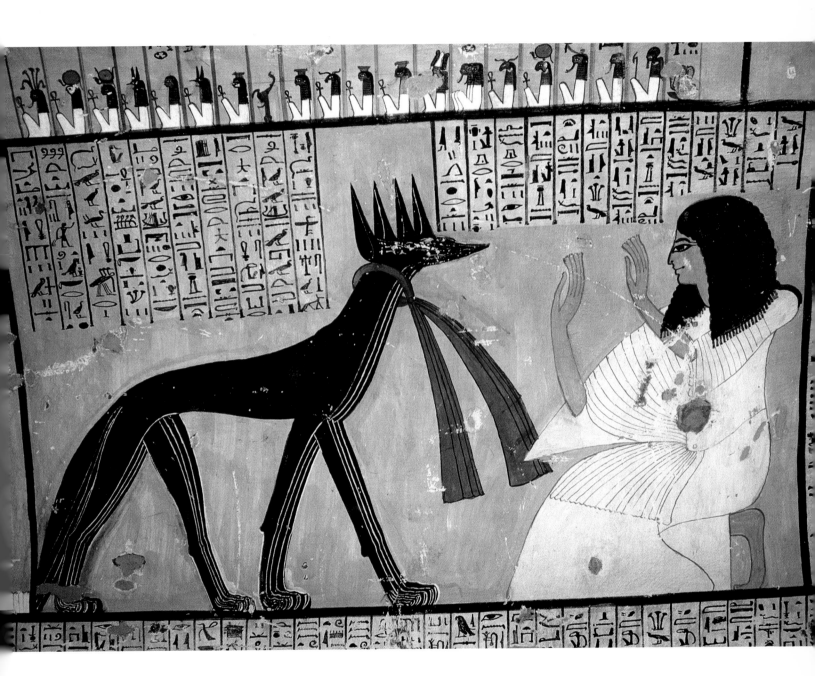

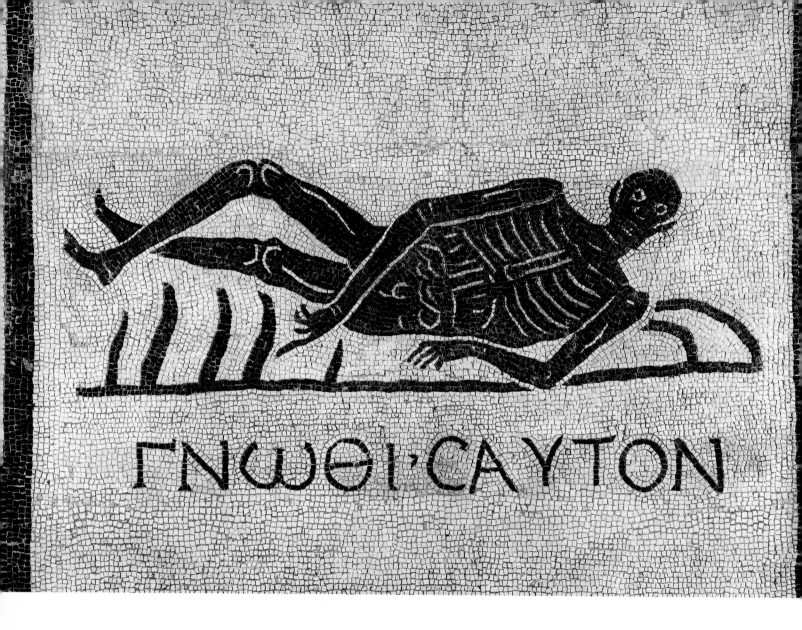

ΓΝΩΘΙ·CAYTON

of the Old Testament, which is the future sojourn reserved for sinners, a place of torment, of "tears and clashing of teeth," which resembles a blazing oven or a lake of fire.[27] To the black of darkness is added the red of this eternal fire that burns without illuminating. From earliest Christian times hell is black and red, two colors that will long remain associated with it and with the devil.

For other ancient religions or mythologies, hell is more monochromatic, more black than red. Often fire is absent from it because it is a sacred, divine element; the wicked must thus

Funeral Mosaic
Already in Roman iconography from the imperial period, the color black associated with the image of a skull or skeleton was an inevitable symbol of death. It has remained so to the present day.
Know Thyself. Funeral mosaic found on the Appian Way (San Gregoria), early 3rd century. Museo Nazionale delle Terme, Rome.

endure without it, which causes them to suffer from the cold and dark. In the underground world everything is black and frozen. The Greek Hades is nearly archetypal, at least for the Hellenistic period. Located in the depths of the earth, near the realm of Night, it is a multifaceted place where all souls find themselves after death. Many rivers separate it from the world of the living, notably the Acheron with its black, muddy waters. For an obol, Charon, a very ugly old man dressed in rags and wearing a round hat, helps souls across it in his funeral boat. But on the other side awaits Cerberus, a monstrous dog endowed with three heads branching from a neck bristling with serpents. He is the guardian of hell, a terrifying guardian with dark fur, sharp teeth, and venomous saliva. Behind the enormous door sits the tribunal before which the souls appear one by one. According to the life that each has led on earth, the souls are sent to the right, toward the luminous dwelling place of the just, or to the left, toward the dark world of the condemned, where punishments depend upon the gravity of the offenses. The most serious ones lead to Tartarus, the deepest, darkest region of hell, riddled with sulfur lakes and burning pitch. It is the prison of the deposed divinities (the Giants, the Titans) and criminals condemned to eternal punishment (Tantalus, Sisyphus, the Danaids). At the center, behind a triple wall, is the palace of Hades, god of the underworld, seated on an ebony throne. Brother of Zeus, his attribute is a serpent, emblem of the underground world that he never leaves. His wife Persephone, on the other hand, lives with him only half the year, spending the other half on earth and in the heavens.

This representation of the Greek hell unfolded gradually. The oldest authors gave it a different topography. Homer, for example, located hell at the ends of the earth, beyond the river Oceanus, where night and fog reign permanently. Hesiod placed it halfway between the celestial dome and Tartarus, in a dark, ill-defined zone beyond the land of the Cimmerians where the sun never appears. Still others made it the underground country of shadows, where earth and sea thrust their roots; a triple wall surrounds this place of darkness, realm of Erebus, son of Chaos and brother of Night. All insist on the color black for the dwelling place of the dead.

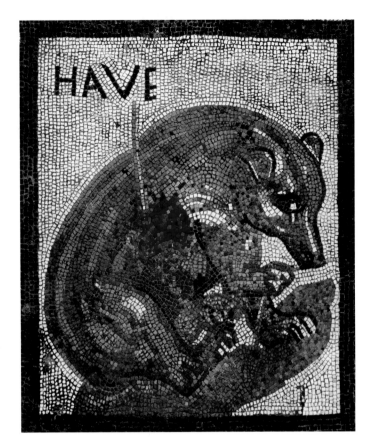

The Bear, a Wild Animal

For the Romans, the bear was the strongest of all animals and the wild beast par excellence. Its dark fur and anthropomorphic appearance made it a formidable creature, good to hunt but attributed with wicked behavior. "No other animal is more apt to do harm," declared Pliny in his *Natural History*.
Bear Mosaic. Pompeii, Casa dell'orso ferito, atrium, 1st century A.D.

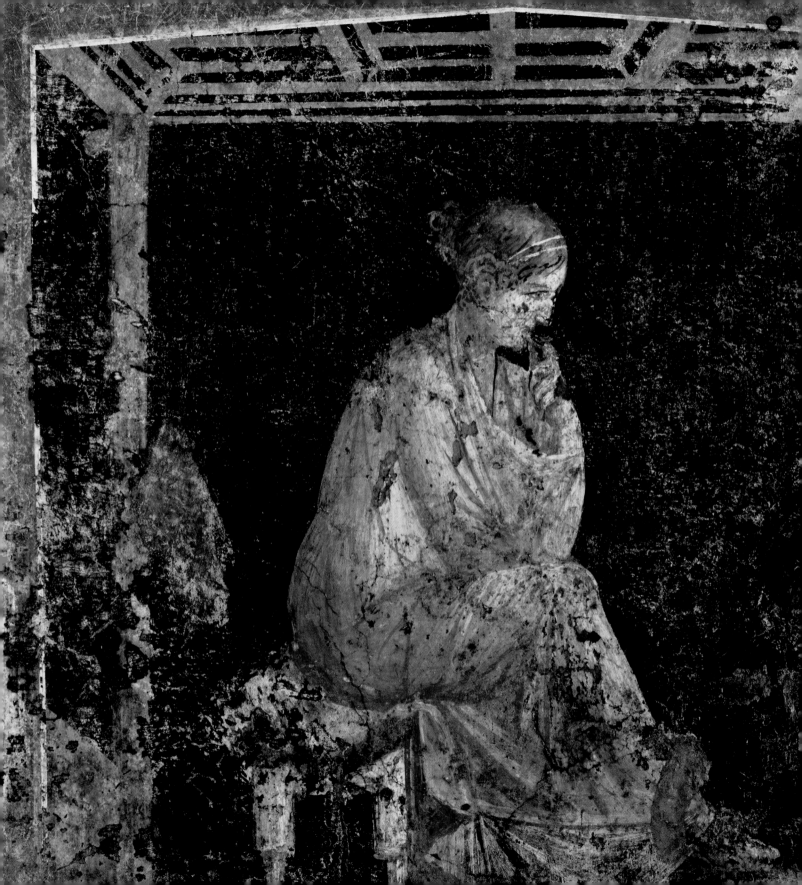

The Roman hell hardly differs from the Greek one, and black remains the color of death. From the beginning of the Republic, black was present in various forms (objects, offerings, paintings) in Roman funeral rites. Then, beginning in the second century B.C., the magistrates participating in funerals began to wear it: a dark-colored toga praetexta (*praetextam pullam*). This was the beginning of mourning clothes in Europe—clearly a limited beginning, but it marked the start of a custom that would continue to expand socially and geographically until the modern period. Already under the empire, Roman high society imitated the magistrates, and relatives of the deceased appeared in black clothing, not only at the funerals but also for a more or less extended length of time afterward. The period of mourning ended with a banquet at which the participants no longer dressed in black but in white.[28]

In actuality, Roman mourning clothes were more dark than black; for textiles, the adjective *pullus*, used to characterize them, generally refers to a dark, drab wool, its color somewhere between gray and brown.[29] A few authors have sometimes made it synonymous with *ater*, but the toga pulla of funerals was probably closer to an ash gray than to a true black.[30] Nevertheless, true black remained the symbolic color most often associated with death, which was itself sometimes evoked in poetry by the figurative expression *hora nigra*, the black hour.[31]

In imperial Rome, the color black thus seems to have lost the beneficial aspect (fertility, fecundity, divinity) that it possessed in the East and the Middle East, in Egypt, and even in archaic Greece. The two adjectives that designate it, *ater* and *niger*, are laden with many pejorative figurative meanings: dirty, sad, gloomy, malevolent, deceitful, cruel, harmful, deathly. In the past it had been possible to take only *ater* in a bad sense; henceforth, that was equally true for *niger*. Many authors go so far as to relate *niger* to the large family of the verb *nocere*, to harm.[32] Like night (*nox*), black (*niger*) is harmful (*noxius*): admirable proof provided by the words themselves, which the authors of the Christian Middle Ages would use again to evoke sin and construct a negative symbolism for the color.[33]

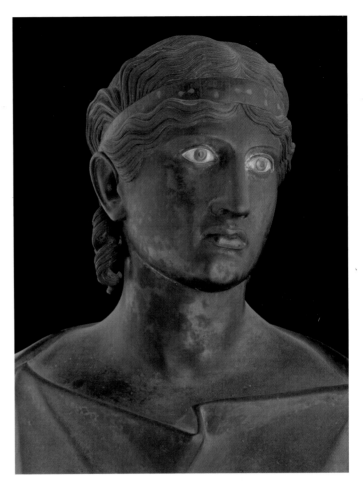

Black Marble Statue

In Rome, the trend in columns and statues made of black marble, imported from the Greek islands of Chios and Melos, began in the first century B.C. This marble is sometimes called Lucullian marble, named for the consul Lucullus, who was the first to use it prominently in his Roman villa. Statue of a danaid with painted eyes. Museo Nazionale archeologica, Naples.

Pompeian Black (opposite page)

In Roman painting, the use of black backgrounds helped to create the effects of depth, which, combined with trompe-l'oeil architectural décor, were characteristic of the "illusionist" style, very much in vogue in Pompeii in the first century B.C. *Seated Woman*. Wall painting, Pompeii, 1st century B.C.

THE BLACK BIRD

The Crow, Black Bird

Many ancient and medieval tales relate how the
crow, whose feathers were formerly white,
became a black bird. The reasons for this change
vary according to the versions, but they always
involve atonement: the crow is being punished
for talking too much or for boasting.
Its feathers are a sign of sin.
Miniature from a collection of Austrian fables
from the mid-15th century. Vienna, Österreichiche
Nationalbibliothek, Cod. 2572, fol. 37v.

Like the Greco-Roman pantheon, the German and Scandinavian
one includes a divinity of the night: Nott, daughter of the giant
Norvi. Dressed in black, she crosses the sky in a chariot
drawn by a horse of the same color, the swift but capricious
Hrimfaxi. Neither of them is consistently evil, unlike the formidable
Hel, goddess of the realm of the dead, daughter of Loki, the evil
god, and sister of the wolf Fenrir and the serpent Midgardr. Her
appearance is ghastly—not only are her features hideous and her
hair a disheveled tangle, but her skin is two-tone: black on one
side, "pallid" (*blass*) on the other.[34] This makes her more
disturbing than if she were entirely black or even black and white,
which would be a simple sign of ambivalence. No, this is a matter
of a far more sinister combination. Black is coupled with
the pallor so feared by the Germans; it precedes the fog,
accompanies ghosts, and shrouds evil spirits. Bearing the color
of darkness on one side and phantoms on the other, Hel seems
doubly associated with death. Her brother, the monstrous wolf
Fenrir, who will mortally wound Odin and play a decisive role in
the demise of the gods, is almost less frightening because he
generally appears all gray.

For the Germans black is not the worst of the colors. What is
more, there is black and then there is black, as the vocabulary
mentioned earlier makes clear. One is matte and dull, always
disturbing, often deathly (*swart*); the other is intense and fertile,
so brilliant that it seems to light the darkness and allow one to
see in the night (*blaek*). This "luminous" black, a tool of
knowledge, finds its most striking manifestation in the plumage
of a bird that observes the world and knows the destiny of men,
a bird that knows all: the crow.

In antiquity, for all the peoples of the Northern Hemisphere,
the crow was the blackest living creature that could be
encountered. Like black itself, it could be taken for good or for
evil. Among the Germans it was entirely positive; this bird was
simultaneously divine, warlike, and omniscient. Odin, the
principal divinity of the Nordic pantheon, is old and one-eyed,
but his two crows, Huginn (thought) and Muninn (memory),
travel the world in his place, observing and listening then
reporting to him what they have seen and heard. Thanks to them,
Odin knows everything, controls the future, and decides the fate
of mortals. He is quick to change into crows those who have

displeased him or even to take on the appearance of a crow himself to torment them or put them to death.

God of knowledge and magic, master of life and death, Odin is also the god of war. That is why German warriors sought to win his favor by bearing the image of his principal attribute into battle: a black crow believed to have protective powers.[35] The bird appeared on helmets, belt buckles, ensigns and banners, sometimes assuming the role of a personal insignia, sometime of a group emblem. Archaeology provides various proofs of this, and the sagas highlight the confidence placed in that tutelary bird by recounting how the imitation of its cry constituted the war cry itself for Scandinavian warriors. On the sea, its protective image was painted on the sails of ships or sculpted on the prows. On land, it was carried into battle, displayed at the top of a pole or embroidered on a piece of cloth. An anonymous chronicler from about the year 1000 even reported how, during the 876–78 wars in northern England between the Anglo-Saxon king Alfred and Danish invaders, the invaders had a magic banner at their disposal. In times of peace it was an immaculate white, but in times of war a black crow appeared on it, flapping its wings and shifting its feet, pecking and letting out appalling cries.[36]

Anthroponymy also attests to this worship of crows among the Germans.[37] Nevertheless, more significant than names were rituals performed by pagan warriors[38] in the Saxon or Thuringian forests that frightened the Christian missionaries: animal sacrifices, worship of animal idols, the custom of placing animal bones in tombs to accompany the dead on their last journey, and, especially, before leaving for battle, ritual banquets that consisted of drinking the blood of wild animals and eating their flesh in order to take on their powers and be assured of their protection. It was most often a matter of the bear and the wild boar.[39] But sometimes it was also the crow—the raven was a formidable warrior—and this left the missionaries perplexed. For the Bible and the church fathers, the crow was an impure bird because it ate carrion and was diabolical because it was covered with entirely black plumage; its flesh was not to be consumed, much less its blood. But early on some missionaries understood that it was impossible, at least at first, to deny everything to pagan peoples only recently or not yet converted

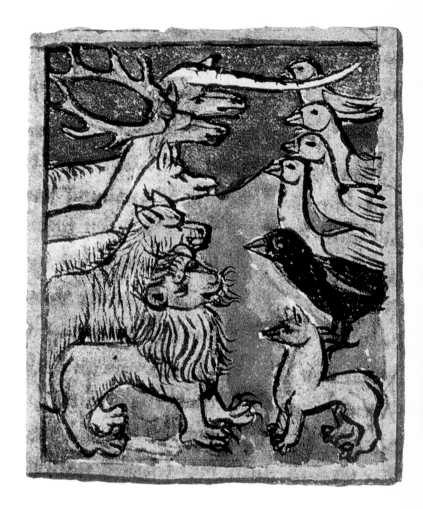

to Christianity. In addition to forbidding the worship of trees, springs, and rocks, was it also necessary to impose upon them food restrictions? And, if so, which ones? As early as 751, Saint Boniface, archbishop of Mainz, "apostle" of Germany and then of Friesland, wrote to Pope Zachary on this matter. He offered him a list of wild animals not eaten by Christians but which the Germans were accustomed to consuming, devouring the flesh after the animal was ritually sacrificed. The list was long; all of them could not be forbidden. That was why Boniface asked the pope which animals it was most important to ban. Zachary answered him that it was necessary to ban first the crows, the ravens, the storks, the wild horses, and the hares. The crow, sacred bird of the Germans, pagan animal par excellence, was

cited first; it had to be absolutely forbidden, and the raven, its cousin, with it.[40] A Christian did not eat black birds.

Nevertheless, if the church fathers and the evangelist prelates assigned the crow to the devil's bestiary, it was not only because of its natural plumage, the color of death. They also looked to the Bible, which nearly always presents the crow in a bad light. That begins very early, as early as Genesis, with the account of the Flood. After forty days on the water, Noah asked the crow to leave the ark to go see if the floods were receding. The bird flew off, saw that the waters were receding, but instead of reporting the information to Noah it lingered to eat cadavers.[41] Not seeing it return, Noah cursed it and let the dove take its place; the dove returned to the ark twice, carrying in its beak an olive branch, a sign of the retreating waters.[42] Thus, from the beginning of humanity, the crow—the first bird named in the Bible, and the second animal after the serpent—appeared as a negative creature, a carrion eater, an enemy of God. It would remain thus throughout the Old Testament, living in the ruins, devouring cadavers and pecking out the eyes of sinners.[43] The dove, on the other hand, is obedient and peaceful. Each of the two birds transmits to its color the symbolism it possesses in the story of the ark: white is pure and virtuous, the sign of life and hope; black is dirty and corrupt, the sign of sin and death. Just a few verses after the account of Creation, which opposes light to darkness, the symbolism of white and black is thus found to be fully confirmed. That will not change, either for the Bible or for early Christianity: white is positive and black is negative.

Here we witness a clear departure from most other ancient cultures with regard to the symbolism of these two colors. Not only is the opposition between black and white not always so well defined—this has nothing to do with an archetype, as some would like to believe—but, as we have seen, each of these two colors can be regarded in a good or bad light.[44] The crow itself is regarded with ambivalence among the Greeks and Romans and very positively among the Celts and Germans. Moreover, it was not always black. Greek mythology relates how Apollo's favorite bird, the raven, was originally as white as the goose or swan, but an ill-advised denouncement led to its ruin and made the bird black. Apollo, in fact, was in love with the beautiful Coronis, a mortal with whom he conceived Asclepius. One day before leaving for Delphi, the god charged the raven to keep watch over the young maiden in his absence. The bird saw her going to a beach to meet her lover, the handsome Ischys. Despite entreaties from the crow, who advised it wisely to say nothing, the raven hurried off to report everything to Apollo. Furious, the god killed Coronis. Then, repenting of having listened to the informer raven, he cursed it and decided to exclude it from the family of white birds; henceforth and for eternity its feathers would be black.[45]

Christians had another reason for considering the crow a diabolical bird: its leading role in divinatory practices. Nearly all ancient peoples observed the flight of crows, studied their speed, direction, wing beats, determined the exact color of their feathers, examined their movement on the ground, listened to, counted, and evaluated their cries in order to learn the will of the gods.[46] Of course ancient divination appealed to other birds as well, but the crow took precedence over all others, especially among the Romans and Germans, who saw it as the most intelligent of all birds. Pliny even maintained that it was the only one that understood the meaning of the omens it bore.[47] Its black color did not at all compromise its discernment—quite the contrary. Moreover, the crow's intelligence, noted by all the Greek and Roman authors, is confirmed by today's knowledge. Many experiments done in recent years have confirmed that the raven (and also the crow) is not only the most intelligent of all birds but undoubtedly also the most intelligent of all animals. In many areas their intellectual capacities are comparable to those of the big apes.[48]

Perhaps the crow, admired by the Romans, revered by the Germans—the living, positive image of the color black—was too clairvoyant for medieval Christianity?

BLACK, WHITE, RED

For early Christian theology white and black formed a pair of opposites and often represented the colored expression of Good and Evil. Such an opposition relied on Genesis (light/darkness), but also on sensibilities aligned with nature (day/night, for example). The church fathers and their successors provided commentary and developed it further. In practice, however, exceptions did exist. Not that the symbolic code could actually be reversed—Christianity had no notion of a negative white—but black, considered alone, could be seen positively in certain cases and could express some virtue. Monastic dress provides an old and enduring example. From the late Carolingian period the black scorned by the first Christians tended to become the standard color for monks living according to the Rule of Saint Benedict—which nevertheless recommended disinterest in the color of one's habit.[49] This Benedictine black, destined for a long future, was neither demeaning nor diabolical. On the contrary, it was a sign of humility and temperance, two essential monastic virtues, as we will later see.[50]

It was more common, however, for black to be a sign of affliction or penitence, for example, in the case of the liturgy. In earliest Christian times, the officiant celebrated the worship service in his ordinary clothes, which resulted in a certain uniformity throughout Christendom, and also a predominance of white or undyed clothing. Then, gradually, white seemed to become reserved for Easter and the most solemn holidays in the liturgical calendar. Saint Jerome, Gregory the Great, and other church fathers agreed upon making white the color endowed with the greatest dignity. By about the year 1000 a certain number of customs were already common throughout all of Roman Christianity, at least for the principal celebrations, even if important differences remained between one diocese and another. These shared customs formed a system that all eleventh- and twelfth-century liturgists would subsequently describe and comment upon, as would the future Pope Innocent III in 1195 (he was as yet only a cardinal) in his famous treatise on the Mass.[51] This system can be summarized thusly: white, the symbol of purity, was used for all celebrations of Christ as well as for those of the angels, virgins, and confessors; red, which recalls the blood spilled by and for Christ, was used for celebrations of the apostles and the martyrs, the cross, and the Holy Spirit,

notably Pentecost; as for black, it was used for times of waiting and penitence (Advent, Lent), as well as for the masses for the dead and for Holy Friday.[52]

This threefold system was not at all arbitrary or exclusively religious. On the contrary, it demonstrates that during the high Middle Ages three colors continued to play a more significant symbolic role than others: white, red, black. That was already the case in classic antiquity and would remain so until the great chromatic changes of the central Middle Ages, characterized by the remarkable promotion of blue and the transition in most codes and systems from three basic colors to six (white, red, black, green, yellow, blue).[53] Before this time the ancient triad continued to dominate. Moreover, it was not only present in the liturgy and Christian symbolism, but also in the secular world. In toponymy, for example, only three colors were called upon to create place-names: white, red, black. The same is true for anthroponymy, even if the names of people were more geared toward current events and sensibilities than were place-names, sometimes established very early on. From the Merovingian until the feudal period, in charters, chronicles, and literary texts, there are many individuals—real or imaginary—characterized as "the White," "the Red," or "the Black." With a few exceptions, we do not know what qualities such nicknames referred to: hair color (white being synonymous with blond, red with red, black with brown), habits of dress, character traits (white evoking wisdom or virtue, red anger, black sinfulness)? Often we do not even know if these characterizations were ascribed to individuals while they were still living or after their deaths. Sometimes, however, a contemporary chronicler provides us with some information. We know, for example, that the German emperor Henry III the Black (1039–56) was given his nickname during his lifetime not because of his skin or hair color but because he imposed his power harshly upon the church and the papacy. "The Black" here signifies "the Evil" or "the enemy of the church." As for the famous Foulque Nerra (that is, "the Black"), count of Anjou for more than half a century (987–1040), he owed his name to his treacherous, brutal temperament. Even if he ended his life in penitence, traveling to Jerusalem many times to atone for his sins, the nickname he acquired in his youth remained with him.

In literary texts, where remarks on color are otherwise rare, the presence of white, red, and black is even more pronounced. They often serve to distinguish three individuals—for example, three brothers—recalling the three-tier system mentioned earlier: the priestly class (white), the warrior class (red), the artisan class (black).[54] In tales and fables, this same triad governs the color system, though responding to different stakes. Let us consider the example of *Little Red Riding Hood*, the oldest written version of which was attested in the area of Liège at the beginning of the eleventh century, though it was no doubt preceded by a long oral tradition.[55]

"Why red?" many readers of the tale have wondered. Some are satisfied with simple answers: red might signal danger and anticipate the blood about to be spilled. This explanation seems too slight, even if it affirms that the wolf—all black—is the devil. More anachronistically, others have attempted a psychoanalytic interpretation. This might be the red of sexuality; in fact, the little girl might have wanted very much to find herself in the wolf's arms (or even in the wolf's bed, in more recent versions). This is an appealing but too modern interpretation. Did red actually have sexual connotations in medieval symbolism? Nothing could be less certain. Historical explanations are more solid, but they leave us unsatisfied. For example, dressing young children in red was a very old practice, especially among the peasantry. Is this the best explanation? It may be. At least on that day, a holiday, the little girl might have dressed in her most beautiful clothing, which was, as always for the female sex in the Middle Ages, dyed red. Or again, as the oldest version of the tale expressly states, could the little girl, born on the day of Pentecost, have been devoted to red, the color of the Holy Spirit, from her birth? This last explanation is probably the right one, but it also leaves us unsatisfied. What remains then are structural explanations, relying on the ternary color arrangement: a little girl dressed in *red* carries a *white* object (the jar of butter) and encounters a *black* wolf. Again we find our color triad, as we may find it in other tales and many old fables.[56] In *The Crow and the Fox*, for example, a *black* bird drops a *white* cheese, which is seized by a *red* fox. The arrangement of colors is different, but the story unfolds around the same three chromatic poles: white, red, black.

Hell

Hell is a place of darkness where eternal flames burn without giving light. Black and red are its colors, the damned and demonic creatures its inhabitants. Hybrid beings, with hooked beaks, formidable horns, and terrifying mouths cause perpetual terror to reign there. Miniature from a large picture Bible, painted in Pamplona for the king of Navarre, Sancho the Strong, 1197. Amiens, Bibliothèque municipale, ms. 108, fol. 254v–255.

Thus during the high Middle Ages two systems seem to have coexisted for constructing the symbolic color base: a white/black axis, inherited from the Bible and earliest Christian times; and a white-red-black triad, coming from other older or more distant sources. That triad can itself be broken down into three axes: white/black, white/red, and red/black, and thus adapted more easily to the objects or areas in question. The history of the game of chess is a relevant example.

Originating in northern India, probably in the early sixth century A.D., the game spread in two directions: toward Persia and toward China. It was in Persia that it definitively acquired the principal characteristics it still possesses today. When the Arabs took over Iran in the seventh century they discovered the game, delighted in it, and exported it to the West. It found its way to Europe in about the year 1000, by the Mediterranean route (Spain, Sicily) as well as the northern one: Viking merchants trading in the North Sea introduced it early to northern Europe. But to spread throughout Christendom the game had to undergo a certain number of transformations. The first of them concerned colors. We should pause to consider this change.

In the original Indian game, and then in the Arabic-Muslim version, black pieces and red pieces opposed each other on the chessboard—as is still the case today in the East. These two colors formed a pair of opposites in Asia from time immemorial. But in Christian Europe that black/red opposition, so striking in India and Islamic lands, had little significance. The European symbolic color system was totally oblivious to it. Thus, over the course of the eleventh century the color of one set of pieces changed to provide an opposition conforming more to Western values, and white pieces faced red pieces on the chessboard. In fact, for the secular world in the feudal period white and red represented a more powerful contrast than white and black, more significant in the religious domain. For two or three centuries white and red pieces thus appeared on European chessboards, the squares of which themselves were these two colors. Then another change occurred beginning in the mid-thirteenth century; slowly, first for the chessboard and then for the pieces, the black/red opposition changed to a white/black opposition, which has lasted until the present day.[57]

Thus, in the West, in about the year 1000, black and white did not always represent a pair of contrasting colors. In the cultural world white possessed a second opposite, red, which was sometimes more powerful than black in this role. And in the natural world combinations or contrasts of black and white were rare. Only a few animals and plants combined these colors, in the image of the magpie, an ambiguous bird presented in the aviaries and bestiaries as gossip and thief, the symbol of lying and deception. It shared this role with the swan, supposedly hiding black flesh under its white plumage.[58] At the height of the Middle Ages it was not good to be black and white.

Moors Playing Chess
Originating in northern India, the game of chess was introduced to Europe by the Muslims of Spain and Sicily in about the year 1000. Originally black pieces and red pieces opposed each other on the chessboard. It was only during the thirteenth century that the colors we are familiar with today appeared: white pieces versus black pieces. Here we see one of the oldest examples.
Miniature from the *Libro de Juegos* of the king of Castile, Alfonso X the Wise (c. 1282–84). Madrid, Bibliothèque de l'Escurial.

Este es otro uego departido en que a∙
uente un tablero que an a seer enta
blados assi como esta en la figura dell
entablamiento ∙τ∙ an se de iogar desta
guisa. mmm...m
Os puctos uegan
primero τ dan ma
te al Rey blanco en
siete uezes delos so
uegos muimos en
la quarta casa del
alfil pueto que es entablado en ca
sa blanca. El primero uego es dar
la xaque con el cauallo pueto en la
segunda casa del cauallo blanco τ to
mar lo a el Rey blanco por fuerça con
su xaque blanco. El segundo ue
go dar la xaque con el xoque pueto
que esta en la tercera casa del alfer
za blanca τ poniendol en la casa del al

blanco en la segunda casa de su alfer
za. El quarto uego dar la xaque
con ell alfil pueto en la quarta casa
del cauallo blanco∙τ entrara el Rey b∙
blanco en la tercera casa de su alfer
za. El quinto uego dar la xaque
con el xaque con el xoque pueto en
la casa del alferza blanca∙τ entrara
el Rey blanco en la quarta casa de su∙
alfil. cas isse encubriesse con su roq∙
blanco∙tomargelo ya con esse mismo
xaque τ dar le xaque τ alongarse∙τ
un uego del mate. El seseno ue
go dar la xaque co el alfil pueto en
la tercera casa del xoque pueto∙τ entra
ra el Rey blanco∙en la quarta casa dl∙
alfil pueto. El seteno uego dar la
xaque τ mate con ell alferza pueta
en la tera casa del cauallo pueto. En

decestur an pluvor

ter. iv.

An
lep
li
eito
ha
e esta

uelt urez. rule

IN THE DEVIL'S PALETTE

TENTH TO THIRTEENTH CENTURIES

After the year 1000 the color black began to become less prominent in daily life and social codes and then to lose a good portion of its symbolic ambivalence. In Roman antiquity and throughout the high Middle Ages good black and bad black coexisted: on the one hand, the color was associated with humility, temperance, authority, or dignity; on the other hand, it evoked the world of darkness and the dead, times of affliction and penitence, sin and the forces of evil. Henceforth the positive dimension of that color practically disappeared, and its negative aspects seemed to occupy the whole symbolic field. The feudal period is the great period of "bad black" in the West. The discourse of theologians and moralists, liturgical and funeral practices, artistic creations and iconography, chivalric customs and the first heraldic codes all converged to make black a sinister, deathly color. In the area of clothing only the Benedictine monks remained faithful to it and continued to let their robes proclaim the ancient virtues of a color now scorned, rejected, or condemned. Elsewhere, indeed everywhere else, black made its entrance into the devil's palette and became for many centuries an infernal color.

THE DEVIL AND HIS IMAGES

Forms and Colors of the Devil (page 44)
Medieval devils were polymorphous and polychromatic. Their bodies took on the forms not only of the bear, goat, and bat, but also of the cat, monkey, wolf, pig, griffin, dragon, and a whole bestiary that became increasingly diverse over the course of time. On the other hand, black and red remained their colors of choice, even if green, blue, and brown devils existed as well. Miniature from a manuscript of *Merlin* by Robert de Boron, c. 1270–80. Paris, Bibliothèque Nationale de France, ms. fr. 748, fol. 11.

The devil was not invented by Christianity. Nevertheless he is almost unknown in Jewish traditions and does not appear in the Old Testament, at least not in the form that Christian traditions have given him. In the Bible it is the Gospels that reveal his existence, and the Apocalypse that grants him a major role. Subsequently, the church fathers definitively made him a demonic power, daring to defy God. The Old Testament had absolutely no investment in this dualistic conception of the universe in which the principles of Good and Evil confronted one another, but the Christian tradition was more ambiguous on this point. Of course it is not Manichean—far from it. Christian theology considered it genuine heresy, perhaps even the greatest heresy, to believe in the existence of two divinities and to grant the devil the same status as God. The devil was not in the least God's equal; he was a fallen creature, the chief of the rebel angels, who occupied in the infernal hierarchy a place comparable to Saint Michael's in the celestial one. The Apocalypse announced his short-lived reign, which would precede the end of time. But that was the opinion of theologians and sophisticated religious thinkers. In the everyday lives of ordinary men and women, and perhaps even more in the lives of monks, it was a different story. The devil was present everywhere and wielded considerable power, nearly as considerable as that of God himself; hence the whole pastoral domain and everyday moral life saw Good and Evil, completely without nuance, confronting one another. On the day of Final Judgment the chosen would be on one side, on their way to paradise, and the damned on the other, to be cast down into hell. The belief in a third place for the afterlife developed slowly, until, at the turn of the twelfth and thirteenth centuries, purgatory assumed the form it still takes today.[1]

Thus, in medieval Christianity, if God remained omnipotent there clearly existed a malefic being who, even while inferior to God, enjoyed great freedom: Satan. This name, of biblical origin, derives from a Hebrew word meaning "the adversary," and in the book of Job it characterized the angel charged with tempting Job in order to test his faith.[2] It was the church fathers who gave this name to the head of the rebel angels, who defied God and incarnated the forces of evil. The term was rarely used and scholarly; in the feudal period the Latin and then vernacular texts

used the word *devil* (*diabolus*) much more frequently. This word was Greek in origin (*diabolos*) and long remained an adjective before becoming a noun. In Ancient Greek it characterized any individual who inspired hatred, confusion, or jealousy and, by extension, a deceiver or slanderer. Moreover, it is from Greek iconography of the satyr (a kind of rustic spirit, companion to Dionysus, with hairy ears, a faun's horns, the hooves and tail of a goat) that Christian art borrowed the first features of the devil, before granting him a pair of wings (he was a fallen angel, after all) and then exaggerating his animal characteristics.

In art and images the devil hardly appeared before the sixth century and remained rare until the end of the Carolingian period. It is Romanesque art that features him prominently and beginning in the mid-eleventh century makes him almost as common a figure as Christ. He does not appear alone, but escorted by an entourage of demons, monsters, and dark-colored animals, who seem to come out of the infernal abysses to corrupt or torment men. Weak and sinful, men saw the devil rising before them everywhere, notably in the sculpted décor of the churches where Satan and his acolytes were ubiquitous, evoking the threat of eternal damnation. The Last Judgment, of which the Bible speaks many times, makes its entry into Western art during the Carolingian period. But it was Romanesque sculpture that gave it its classic form as presented on the tympana of the great churches. There Christ the Judge appears, enthroned in majesty, with Saint Michael assisting him in identifying the chosen and the damned by listing their good deeds and their sins. The archangel weighs the souls on a scale that a demon fraudulently tries to tip to his side. To the right of Christ, the chosen, dressed in long robes, guided by an angel make their way toward paradise, where they are welcomed either by Abraham and the patriarchs or by Saint Peter, recognizable because of his immense key. To Christ's left, the damned, naked and terrified, are cast into the abyss of hell by laughing, sneering demons. Today the colors have disappeared from these great sculpted tableaux (Autun, Conques, Vézelay, Beaulieu, and others) where they once played an essential role nevertheless, as much in constructing the image as in giving it meaning. Black played an important part in representing the devil and his creatures.

In illumination as in sculpture, hell is represented by a monster's enormous maw out of which flames are leaping and inside of which a furnace burns; demons armed with forks prod the damned toward it, subjecting them to cruel, indecent torments. These jaws evoke the monster Leviathan, discussed in the book of Job (41:11), but the image of hell itself, with its sadistic scenes of torture, also owes much to the apocryphal texts of the New Testament and to commentaries by the church fathers. For these latter hell is simultaneously an abyss located in the center of the earth, a place of darkness, and an ocean of fire. It is the reverse image of paradise: blazing fire, torments, and darkness on the one side; coolness, pleasures, and light on the other. The flames of hell, which exhibit the peculiarity of burning without illuminating, are not meant to consume the bodies of the tortured, but, on the contrary, like salt, preserve them so that they may suffer eternal punishment.[3]

For the great theologians this place of terror, for which sinful humanity seemed destined, was not really an end in itself but a warning—an invitation to confess one's misdeeds and find the way of Christ so as not to die in the state of mortal sin. The most terrible punishment inflicted upon sinners destined for hell was the *dam*, that is to say, the loss of God, to which various psychological torments were added, such as despair, remorse, and jealous rage at seeing the chosen in paradise. When the theologians spoke of physical punishments involving the senses, they remained more vague: fire, cold, darkness, noise, suffering. A few imaginative authors and many artists in the Romanesque period created the series of appalling tortures seen first in mural paintings, then on the tympana and capitals of churches, and finally in stained-glass windows and illuminations. The idea emerged gradually that a specific kind of torture corresponded to each kind of sin, so that the image became a moral lesson. At the beginning of the thirteenth century, when the system of the seven deadly sins became firmly established, each began to be associated with a special color: pride and lust with red, envy with yellow, gluttony with green, sloth with white, and anger and avarice with black.[4]

THE DEVIL AND HIS COLORS

Satan Devouring the Damned (preceding page spread) The Romanesque period did not have a monopoly on black devils. Black remained the color most frequently used to represent Satan in the Gothic period. Here it was paired with red, representing the flames of hell and the blood of the damned, whose white bodies are being devoured by the prince of darkness. Black, red, white: the kind Fra Angelico, normally accustomed to a much gentler palette, used the most expressionistic chromatic triad to depict a particularly savage Last Judgment.
Fra Angelico, *The Last Judgment*, c. 1431–32. Florence, Museo di San Marco.

Thus the image of the devil developed gradually between the sixth and eleventh centuries and long remained polymorphous and unstable. After the year 1000 it tended to stabilize, taking on a hideous, bestial appearance. The body of Satan was usually thin and withered to show that he came from the realm of the dead; he was naked, covered with hair or pustules, sometimes spotted or striped, generally bicolored (black and red), and always repulsive. On his back were attached two wings (bat wings), recalling his condition as fallen angel, and a tail (monkey or goat); his cloven hooves resembled a goat's. His head, on the other hand, was dark and enormous, endowed with pointed horns and bristling with hair that stood on end, recalling the flames of hell. The expression on his face, sometimes adorned with a snout or muzzle, was a grimace: his grin stretching from ear to ear, his appearance distorted and cruel. In its representation of Satan, Romanesque art, always inventive in depicting good and evil, demonstrated incomparable diversity and expressiveness.

By way of an example, here is how in the first half of the eleventh century the monk and chronicler Raoul Glaber described the devil as he appeared to him one night "before morning prayers" in the Saint-Léger de Champeaux monastery in Burgundy: "I saw rise at the foot of my bed a type of man horrible to see. He was, it seemed to me, small in size, with a spindly neck, an emaciated face, very black eyes, a prominent, strained forehead, pinched nostrils, a mouth in the form of a muzzle, with thick lips, weak chin, and the beard of a goat; his ears were pointed and hairy, his hair tousled and on end, his teeth like the fangs of a dog; the back of his skull was pointed, his chest distended, and he was hunchbacked; his buttocks hung and trembled and he wore on his thin body the tatters of dark, sordid clothes."[5] This last feature is remarkable because in general the devil appeared completely naked and was represented that way. Like Satan, the demons, "which are legion" and under his command, were usually naked, black figures, hairy and hideous; like him, on some body part or another (generally the most obscene one, the belly, or the buttocks), they sometimes presented a second or even a third face in the form of a mask, also grimacing like the one on the head. They tormented men, entered them to possess them, spread vice and

cruelty, started fires, unleashed storms, and propagated epidemics. Above all they watched for weakness among the feeble and the sick and tried to seize the soul of the dying sinner at the moment when it was about to leave the body. They were defeated through prayer and faith in Christ; the light of a candle, the sound of the bells, the sprinkling of holy water constituted defenses against their attacks. Exorcisms—apotropaic gestures and formulas recited by the bishop or his representative—were also a way of banishing them or expelling them from the body of the possessed.

Whether it was a matter of Satan himself or his creatures, one color constantly recurs in the texts and images depicting or presenting them: black. In the West, beginning in the eleventh century, black became the diabolical color par excellence, although it is impossible to clearly identify the reasons why. Of course, the darkness of hell justifies the dark or black qualities of those who resided there, who came and went there, but it does not explain everything. The Bible itself, hardly expansive on colors and much more so on light, frequently speaks about darkness and its oppressive or punitive quality, but it does not always associate darkness with black and does not systematically make black the evil color.[6] Such an idea is foreign to it. It was the church fathers who gradually assigned black that role, perhaps more under the influence of pagan traditions than strictly biblical ones.

Whatever the case, before and after the year 1000 and for many centuries, black was constantly called upon to adorn the body or clothes of all those maintaining relationships of dependence or affinity with the devil. It was not just a matter of black, but involved all dark colors: brown, gray, purple, and even blue, which did not begin to gain prominence until the twelfth century. Before that time, dark blue was often considered and perceived as equivalent to black, a semi-black or a sub-black, used notably for painting hell and demons. The few remaining traces of the tympanum of Conques's original polychromy, for example, demonstrate that function of blue in Romanesque iconography. Similarly, the painted wooden ceiling of the church of Zillis (now in the Swiss canton of Grisons), almost contemporary with Conques (about 1120), offers many examples of a blue devil. Though this is not the only case of such

evidence, it helps us recall how blue long remained an unvalued and evil color.[7]

More frequent than blue devils, however, were black devils and red devils, indeed even black-and-red devils: black body and red head, red body and black head, or even bicolored body (striped, spotted) and entirely black head. These two colors came directly from hell; they were the colors of darkness and infernal flames. The devil displayed them and made them even more evil by doing so. Of course, reds existed in Romanesque iconography and symbolism that had to be perceived as good—the red of Christ's blood, spilled to save men, the purifying red of the Holy Spirit and the Pentecostal fire—but red associated with black was wholly diabolical.[8] Some time later, toward the middle of the twelfth century, green devils made their appearance in illumination and mural painting and began to compete with black and red devils. They became numerous in the thirteenth century, especially in stained-glass windows, and contributed in their turn to the debasement of the color they displayed. They probably originated in the growing hostility between Christians and Muslims—as green is the emblematic color of the Prophet and the sacred color of Islam, Christian iconography in the period of the Crusades gladly adopted it to paint devils and demons.

Beyond black coloration and somber tones, the essential element upon which the devil's palette was constructed in the

A Blue Devil

In images from the Romanesque period, the devil could be any color as long as it was a dark one. His hairiness was emphasized and he was frequently given wings and horns. That is how he is depicted on the wood ceiling panels of the Swiss church in Zillis, today in the canton of Grisons. His dark blue, almost black, fur contrasts with the red and white robes of Christ. *Christ's Temptation in the Desert*. Painted ceiling of the church of Zillis, Switzerland, c. 1120–25.

Romanesque image was the density of the colored pigment. Satan—this is clearly observed in illuminations and seen again in certain sculptures—was almost always the most saturated figure in the image, the most chromatically dense. That was a way of emphasizing and evoking the suffocating opacity of darkness in contrast to the translucent quality of light and all that was divine. Saint Bernard was not wrong to reproach color in general and black in particular—he will be discussed further on in relation to the conflict between black monks and white monks in the first half of the twelfth century—for being a thick envelope that hinders contact with the divine. For him black is density and density is hell.[9]

Nevertheless, as is often the case in the Middle Ages, customs and codes tended to violate or reverse themselves.

Thus, unlike the devil, demons are not more, but less saturated, evoking the idea of paleness, a disturbing pallor. What is without color is sometimes more frightening than what possesses too dense or too rich a color. Certain satanic creatures even pass for colorless, thus posing a difficult technical problem for painters and illuminators: how to represent the unrepresentable? How to represent in colors the notion of colorlessness? Many processes seem to have been considered: leaving the medium of the image bare; greatly diluting a color (thus confirming that color is, first of all, material, density); using greenish tints, green being the least colored of colors for the medieval eye (and for the ancient eye as well). On the other hand, colorlessness is never expressed using white. Like black, in the Middle Ages and even well into the modern period, white is a color in its own right.

Jean Hus Led to the Stake
At the end of the Middle Ages, among the marks of infamy imposed upon outcasts and the condemned, figures in the form of devils were reserved for heretics. That was the case with Jean Hus, Czech theologian and author of treatises judged to be heretical. He was excommunicated in 1411 and then condemned by the Council of Constance to be burned alive; on July 6, 1415, he was led to the stake wearing a cardboard miter decorated with devils.
Jean Hus Led to the Stake. Miniature from a manuscript of the *Chronicle of the Council of Constance* by Ulrich Richental, c. 1460. Constance, Rosgartenmuseum, ms. 1, fol. 57v.

A DISTURBING BESTIARY

The Cat

Until the end of the fourteenth century, the cat was often regarded as a deceitful, disturbing animal, especially the black cat, who found a place in the devil's bestiary. Subsequently, when it became clear that the cat was more useful than the weasel for catching rats and mice, it earned the right to enter the house and gradually became the household companion we know today.
Black Cats in Procession. Miniature from an English bestiary, mid-13th century. Oxford, Bodleian Library, ms. Bodley 533, fol. 13.

The devil and demons did not have a monopoly on black and on dark skin. An entire entourage of animals accompanied them that seemed themselves to have emerged from the infernal abyss and to bear on their bodies a share of the obscurity that reigned below. There is a long list of animals Satan liked to be incarnated as or that served as his attributes or constituted his court. It included real animals like the bear, goat, wild boar, wolf, cat, crow, and owl, among many others, but also hybrid or imaginary animals like the asp, basilisk, dragon, and bat (in medieval zoology the bat is both rat and bird), or again, half-human monsters like satyrs, centaurs, and sirens. They were all in one way or another animals scorned or condemned by medieval culture. Moreover, we can observe that this abundant bestiary was dominated by animals with dark coats or plumage or by nocturnal animals; in both cases these were creatures that maintained privileged relationships with the color black. They were diabolical because their hair or feathers were black or because they lived in the darkness. Let us pause to consider a few of these black animals, the stars of the infernal bestiary.

The crow, which we discussed at length in the last chapter, is the most emblematic: admired by ancient mythologies that praised its memory, intelligence, and gifts of prophecy, but viewed in a bad light by the Bible—the episode of Noah's ark made it an enemy of the just—and violently rejected by Christianity, which saw it only as a black bird, a carrion eater, and evil. That was even more true in northern Europe, where the Christian church faced a long struggle against pagan worship of the crow—Odin's attribute, the gods' messenger, protector of all warriors, and veritable memory holder of the world. Thus early on the church fathers reserved for it a choice place in the diabolical bestiary and made it the attribute of a great number of vices. Its totally black plumage linked it to the negative symbolism of that color, dark, sinister, and deathly.[10]

The case of the bear is related to that of the crow. In much of Europe, it was the king of the animals until the twelfth century. Hunters and warriors admired its wild, brutal strength, confronted it in single-handed combat, drank its blood, and ate its flesh before departing for battle. Kings and princes made it the favorite animal in their menageries, and some even claimed to belong to a lineage descending from the prestigious "son of the bear,"

that is, a being born of a woman carried off and raped by a bear. The bear was in effect the animal whose anthropomorphic nature was the most firmly established. It passed for an ancestor or a relative of human beings and was even believed to experience a violent, carnal attraction for women. Such an animal could only frighten the church, which declared war on it early on, not only by organizing battues in the Carolingian period meant to exterminate it and put an end to the last pagan worship of it in Christian lands, but also by making it diabolical. Christian authors assigned the bear to the side of Satan, looking to the Bible for support, where the bear was always viewed in a bad light.[11] They also adopted Saint Augustine's claim that "the bear is the devil."[12] Like Satan, the bear was dark and hairy; like him, it was cruel and harmful; like him, it loved dark, secret places. Moreover, where did the bear go when it hibernated each year? It went to the land of darkness, that is, hell. That was why its vices were innumerable: brutality, wickedness, lechery, squalor, gluttony, sloth, anger. Gradually the ancient king of the animals, the animal so admired by the Germans, Celts, and Slavs, became the leading figure in the infernal bestiary.[13]

The cat was less prominent, but it was not yet the domestic animal that by the end of the Middle Ages would come home to curl up by the fire. It was a cunning, mysterious creature, treacherous and unpredictable; it prowled around the house or monastery, was nocturnal, and often had black or striped fur. It prompted fear, especially when it was totally wild, as did the wolf, fox, and owl, other nocturnal creatures, and attributes of the devil. For catching rats or mice in the feudal period, the weasel, which had been more or less domesticated since Roman times, was preferred to the cat and would remain so until the fourteenth century.[14]

But it was perhaps the wild boar that best incarnated the wild beast Christianity struggled so fiercely against. The bear was only brown, the wild boar was truly black. By the fifth or sixth century, the church fathers had transformed this animal, so admired by Roman hunters, Celtic druids, and German warriors, into an impure, frightening enemy of the good, image of the human sinner in revolt against his God. Here again Augustine is the first to make this animal, "who ravages the vineyards of the Lord" (Psalm 79), a creature of the devil.[15] Two centuries later, Isidore of Seville, with some laborious lexical juggling, explained how the wild boar owed its name to its very ferocity.[16] Some of his phrases would appear word for word in eleventh- and twelfth-century Latin bestiaries and then in the great encyclopedias of the thirteenth century.[17] In this period similar explanations for the diabolical ferocity of the wild boar were found in sermons,

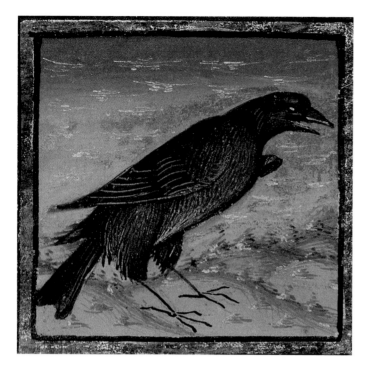

removed from a creature's "normal" anatomy. There was no boundary between real animals and legendary ones or between legendary animals and monsters. Artists paid particular attention to the treatment of bodily surfaces. Whoever takes the trouble to look closely will discover their meticulous efforts to express the flaws, diseases, and disturbing qualities of the skin, fur, feathers, and scales on Satan and his companions. To do this artists played with the contrasts between the uniform and the striped, the flecked and the spotted, the different structures of frames or partitioning. The smooth and uniform were relatively rare and appeared in contrast to all the worked surfaces. The stripe was the usual contrast to the uniform; it always connoted something improper, dubious, or dangerous.[20] A related case is the one of partitioned structures (checks, diamonds, spindles, or scales); they established a rhythm and, reinforced by the play of colors, succeeded in creating more or less disagreeable impressions. Typical in this regard was the method of rendering the idea of the viscous, so common in the world of dragons and serpents. Viscosity was conveyed by undulating lines, delineating partitions arranged into scales, and various shades of green were applied, especially desaturated greens, as wetness was always closely related to the lack of density or opacity for the medieval eye. Desaturating a color, notably green or black, was a way of making it wetter. The case of the spotted was different; it expressed an idea of disorder, irregularity, and impurity. In the diabolical universe it served to render the idea of pilosity (with irregular tufts) and, better still, pustules or skin disease. Whatever was spotted was related to scrofula, leprosy, the bubonic plague. In a society where skin diseases were both more common and more serious, as well as more feared, spots represented absolute degeneration, banishment from the social order, and death's door, especially when the spots were red, brown, or black.

collections of exempla, treatises on vices, and even books on hunting; for hunters it ranked first among the formidable "black beasts." This animal's courage, praised by the Roman poets, became a kind of blind, destructive violence. Its nocturnal habits, its dark or black fur, its eyes and tusks that seemed to shoot sparks made it a creature emerging directly from the depths of hell to defy God and torment men. The wild boar was ugly, it drooled, it smelled bad, it was noisy, its hair stood on end, its bristles were striped, and it had "horns in its mouth."[18] Clearly it was in every detail an incarnation of Satan.[19]

The devil's bestiary did not rely only on its animals' dark colors, but also on their corporal animality. An arm, a foot, or a mouth was enough to suggest this animality, no matter how far

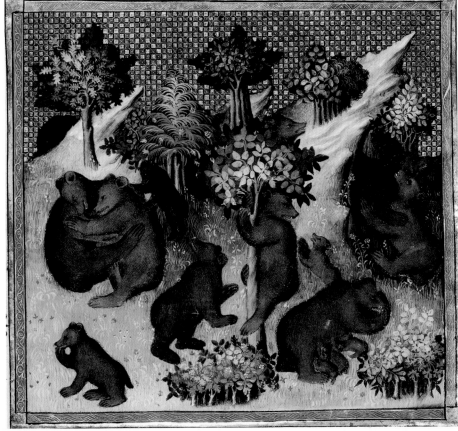

The Crow

Like the wild boar, the crow, venerated by the Celts and Germans, was held in great contempt by Christianity. Its habits as a carrion eater, its selfish behavior during the Flood, and above all its black plumage made it the star of the satanic bestiary.

Miniature from a manuscript of the *Livre des propriétés des choses*, French translation of the *De proprietatibus rerum* by Bartholomew the Englishman, c. 1445–50. Paris, Bibliothèque Nationale de France, ms. fr. 136, fol. 19.

The Wild Boar

Venerated by the Celts and Germans, the wild boar became a diabolical animal for medieval Christianity. Its dark coat, raised bristles, hornlike tusks, and frothing rage made it an infernal creature. Treatises on hunting happily set forth ten properties of the wild boar that were similar to the ten commandments of the devil.

The Ten Diabolical Properties of the Wild Boar. Miniature from a manuscript of the *Livre du roi Modus et de la reine Ratio* by Henri de Ferrières, 1379. Paris, Bibliothèque Nationale de France, ms. fr. 12399, fol. 45.

The Bear

Medieval treatises on hunting distinguish the "red" beasts (stag, fallow deer, roe deer) from the "black" beasts (wild boar, wolf, bear, fox). More than the color of their fur, it was their habits that earned them these epithets. The first were gentle, nonaggressive herbivores, the second fierce, "foul-smelling," diabolical carnivores.

Bears in the Forest. Miniature from a manuscript of the *Livre de la chasse* by Gaston Phébus, early 15th century. Paris, Bibliothèque Nationale de France, ms. fr. 616, fol. 27v.

TO DISPEL THE DARKNESS

The Black Mantle of the Virgin

Mary was not always dressed in blue. In images, until the twelfth century, the palette for her clothing was relatively varied but almost always dark, because she wore mourning for her son: black, gray, brown, purple, dark blue. In Spain, black dominated, and in the Gothic period, blue was slower to triumph there than elsewhere. *Virgin with Child*, central panel of a painted retable, late 12th century. Barcelona, Museu Nacional d'Art de Catalunya, Inv. MNAC 15784.

o the blackness of the devil and the darkness of hell were opposed the beings of light. For medieval theology light was the only part of the sensory world that was both visible and immaterial; it was the ineffable made visible and, as such, an emanation from God. Which prompted these questions: was color immaterial as well? Was it light, or at least some part of light, as many ancient and medieval philosophers claimed?[21] Or rather, was it material, a simple envelope that covered objects and bodies? All the theological, ethical, and even social issues that arose with regard to color in the Middle Ages seemed to revolve around these questions.

For the church the stakes were high. If color was a part of the light, it participated ontologically in the divine because God was light. To seek to expand the place of color here below was to diminish the place of darkness, therefore increasing the place of light and God. The quest for color and the quest for light were thus inseparable. On the other hand, if color was a material substance, a simple envelope, it had nothing to do with an emanation from the divine, but, on the contrary, was an artifice frivolously added to Creation by man; it had to be resisted, driven from the temple, excluded from worship. It was both useless and immoral, even harmful because it hindered the sinner's progress toward God.

These questions were not just theological. They also had concrete significance, an influence on the material culture and everyday life. The answers they solicited determined the place of color in the environment and behavior of Christians: places they frequented, images they contemplated, clothes they wore, and objects they handled. Also, and most importantly, they influenced the place and role of color in churches and worship practices. Now, from late antiquity until the end of the Middle Ages, these responses varied. In their discourse as in their actions theologians and prelates were sometimes friendly toward color, sometimes hostile. After the year 1000, however, despite a few exceptions (Saint Bernard, for example), most of the founding prelates of the churches were chromophiles and this chromophilia, for which Abbot Suger (1081–1151) remains most famous, profoundly influenced the Romanesque period. In about the years 1130–40, when he had his abbey church of Saint-Denis rebuilt, Suger was among those who believed that God was light, that color was light, and that nothing was too beautiful to

serve the divine. All techniques and all media—painting, stained glass, enamel, silver and gold, fabric, gems—were thus employed to make his new abbey a temple of color, because richness and beauty, necessary to venerate God, were expressed through color. For him color was first of all light (which accounts for the importance accorded stained glass) and only afterward material.[22]

This opinion was repeated many times in Suger's writings, notably in his *De consecration* treatise, written about 1143–44.[23] It was shared by most of the prelates, not only in the twelfth century but across a wider chronological span extending from the time of Charlemagne until that of Louis IX (Saint Louis). The Sainte-Chapelle in Paris, for example, completed in 1248, was still fully considered and conceived as a sanctuary of light and color. Judging by Romanesque Christian churches, negative attitudes, those hostile to color—like the Cistercians, for example—were in the minority. Almost everywhere, churches maintained a privileged relationship with color because like light colors banished darkness and in doing so expanded the place of the divine here below.

Such attitudes invite questions regarding the place of black in the color order. If, as for most of the prelates and theologians of the central Middle Ages, colors stood in opposition to darkness, then black, the color of darkness, was not one of them. In fact, it was their opposite. Are we witnessing here, as early as the Romanesque period, the beginnings of an opinion destined to be developed later, much later, first by a few Italian Renaissance painters, then by the great sixteenth-century Protestant reformers, and finally by men of science in the modern and contemporary periods? Just after the year 1000, in any case, such an opinion was a new thing. Missing from ancient theories on the nature of color, barely imagined in the high Middle Ages, it seems to have appeared for the first time at the turn of the eleventh and twelfth centuries and to be related to a new theology of light. A few decades later that theology would give rise to the first Gothic cathedrals and then it would be grounds for all learned speculation in the thirteenth century on questions of optics and the physics of light.

Such a hypothesis must be qualified by two remarks, however. First of all, black seems to be the only color affected by this new

concept, the only one omitted from the color order. White does not follow suit; their fates were not linked because at this point, the two colors were not really paired. Second, in this twelfth century, so rich in new theories and practices, the enemies of color—chromophobic prelates and punctilious moralists—were not at all zealous about black. Although they considered color an embellishment or a useless luxury, that was not why they recommended the use of black and recourse to darkness. On the contrary, they were themselves apostles of the light, although in a different manner. The most famous example is that of Saint Bernard, and more generally, of the Cistercian sensibility as a whole.

For Bernard color was material before being light. Thus the problem was not so much one of coloration (moreover, when he speaks of color, Bernard only rarely uses terms of coloration: red, yellow, green . . .) as one of density and opacity. Not only was color too rich, not only was it impure, not only did it constitute a vanity (*vanitas*), but it was related to thickness and obscurity. In this regard Bernard's vocabulary is particularly instructive. The word *color* was not associated with ideas of clarity and brightness there; rather, color was sometimes characterized as "cloudy" (*turbidus*), "saturated" (*spissus*), and even "muffled"

(*surdus*).[24] It did not brighten but obscured; it was suffocating, diabolical. Thus the beautiful, the bright, the divine, all three emerging beyond opacity, had to be diverted from color and, more importantly, from *colors*.

Bernard actually felt a true aversion for polychromy. If the Cistercian monks sometimes tolerated a certain monochromatic harmony, perhaps built around one color, Saint Bernard himself rejected everything related to the "variety of colors" (*varietas colorum*), like multicolored stained glass, polychromatic illumination, silver and gold works, and glistening gems. He detested all that sparkled or shone, in particular gold, which was an abomination to him. For Bernard—and in this he differed from most men of the Middle Ages—light was not brilliant. This resulted in his very idiosyncratic way of apprehending the various properties of color, as compared to his contemporaries. It also resulted in his unusual (and modern from certain perspectives) association of lightness with desaturation, indeed even with transparency. For him color was always thick and dark.[25] So much so that, far from admiring black, he shunned it and condemned it as the worst of colors. His quarrel over monastic habits with Peter the Venerable, abbot of Cluny, lasted for years and gave him the opportunity to declare his hatred for black.

THE MONKS' QUARREL : WHITE VERSUS BLACK

Benedictine Monks (following page)
The first monks were not concerned with the color of their clothing. Moreover, that was what the rule of Saint Benoît, written in the sixth century, recommended. Beginning in the ninth century, in texts and images monks were increasingly associated with the color black. Subsequently black became the color of the Benedictine order in particular, whereas new orders chose white or brown in reaction. Miniature from an English manuscript of the *Life of Saint Cuthbert* by Bede the Venerable, circa 1180–85. London, British Library, Ms. Yates Thompson 26, folio 71 verso.

It is a shame that works on the history of monastic dress—works few in number and disappointing, moreover—so rarely mention colors.[26] In the earliest days of Western monasticism a great concern for simplicity and modest dress prevailed; the monks adopted the same clothing as the peasants and neither dyed nor prepared the wool. That, moreover, was what the Rule of Saint Benedict, formulated in the sixth century, recommended: "Let the monks not be concerned about the color nor the thickness of all these things" (referring to articles of clothing).[27] For the father of Western monasticism color was useless artifice. But gradually clothing acquired greater and greater importance for the monks; it became both the symbol of their condition and the emblem of the community to which they belonged. This resulted in a growing discrepancy between the monastic habit, which tended toward uniformity, and secular dress. In the Carolingian period that uniformity already tended to express itself in color, not so much in a predetermined coloration (black) as in a range of shades (dark). Until the fourteenth century, dyeing cloth a true, dense, solid black was a difficult exercise, and that was no different for the monks than for the laity.[28]

Over time, however, monks became more and more closely associated with the color black. Beginning in the ninth century that color—the color of humility and penitence—became the monastic color par excellence. Even if in everyday reality the actual fabric was never truly black, and perhaps sometimes even blue, brown, or gray (easier to obtain in dyeing) or dyed a so-called natural color (*color nativus*), the texts spoke more and more frequently of "monks' black" (*monachi nigri*).[29] That custom was definitively established in the tenth and eleventh centuries during the expansion of the Cluniac empire, when the number of monks living under the Rule of Saint Benedict grew considerably. Negative proof is provided, moreover, by all the movements with hermetic tendencies that developed in the eleventh century; as an ideological reaction against the luxury of Cluny these movements sought to readopt original dress, poverty, and simplicity. In terms of color that translated into a sustained quest for coarse wool fabric; it might be left with its own suint and natural color, it might be mixed with goat hair (Carthusians), or it might be simply bleached in the fields by the morning dew (Camaldoles). The display of this desire to return to the austerity

of the first anchorites also involved a turning away from color, useless artifice that the monk had to forgo. It may also have involved a desire to shock; the boundary separating wool from animality was permeable. In fact, in the eleventh century, these separatist monastic movements for the most part bordered on heresy, which, in the Middle Ages, was often expressed through dress. Many of them rejected black and white because they claimed John the Baptist as their inspiration, often represented as a wild man simply dressed in a bit of poor cloth made of a mixture of goat and camel hair.

The Cistercian order grew out of this chromophobic trend. Founded at the very end of the eleventh century, this new order soon reacted against Cluniac black and sought to return to the sources of early monastic life. In matters of dyes and color, it also wanted to reclaim the essential principles of the Rule of Saint Benedict: to use only common, inexpensive cloth made of undyed wool, spun and woven by the monks themselves within the monastery. Now undyed wool meant a color tending toward gray. Like others, the first Cistercian monks were thus characterized as "gray monks" (*monachi grisaei*).[30] When and how did they pass from gray to white, that is, from the absence of color to a true color? It is impossible to know because the gaps in documentation are so great. It may have been as early as the abbacy of Saint Albéric (1099–1109), or perhaps at the beginning of the time of Étienne Harding (1109–33), perhaps even at Clairvaux (founded in 1115) before Cîteaux. For what reasons? To distinguish the choir monks from the simple lay monks? Academic honesty requires us to acknowledge that we know nothing.[31] It is certain, on the other hand, that the violent controversy opposing the Cluniacs to the Cistercians for two decades (1124–46) with regard to the luxury of churches and the color of habits contributed to definitively making the Cistercians the white monks. It is worth pausing to examine this controversy because it constitutes an important time not only for monastic history but also for the history of colors.

It was Peter the Venerable, abbot of Cluny, who first opened hostilities beginning in 1124. In a famous letter addressed to Bernard, abbot of Clairvaux, he publicly questioned him, characterizing him ironically as the "white monk" (*o albe monache...*) and reproaching him for the excessive pride this choice of color

The Monks' Habit

Black, white, gray, brown: these were the four colors used for the clothing of monks and religious figures in the Middle Ages. They originally had symbolic value (austerity, purity, modesty, temperance) that gradually became emblematic. Miniature from a manuscript of the *Chronicle of the Council of Constance* by Ulrich Richental, c. 1460. Constance, Rosgartenmuseum, ms. 1, fol. 50.

represented: "White is the color for holidays, the glory and the resurrection," whereas the traditional black of monks living according to the Benedictine rule "is the color of humility and renouncement."[32] How could the Cistercians be so proud as to display themselves in white, even in "gleaming" white (*monachi candidi*), while all the other monks humbly wore black? Such pride! Such indecency! Such scorn for traditions! Saint Bernard responded to him just as violently. He reminded him that black was the color of the devil and hell, the color "of death and sin," whereas white was the color "of purity, innocence, and all the virtues."[33] The quarrel was rekindled many times and turned into a veritable dogmatic and chromatic confrontation between black monks and white monks, with each letter exchanged constituting a veritable treatise on what the true monastic life ought to be. Despite many attempts at appeasement, the controversy lasted until 1145–46.[34]

Thus, in just two decades, just as the Cluniacs were long symbolized by black, so the Cistercians would find themselves—permanently—symbolized by white. Subsequently, that color would give rise to various legends retroactively explaining its miraculous origins. One of the longest standing explanations, but documented only beginning in the fifteenth century (possibly earlier), recounts how the Virgin, appearing to Saint Albéric in the 1100s, charged him to adopt the white habit, the virginal color, as a symbol of the purity of the order. Actually, it is likely that, as for Cluniac black, the white of the Cistercian robe remained for a long time a symbolic ideal rather than a material reality. Until the eighteenth century, producing a true white was a difficult exercise. It was only just possible for linen and even then involved a complex operation. For wool, one often had to be content with shades naturally bleached in the fields through the combination of the oxygenated water of the morning dew and sun. But the process was slow and long, required much space, and was impossible in winter. Moreover, the white obtained in that way did not remain white but turned grayish brown, yellow, or ecru over time. By the same token medieval societies did not know how to bleach with chlorine.[35] It was unusual to be dressed in an absolutely white white.[36] The tinctorial use of certain plants (saponins), washes with an ash base, or even clays and minerals (magnesium, chalk, ceruse) gave grayish, greenish, or bluish highlights to various whites, reducing in part their brightness.

That was not the essential thing, however. The most remarkable aspect of the epistolary conflict between Peter the Venerable and Saint Bernard in the first half of the twelfth century resides in this new symbolization of monks by color and by habit. Henceforth each monastic order had its own color and proclaimed itself the champion of the color it wore. The history of Cluny versus Cîteaux was the history of black versus white, a relatively obscure pair of opposites until then—in many areas, as we have seen, the true opposite of white was red, not black—but which would now assert itself. Henceforth colors took on an emblematic dimension that they hardly possessed until that time, at least in clothing. Heraldry was no longer very far off; it developed two decades later and began to alter all the color systems profoundly.

Saint Dominic

Dressed in white robes and black copes, and with preaching as their principal mission, the Dominicans, or Preaching Friars, were often compared to magpies, as talkative as they were and with plumage of the same colors. For the great artists, however, the black of the cope was never truly black, nor especially uniform. It had blue, brown, and purple highlights that increased the color's value and distinguished it from infernal or deathly black.
Fra Angelico, *Deposition with Saint Dominic*, fresco, c. 1437–45. Florence, San Marco monastery, dormitory.

A NEW COLOR ORDER: THE COAT OF ARMS

The earliest coats of arms actually developed toward the middle of the twelfth century. Their appearance on the battlefield and at tournaments was first linked to a material cause: the evolution of military equipment. Since the transformation of the helmet and hauberk rendered the knight unrecognizable, he gradually acquired the habit of having figures painted on the large surface of his shield (animals, plants, geometric designs) that helped to identify him in the heat of battle. Nevertheless, this material cause does not explain everything. The appearance of coats of arms was more closely connected to the new social order that transformed feudal society. Like patronymic names and attributes of dress, then in full expansion, coats of arms provided new signs of identity to a society in the process of reorganizing itself. First associated with a single individual and reserved for warriors, they gradually became applied to families and were inherited through noble lines. Women, too, began to make use of them. Subsequently, over the course of the thirteenth century, their use expanded to ecclesiastics, the bourgeois, artisans, and even peasants in certain regions. Finally, a bit later, they were adopted by various communities: cities, trade guilds, abbeys, chapters, institutions, and various jurisdictions.

With regard to social and legal history, it is important to correct a widespread error that has no basis in historical reality: the right to coats of arms was not restricted to the nobility. At no time, in no country, was bearing coats of arms an exclusive prerogative of one social class. Every individual, family, group, or community, always and everywhere, was free to adopt the coat of arms of its choice and to make private use of it however it pleased, the only condition being not to usurp someone else's. In fact, as coats of arms were simultaneously signs of identity, symbols of possession, and decorative ornaments, they appeared on innumerable objects, monuments, and documents to which they lent official status. Studying them is often the only means we have today for locating these objects and monuments in place and time, identifying their sponsors or successive owners, retracing history and its vicissitudes.[37]

Coats of arms were composed of two elements: figures and colors, which occurred on a shield delimited by a perimeter, the form of which was not significant. The triangular form, inherited from medieval shields, was in no way obligatory; it was simply

Heraldic Colors

Medieval heraldry used only six colors, the six "basic" colors of Western culture: white, yellow, red, black, blue, green. These were absolute colors; their shades did not matter, but their combinations followed a strict rule. Black, called *sable* in the French language of heraldry, was neither the most common color (red), nor the rarest (green). It appeared in about 20–25 percent of European coats of arms. *Armorial of Europe and the Golden Fleece*, c. 1434–35. Paris, Bibliothèque de l'Arsenal, ms. 4790, fol. 34 (Dutch coats of arms).

the most frequently used. Within this shield shape, however, colors and figures were not used and combined in any fashion whatsoever. They obeyed a few rules of composition, not numerous but rigid. It was these rules that most clearly distinguished European coats of arms from other categories of emblems used by other cultures. Among these rules, the main one concerned the use of colors. Unlike the figures, for which the repertoire was open, colors only existed in a limited number (six in regular use in the Middle Ages) and were called by specific names in the language of French heraldry: *or* (yellow), *argent* (white), *gueules* (red), *azur* (blue), *sable* (black), and *sinople* (green). We should note that the colors represented here have remained the six basic colors of Western culture since the Middle Ages.[38]

These heraldic colors were absolute, abstract, and nearly immaterial; their shades had no significance. For example, *gueules* could be light, dark, matte, or glossy and could tend toward pink or orange. None of that mattered; what counted was the idea of red and not the chromatic, material representation of that color. The same was true for *azur*, *sable*, and *sinople*, and even for *or* and *argent*, which could be conveyed by yellow and white (as was most often the case) or by gold and silver. In the coats of arms of the king of France, for example, *azur semé de fleurs de lis d'or*, the *azur* could be sky blue, medium blue, or ultramarine, and the *fleurs de lis d'or* could be lemon yellow, orange yellow, or gilded; that had no importance or meaning. The artist was free to convey that *azur* and *or* as he understood them, according to the media in which he worked, the techniques he used, and the aesthetic concerns that occupied him. Over the course of time the same coat of arms could thus be represented in very different shades.[39]

But there was more. Heraldry did not, in fact, use these six colors without restriction. It divided them into two groups: in the first group it placed white and yellow; in the second group, red, black, blue, and green. The fundamental rule of color use forbade juxtaposing or superimposing (except with regard to small details) two colors that belonged to the same group. Let us take the case of a shield for which the figure was a lion. If the field of this shield was black (*de sable*), the lion could be white (*d'argent*) or yellow (*d'or*), but it could not be blue (*d'azur*), red (*de gueules*), or green (*de sinople*) because blue, red, and green belonged to the same group as black. Conversely, if the field of the shield was white, the lion could be black, blue, red, or green, but not yellow. This fundamental rule existed from the beginning of heraldry and was always respected everywhere (the infractions rarely exceed 1 percent of examples in a given group of coats of arms). It may have been borrowed from vexillary banners and ensigns—which had considerable influence on the first coats of arms—and initially may have been linked to questions of visibility. The first coats of arms, all bicolored, were actually visual signs made to be seen from a distance.[40] But these questions of visibility are not enough to explain the deeper reasons for the rule, no earlier trace of which can be found. Probably it was also related to the rich color symbolism of the feudal period, a symbolic system then undergoing massive change. To a new society—the one establishing itself in the West just following the year 1000—corresponded a new order of color: white, red, and black were no longer the three basic colors, as they had been throughout antiquity and the high Middle Ages. Henceforth, blue, green, and yellow were promoted to their ranks, in social life and in all the social codes related to it.

Early heraldry was one of those codes, perhaps the most original one. Emerging from one particular world—the world of war, the tournament, and chivalry—it rapidly expanded to the whole of society, upon which it eventually imposed its classifications and value systems, altering in particular the various hierarchies involving colors. In this regard, the case of black seems exemplary.

The Theatricality of Funerals

At the end of the late Middle Ages, the kings of France still wore purple for mourning, and the queens still wore white. But at the turn of the sixteenth century, Anne of Brittany, first the wife of Charles VIII and then of Louis XII, introduced to the French court the use of black for mourning queens. That put an end to the famous "white queens," sometimes widowed at twenty years old, and living into their eighties, who burdened the court for long decades.
Ardent Chapel for the Heart of Anne of Brittany in the Church of the Carmelites of Nantes. Miniature from a manuscript of the *Funérailles d'Anne de Bretagne*, c. 1515. Paris, Bibliothèque Nationale de France, ms. fr. 5094, fol. 51v.

WHO WAS THE BLACK KNIGHT?

With heraldry, in effect, black was no longer a central color marking a pole, as had been the case—for white and red, as well—in all earlier systems. For the coat of arms, black was an ordinary color, not the most frequently used, nor the most rare, nor the most impressive or significant on symbolic and emblematic levels. However, far from doing it harm, this average position, on the contrary, helped make it a color like all others and by the same token to mitigate its negative aspects. In the thirteenth century, when the use of coats of arms was in full expansion and began to enter all areas of social and material life, heraldry managed to remove black from the devil's palette, where it had been trapped for three centuries. By doing so it prepared the way for the great revival black enjoyed at the end of the Middle Ages.

In heraldry, the average position of black (*sable* in heraldic terms) was first of all a statistical one. In terms of its presence on European coats of arms from the twelfth and thirteenth centuries, its frequency rating is between 15 and 20 percent; only one coat of arms out of five featured this color. That is much lower than red (60 percent), white (55 percent), and yellow (45 percent); but it is higher than blue (between 10 and 15 percent) and green (less than 5 percent). Geographically it was in northern Europe and the countries of the empire that black was most abundant; in southern France and Italy it was the most rare. On the other hand, no such distinction existed on the sociological level; all classes and social categories made use of black. In matters of heraldic figures and colors trends were always more geographical than social.[41] Modest families and the simple bourgeois used black on their shields, just as illustrious individuals did. Among the latter the rich and powerful count of Flanders was proud of his famous all-black lion (*d'or au lion de sable*) and, most importantly, the emperor of the Holy Germanic Roman Empire displayed a huge, entirely black eagle (*d'or à l'aigle de sable*), first on his banner and then on his coats of arms from the middle of the twelfth century on. For a long time this eagle had only one head, before becoming two-headed at the beginning of the fifteenth century.[42] Undoubtedly, if black had been a negative color for coats of arms, systematically taken as evil, the emperor would never have chosen to dye or paint his heraldic emblem that color. But that was not the case. On the

contrary, the black of the imperial eagle not only had nothing diabolical or evil about it, but it also conferred upon the king of birds a power and incomparable potency that neither the white eagle of the Polish kings nor the red eagle of the Brandenburg margraves and Tyrolean counts, nor even the two-headed golden eagle of the Byzantium emperors possessed. In the French language of heraldry, as we have emphasized, the terms for color were not those of ordinary language. They were terms that originally belonged to the literary language but which gradually, for many of them—*gueules* (red), *sable* (black), *sinople* (green)— became fixed in heraldic use alone. Etymologically, the word *sable* comes from Slavic languages (*sobol*, *sabol*) and designates the fur of the sable martin, the most beautiful and most expensive fur, which became an important object of trade in the Middle Ages.[43] A deep, immaculate black, it was imported from Russia and Poland to the West, where it became the fashion in royal and princely dress over the course of the thirteenth century, thus also contributing to the increasing value of the color to which it lent its name. Beautiful black textiles began to be called *sobelins* or *sabelins* as early as the 1200s; but the heraldic use of the word *sable* in place of the word *noir* (black) had to wait for the second half of the century.[44] Certain heraldic coats of arms that previously said simply *noir* ("*li comtes Flandre porte de or od ung leon noir*") henceforth began to use *de sable* in the place of that adjective: no longer a *lion noir* but a *lion de sable*; no longer an *aigle noire* but an *aigle de sable*.[45] The change became definitive in the following century. It demonstrated the growing specialization of the language of heraldry and the promotion of the color black in the world of signs, emblems, clothing, and appearances. A study of literary heraldry reveals the same pattern. Early on the poets and authors of chivalric romances attributed coats of arms to the heroes they presented. The latter often prove to be very relevant when attempting to study the symbolic dimension of heraldic figures and colors. By considering what the author tells us about a character—the role he plays, his qualities, his family, his position as friend or vassal to other characters—in relation to the figures or colors that make up his coats of arms, the historian gains perspective on heraldic symbolism and how it works in literary texts. This symbolism is more difficult to study in actual coats of arms, subject to different historical and genealogical constraints; in many cases, as we must recognize, their primary significance escapes us.

In this area of heraldic literature, a narrative motif recurring in many Arthurian romances from the twelfth and thirteenth centuries, in verse as in prose, proves to be particularly instructive for the symbolism of color: during the course of the story, the sudden appearance of an unknown knight bearing a monochromatic coat of arms—*plaines* in Old French.[46] In general, this knight appears on the occasion of a tournament, or else he rises up in the path of the hero, challenges him, and leads him to new adventures. This episode was often a delaying device; by means of the color he assigned to the unknown knight the author could suggest to readers what the knight was about to do and let them guess what would happen next. The color code was recurrent and meaningful. A black knight was almost always a character of primary importance (Tristan, Lancelot, Gawain) who wanted to hide his identity; he was generally motivated by good intentions and prepared to demonstrate his valor, especially by jousting or tournament. A red knight, on the other hand, was often hostile to the hero; this was a perfidious or evil knight, sometimes the devil's envoy or a mysterious being from the Other World.[47] Less prominent, a white knight was generally viewed as good; this was an older figure, a friend or protector of the hero, to whom he gave wise council.[48] Conversely, a green knight was a young knight, recently dubbed, whose audacious or insolent behavior was going to cause great disorder; he could be good or bad. Finally, yellow or gold knights were rare and blue knights nonexistent.[49]

What is striking in this literary chromatic code, aside from the total absence of blue knights, is the abundance of black knights.[50] These were heroes of primary importance who, for one reason or another, and for greater or lesser lengths of time, were anxious to hide their identities. Their helmets rendered them unrecognizable, and instead of displaying their usual coats of arms, which would have immediately identified them, they bore shields of *sable plain*, that is, uniform black. Moreover, often it was not just the shield that was black, but also the banner and the horse's cover; from head to foot, the hero and his mount were entirely covered in this color. Black was no longer the color of

death, paganism, or hell, as was systematically the case in the chansons de geste; it was the color of the incognito.

Thus in thirteenth-century chivalric romances, black became the color of the secret. It would remain so for a long time; six centuries later, in 1819, in his famous *Ivanhoe*, an exemplary chivalric tale and one of the greatest bookstore successes of all times, Walter Scott presented a mysterious black knight who during a tournament aids the hero and helps his side achieve victory. Everyone wonders about his identity, but he keeps it secret by hiding it under entirely black armor and equipment. Later in the novel the reader will learn that it is King Richard the Lionhearted, returned from the Crusades and captivity; he returns to England after an absence of nearly four years. The black constitutes a necessary disguise, an obligatory transition between his captive state (he has just spent fifteen months in Austrian and then German prisons) and his recovered status as free man and sovereign of England. Black here is neither negative nor positive; it marks a period of in-between.[51]

The Black Knight

In the stories of the knights of the Round Table, a black knight, that is, a knight whose armor, equipment, and horse's cover were entirely black, was not necessarily a negative figure. He could be a prominent hero—Lancelot, Tristan, Gawain, Perceval—who, during a quest or a tournament, wanted to keep his identity secret by concealing himself in this color.

Tristan in Combat Incognito. Miniature from a manuscript of *Tristan en prose*, illuminated by Évrard d'Espinques, 1463. Paris, Bibliothèque Nationale de France, ms. fr. 99, fol. 641v.

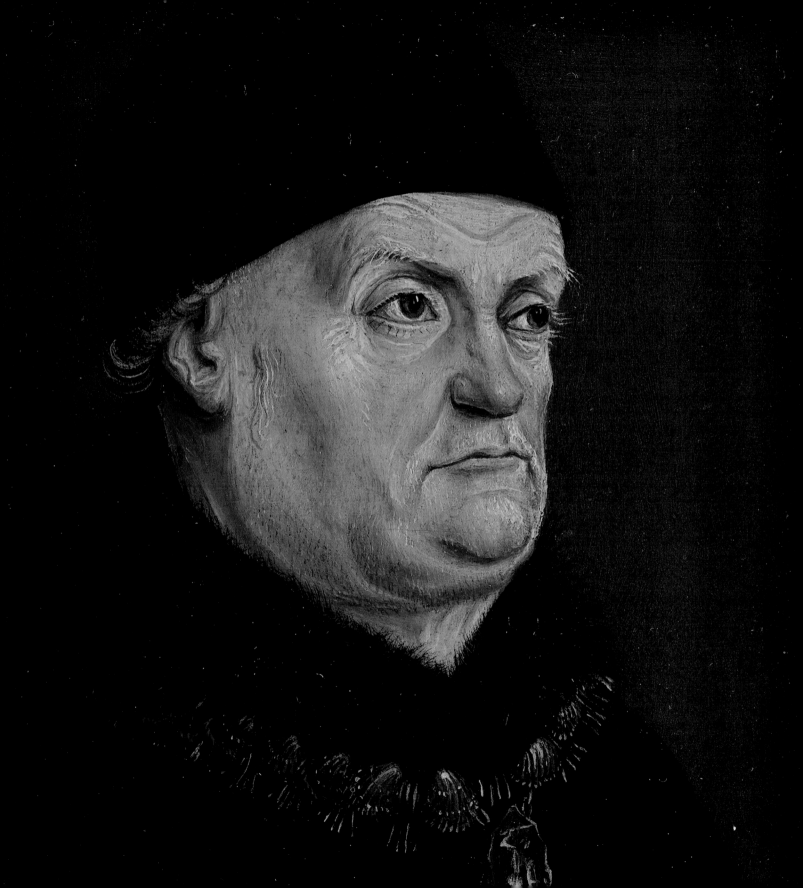

A FASHIONABLE COLOR

COLOR

FOURTEENTH TO
SIXTEENTH CENTURIES

In nearly all aspects of social life, the end of the Middle Ages represented an intense period of promotion for the color black. Of course, diabolical and deathly black did not disappear completely—the business of witchcraft and mourning practices, for example, continued to employ it—but there were many areas in which black regained value and became a respectable, fashionable, and even luxurious color. By returning black to the color order, by dismissing its sinister and harmful aspects, heraldry had prepared the way for such a promotion. By the end of the thirteenth century the dress practices of urban patricians and officeholders or those in positions of authority continued to make black a color with dignity and integrity. In the following century it was the civic moral codes and sumptuary laws that highlighted the virtuous dimensions of the color. Then, as dyeing made definitive progress in the range of black tones, notably for silk and wool fabrics, it was the princes who henceforth demonstrated an immoderate taste for a color that they had nearly always rejected. Black became a curial and even a royal color, which it remained well into the modern period, at least until the mid-seventeenth century.

René d'Anjou (page 76)

Prince and poet, enlightened patron,
René d'Anjou changed the colors of his
livery many times over the course of his long
life (1409–80), but never abandoned black,
either used alone, or in combination
with white or gray or both.
Nicolas Froment, *Diptyque des Matheron:
Portrait de René d'Anjou*, c. 1475.
Paris, Musée du Louvre.

THE COLORS OF THE SKIN

The Subjects of the Antichrist (page 81)

For a long time the Middle Ages believed in
the existence of strange or monstrous peoples,
living on the borders of the known world, near
the great circular ocean. Some had only
one eye or one foot; others went naked and
worshipped a giant goat; still others,
whose skin was burned by the sun, were
vassals of the Antichrist.
Miniature from a Bavarian manuscript of
Marvels of the East, mid-15th century. Berlin,
Staatsbibliothek, Cod. Germ. Fol. 733, fol. 4.

Like most ancient societies the Christian Middle Ages were attentive to the colors of the body, and to skin color even more than hair and eye color. Texts and images offer instructive, abundant information in this area as it evolved over the course of centuries and differed according to the geography and the social milieu involved. In the central Middle Ages dark skin color was almost always negative, belonging to individuals located outside the social, moral, or religious order. These individuals in one way or another maintained more or less direct relationships with the world of the devil and hell; the dark appearance of their skin was a visible sign of their evil, pagan, or transgressive natures. Moreover, this characteristic was often associated with other attributes, related either to the body or clothing, which helped to reinforce their perfidious and diabolical aspects.

In this regard the example of Judas is noteworthy. No canonical text in the New Testament, not even any apocryphal gospel, tells us about his physical appearance. By the same token, representations of him in early Christian and then in Carolingian art are not characterized by any specific features. Nevertheless, in representations of the Last Supper an effort was made to distinguish him from the other apostles by setting him apart in some way that involved his placement, size, or stance. But after the year 1000 and especially beginning in the twelfth century, first in images and then in texts, attributes highlighting the demonic nature of this perfidious apostle multiply: small stature, low forehead, bestial or distorted face, thick mouth, dark lips (because of the accusatory kiss), red hair and beard, very dark skin, yellow robe, clumsy gestures, hand holding the stolen fish or the purse with the thirty silver pieces, toad or black demon entering the mouth, halo either absent or black in color.[1] Each century provided Judas a succession of attributes. Two of these involved the colors of the body and recurred particularly often: dark skin and red hair.[2]

These two attributes are found again in the chansons de geste, where they are associated with the Saracens who challenge the Christian knights. Even more than red hair, the Saracens have dark skin, brown or even distinctly black; that is their most common characteristic and a manifest sign of their evil nature: the darker the skin, the more formidable the character.[3] Certain authors even multiply comparative

expressions to emphasize black's negative connotations: black "as a crow," black "as coal," black "as hot tar," and even black "as pepper sauce"![4] These expressions recurred so frequently that the most common adjective for describing this skin color—*mor, maure*—finally turned into a noun and became the term for designating this ethnic group; the Saracens became the Moors. The term applied not only to North Africans, as was sometimes the case in Classical Latin (*mauri*), but to all Muslims from Spain to the Middle East. In a short, anonymous chanson de geste composed toward the end of the twelfth century, *La Prise d'Orange*, the hero Guillaume and his two companions darken their faces and bodies with coal to disguise themselves as Moors and clandestinely enter the city. Guillaume, in fact, is in love with the Saracen queen Orable, whom he has never seen but whose beauty is renowned. Nevertheless their ruse is soon discovered because their artificial coloring cannot withstand sweat or rain.[5] Happily, with Orable's help, they manage to get themselves out of this tight spot, and the young Moorish woman becomes a Christian, changes her name, and marries Guillaume.

In chivalric romances the colors of the body do not distinguish Christians from Muslims, but, rather, nobility from commoners, and more importantly, knights from villains. Knights won over ladies (and readers) no longer so much with their physical strength as the epic heroes did, but with the elegance of their clothing, their courteous manners, and their physical beauty. Physical beauty was no longer based on impressive muscles and athletic prowess, but on a good complexion, white skin, and blond hair. The knight was a being of light; he contrasted with the villain, who had dark hair and skin. Here is how as early as the 1170s in Chrétien de Troyes's romance *Le Chevalier au lion*, the valiant knight Calogrenant describes to King Arthur's court a peasant herdsman whom he encountered in the course of his wandering and whom he had wrongly identified as a human being, "A peasant who resembled a Moor, ugly and hideous in the extreme—such an ugly creature that he cannot be described in words."[6] A few years later, at the beginning of his *Conte du Graal*, this same Chrétien de Troyes described the knights that the young Perceval encounters. In their magnificent clothing and equipment these are creatures sparkling with light and color, to the point that the naïve young man takes them for angels:

> But when he caught sight of them
> coming out of the woods,
> he saw the glittering hauberks
> and the bright, shining helmets,
> the lances and the shields—
> which he had never seen before—
> and when he beheld the green and vermilion
> glistening in the sunshine
> and the gold, the blue and silver,
> he was captivated and astonished,
> and said: "Lord God, I give You thanks!
> These are angels I see before me."[7]

Green, red, yellow, blue, white: all these colors are named by the author to describe these beings of light—all but black. Not only is dark skin hardly human, much less noble skin, but black is also an ignoble color that knights in their bright garb refrain from wearing. Two or three decades later that would no longer be the case.

What was true for men was even more true for women. In this type of literature women too were often beings of light; their beauty was expressed by brightness, freshness, fairness, and grace. Conversely, dark skin and hair were signs of ugliness. In the same *Conte du Graal*, Chrétien de Troyes thus depicts the most hideous damsel ever seen:

> Her neck and hands were blacker than the blackest of metals; her eyes were simple hollows, as small as the eyes of rats; her nose resembled both a monkey's nose and a cat's nose; her ears, those of a donkey and a cow; her teeth were the color of egg yolk and her chin displayed a beard like that of a goat; from her chest arose a hump, the sister of the one which was found on her back.[8]

This appalling description is instructive on several accounts. It gives this "hideous damsel" an animal-like appearance and confirms that in the Middle Ages the animal nature of the human

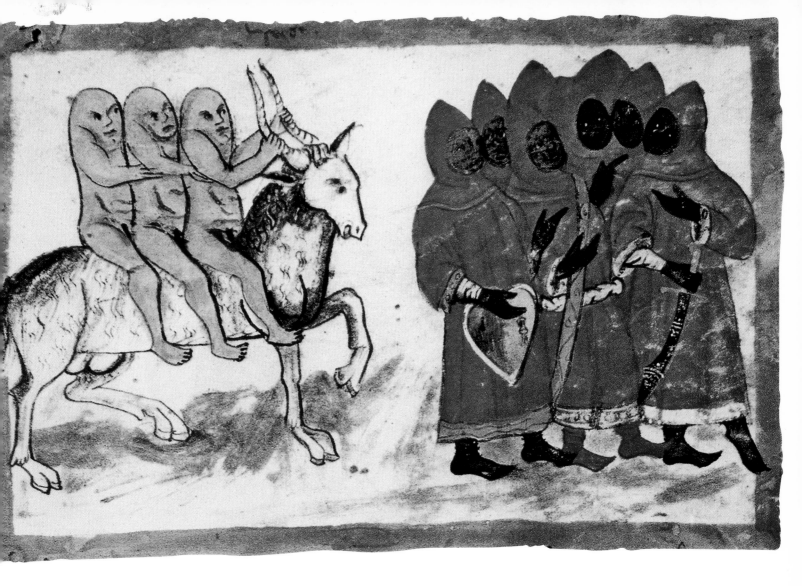

body was considered an abomination. But in a value system where beauty was entirely constructed upon clarity and light, even more significant than these zoomorphic traits is the blackness that constitutes the first and most degrading sign of ugliness: "Her neck and hands were blacker than the blackest of metals." The same rejection of dark skin can be observed in images. From the Carolingian period until the late Middle Ages there are abundant examples that present not only dark-skinned devils and demons, Saracens and pagans, traitors and deceivers (the biblical traitors Judas, Cain, and Delilah; Ganelon and Mordred, the traitors from the *Song of Roland* and Arthurian legend), but also criminals of all kinds, adulterous spouses, rebellious sons, disloyal brothers, usurping uncles, even individuals practicing immoral trades or occupations relegating them to the margins of society: executioners (especially the executioners of Christ and the saints), prostitutes, usurers, witches, counterfeiters, and even lepers, beggars, or cripples. They all lack light skin, the characteristic of well-born, honest men, and good Christians.

THE CHRISTIANIZATION
OF DARK SKIN

A change seems to have occurred at the turn of the thirteenth and fourteenth centuries, which expressed a new value system as well as a new attitude toward the color black. Of course, dark skin as a negative attribute remained dominant, but in miniatures, stained glass, and mural paintings, and then later in tapestries and works on panels, a few black-skinned individuals appeared who were not viewed as evil at all.

Among them, the oldest was certainly the "fiancée" of the Song of Songs who sings so appealingly, "I am black but I am beautiful" (Songs 1:5); she occupied a modest place in medieval iconography, however. More prominent was the Queen of Sheba, who came to render a visit to King Solomon; Solomon's renown had reached her even though she lived far from the realm of Israel. Beginning from the late thirteenth century, artists sometimes gave the Queen of Sheba dark skin, notably on cartographic documents. This new attribute, for which there is only a single example from the preceding century, emphasized not dark skin's negative aspect, but its exoticism.[9] The Queen of Sheba came from a distant country and brought Solomon magnificent gifts: gold, spices, precious gems (1 Kings 10:1–3). In doing so, she seemed to anticipate the visit the Three Kings would make to the infant Jesus. Moreover, many texts presented the Queen of Sheba as the ancestor of the Three Kings. Others made her a prefiguration of the church coming to pay homage to the Savior, foreshadowed by Solomon. Still others transformed her into a magician or even a witch whom the iconography of the late Middle Ages and the modern period gave not only black skin but sometimes also a hairy body and webbed feet, like those of Queen Pedauque.[10] Nevertheless, such depictions were rare before the popular imagery of the seventeenth century.

Relative or descendant of the Queen of Sheba, the famous Priest John shares a certain number of iconographic attributes with her. On the guides to ports from the end of the thirteenth century he also began to be represented as a black king, living in the Indies and struggling simultaneously against the Muslims and the Mongols. He was not in the least negative or evil. On the contrary, he passed for a Christian king from a distant land, evangelized long ago by the apostle Thomas. From the second half of the twelfth century, the papacy hoped for his alliance to turn back Islam. On various occasions voyagers tried to reach

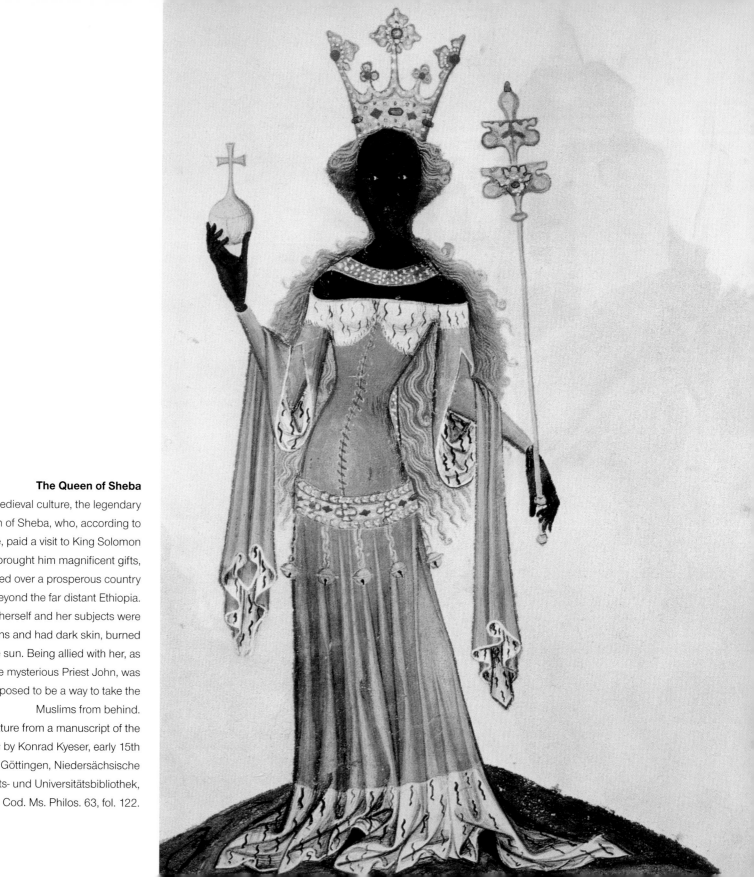

The Queen of Sheba

For medieval culture, the legendary Queen of Sheba, who, according to the Bible, paid a visit to King Solomon and brought him magnificent gifts, reigned over a prosperous country located beyond the far distant Ethiopia. She herself and her subjects were Christians and had dark skin, burned by the sun. Being allied with her, as with the mysterious Priest John, was supposed to be a way to take the Muslims from behind.

Miniature from a manuscript of the *Bellifortis* by Konrad Kyeser, early 15th century. Göttingen, Niedersächsische Staats- und Universitätsbibliothek, Cod. Ms. Philos. 63, fol. 122.

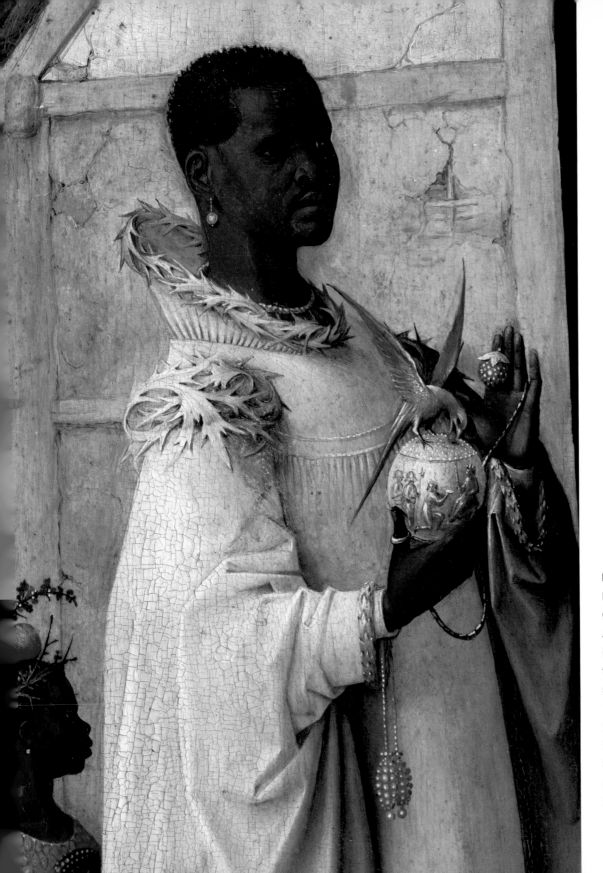

Balthazar, the Black Magus

Mentioned in texts as early as the
Carolingian period, the black-skinned
African only made his appearance in
images of the Three Kings at the end of
the fourteenth century, and did not
show up frequently in paintings until the
1430s to 1440s. He attested to a new
regard for Africa and the color black.
Hieronymus Bosch, *The Adoration of
the Magi*, central panel of the
Epiphany triptych, c. 1500. Madrid,
Museo del Prado.

his realm. They sought him first in Asia, later in Africa, next to Ethiopia. In miniatures and on maps this mysterious Priest John was represented in majesty, bearing the same insignia of power as Western sovereigns (scepter, globe, crown), but his skin was black.[11] Here, again, this was a sign of exoticism and not of paganism or heresy. It was also a way of presenting the universality of the religion of Christ, who accepted his mission to evangelize "all the nations" as the Acts of the Apostles proclaimed. Finally, it was testimony to the new curiosity of Europeans who were venturing farther and farther from their own lands and seas; they were discovering unknown populations, not diabolical or monstrous like the ones described in the bestiaries and encyclopedias of the Romanesque period, but unusual, welcoming, sometimes ready to receive baptism. At the end of the thirteenth century men and women with dark skin could become Christians; indeed some already were.

Akin to Priest John, descending from the Queen of Sheba, arriving from the ends of the earth to honor the infant Jesus, the Three Wise Men could only be subject in turn to these new systems of value and representation. One of them had to become black. Naturally, it was the one who incarnated Africa: Balthazar, whose skin became dark in the second half of the fourteenth century. Curiously, the oldest surviving evidence we have of this is not a miniature, a stained-glass window, a panel painting, or a tapestry, but a heraldic document: the *Armorial du héraut Gelre*, a huge collection of coats of arms compiled in the area of Cologne and Liège between 1370 and 1400. This comprehensive collection, painted in an energetic style, was the first to give imaginary coats of arms to the Three Kings: Gaspard was given a shield displaying a crescent and a star; Melchior, a shield sprinkled with gold stars; and Balthazar, a black man on foot holding a pennant. It was this figure of a black man, accompanied by a portrait of an equally black man below the shield, an enormous head in a pointed cap, that made it clear the third of the Three Kings would be a dark-skinned African henceforth.[12] In this way heraldry was very much ahead of other figurative documents, for the black Wise Man would not make his entry into illumination and panel painting until the 1430s and 1440s. Subsequently, in the second half of the fifteenth century the presence of a black within the triad became systematic. The

texts explained that Balthazar, the youngest of the Three Kings, descended from Ham, son of Noah, and that he reigned in a country where the men and women had skin that was burned by the sun, like that of the fiancée in the Song of Songs.

Despite this spectacular, definitive change in color, the case of the magus Balthazar is neither the oldest nor the most perfect example of the Christianization of dark skin. It was anticipated not only by the Queen of Sheba and Priest John but also and most importantly by a saint venerated throughout the West: Maurice. About the middle of the thirteen century Maurice became a dark-skinned saint, the archetype of the African Christian. Of Coptic origin, according to tradition, Maurice was the leader of an important Roman legion recruited in Egypt and sent to fight on the empire's frontier in the central Alps. A valiant soldier, he confronted the barbarians and served Rome faithfully. But, being Christian, he refused to sacrifice to the pagan gods and toward the end of the third century, under Emperor Maximian, he was martyred with all his soldiers in the area of Agaune, in Valais. That was the basis for a cult that would grow throughout the Middle Ages. In Agaune itself an important abbey preserved the saint's relics and became the final destination for one of the most popular pilgrimages in all of Western Christianity. Admired for his bravery, his fidelity to the emperor, and his steadfast Christian faith, Maurice was even chosen as the patron saint of knights in the twelfth century; he shared this prestigious role with Saint Michael and Saint George. But as his worship and his iconography developed his appearance altered. At first white-skinned and with European features like Michael and George, Maurice was gradually Africanized in images and works of art that sought to evoke his Nubian origins. His skin became darker, his features were transformed—but far from doing him harm, this alteration, unthinkable two centuries earlier, heightened his prestige; the patron saint of knights was henceforth a black man, splendidly exhibiting his negritude. One of the oldest and most admirable examples of this transformation appears in the Magdeburg cathedral in eastern Germany; a stone statue, now defaced, placed along the side wall south of the choir, represents Saint Maurice as a knight dressed in a magnificent coat of mail that allows only his face to show: the face of an African. This remarkable sculpture demonstrated the importance of the Saint

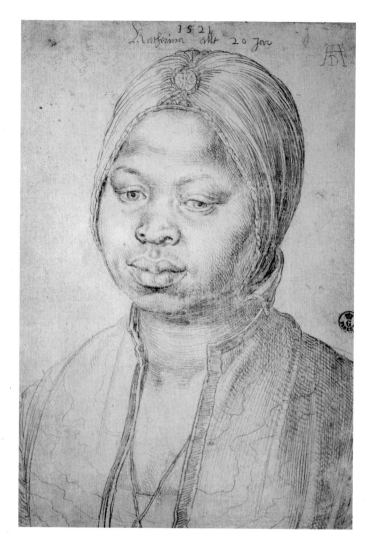

Maurice cult in Germany and inaugurated a long line of statues that would represent him thus, as a black knight, until the beginning of modernity.[13]

In about the same period—the mid-thirteenth century—but for reasons more difficult to understand, Maurice also became the patron saint of dyers. Dyers were proud of evoking him and commissioning works displaying such a venerated saint. They told his story through paintings and stained glass, through performances and processions, and even through heraldry. In many cities the artisan dyers guild displayed on their coat of arms a figure of Maurice on foot.[14] Statutes and professional regulations prohibited "master dyers, following the old, good, and laudable customs, from having their workrooms and shops open the day of the Feast of Saint Maurice."[15] This holiday took place in most Western cities on September 22, the day when Maurice and his companions were martyred. Perhaps it was the saint's black skin—brilliant and indelible, whereas it was so difficult to dye in black—that at the beginning of the thirteenth century led dyers to make him their patron saint. Moreover, in images and in the imagination Maurice undoubtedly took on this skin color as much because of his name as his African origins; for medieval society, which sought in words the truth of beings and things, the transition from *Mauritius* to *maurus* (black) was almost obligatory; a man named Maurice could not help being black. Thus, early on, Maurice the Egyptian became a Moor.[16]

Katharina, Portuguese Métis
At the turn of the sixteenth century, blacks and métis became more numerous in Mediterranean cities. For the most part, they were servants or slaves. Sometimes they were also seen in northern cities, in the service of rich Spanish or Portuguese merchants. Albrecht Dürer, *Katharina Brandao*. Silverpoint drawing, 1521. Florence, Gabinetto dei disegni e stampe degli Uffizi.

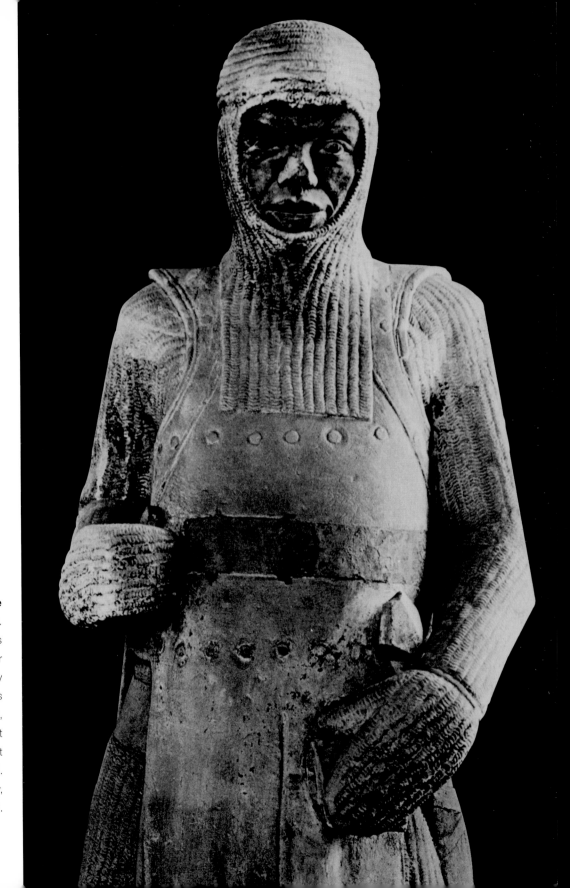

Saint Maurice

Black saints are rare in medieval traditions.
Saint Maurice, the patron saint of knights, was
the most prestigious. He owed his skin color
to his African origins (he was supposedly
from Thebes in northern Egypt) and to his
name, *Mauritius*, from the adjective *maurus*,
black. In the thirteenth century, the cult that
developed around him experienced a great
expansion in the Germanic world.
Statue in the Magdeburg cathedral, Germany,
wall south of the choir, c. 1240.

JESUS WITH THE DYER

Saint Maurice was not the dyers' only patron. The protection of Christ was even more precious to them. In the story of the Savior they looked to a particularly glorious moment: the moment of the Transfiguration, when Christ showed himself to his disciples Peter, James, and John. Surrounded by Moses and Elijah, he appeared to them no longer in his earthly clothes but in all his glory; "his face had become bright as the sun and his clothes white as the snow."[17] Dyers wanted to see in these color changes an affirmation of their occupation and thus often placed themselves under the protection or patronage of the Christ of the Transfiguration. They did not wait for this holiday to be accepted among the number of universal holidays for the Roman Church—not until 1457—to celebrate it; as early as the mid-thirteenth century they commissioned retables with scenes depicting Christ transfigured, dressed in white, his face painted in yellow.[18]

Nevertheless, dyers' commissions were not limited to this glorious image of Christ. Sometimes it was the boyhood of Jesus they decided to present by having depicted, especially in stained glass, an episode recounted by the apocryphal gospels: his apprenticeship with a dyer in Tiberias. Transmitted by noncanonical texts, this episode was not a matter of high theology, but was easier to interpret than the theme of the Transfiguration. Many Latin and vernacular versions of this story (notably Anglo-Norman) have survived, inherited from the Arab and Armenian gospels of the Childhood. Beginning in the twelfth century, these different versions engendered an iconography presented in various media: miniatures, of course, but also stained glass, retables, ceramic tiles.[19] Despite sometimes significant variations, the texts, unpublished in part, articulate the story of this apprenticeship of Jesus with a dyer following the same basic pattern.[20] They can be summarized in the following way.

Mary and Joseph want Jesus to be taught a trade, and when he is seven years old they place him with a dyer in Tiberias as an apprentice. His master, sometimes named Israel, sometime Salem, shows him the vats of dye and teaches him the specific processes for each color. Then the dyer gives him many sumptuous fabrics provided by rich patricians, explaining how each must be dyed a specific color. After having entrusted this work to him, the master leaves for the outlying villages to

make his rounds. During this time, Jesus, forgetting the dyer's orders and anxious to rejoin his parents, immerses all the cloth in only one vat and returns home. That is the vat with blue dye (or black, or yellow, according to the version). When the dyer returns, all the fabric is uniformly blue (or black or yellow). Thus he goes into a violent rage, rushes to Mary and Joseph's house, scolds Jesus, and declares himself disgraced before the whole city. Then Jesus says to him, "Do not be upset, Master, I am going to render each cloth the color that should be its own." He reimmerses them all together in the vat, and when he takes them out one by one each is dyed the desired color.

In certain versions Jesus does not even need to reimmerse the materials in the vat to restore their proper colors. In others the miracle takes place before a crowd of curious onlookers, who begin to praise God and recognize Jesus as his son. In still others, perhaps among the oldest versions, Jesus does not come to the dyer's workshop as an apprentice, but is simply being a rascal. The shop is located next to his parents' house; hiding there with his playmates, he enters the workroom, and as a mean joke immerses the fabrics and clothing waiting to be dyed different colors into a single vat. But he quickly repairs the damage and gives each cloth the most uniform and beautiful color that anyone has ever seen. And, finally, in another version Jesus commits his crime in the course of a single visit that he makes with his mother to the dyer in Tiberias, and it is Mary who tells him to correct the stupid error, as if she already recognized his aptitude for performing miracles.

Regardless of these variations, the episode with the dyer in Tiberias hardly differs from the other miracles performed by Jesus as a child, either during his flight into Egypt or upon his return to Nazareth.[21] The canonical gospels do not breathe a word of it, but the apocryphal gospels speak at great lengths on this subject. For the latter it is a matter of making up for the silences of the former, of satisfying the curiosity of the faithful, and of startling minds with miraculous episodes. Often the anecdote takes precedence over the parable, and thus it is

difficult to draw from these accounts any pastoral or theological teaching, which explains their early exclusion from the canonical corpus and the extreme distrust with which the church fathers always regarded them. Moreover it was possible to interpret them many different ways.

For the dyers of the Middle Ages, scorned by other trade associations, held in contempt or feared by the people, the essential thing was to remember that in his youth the Lord Jesus had visited the shop of a dyer.[22] Thus immense honor was reflected back on those who subsequently took up this trade, so wrongly disparaged, indeed even scorned, that allowed Jesus to perform miracles. Nevertheless, with regard to the question that occupies us here—the redemption of the color black at the end of the Middle Ages—the story of the dyer of Tiberias and its various versions are instructive on another account.

In the oldest versions, formulated at the height of the Middle Ages, Jesus' blunders involve the color blue; he dips all the undyed cloth into a vat of blue dye. In this period, as in ancient Rome, blue still had little value; it was unpopular and rarely used for fabric and clothing. Later, in the feudal period, when blue gained much esteem and even became a fashionable color, indeed a royal color, it was no longer blue, but black dye that Jesus used. Black, as we have seen, was then the bad color, the color of the devil; quite naturally the young apprentice (or rascal) immerses the undyed cloth into a vat of black. But, beginning in the fourteenth century, that was no longer possible; in its turn black had been promoted and hardly bore any negative connotations anymore. Black no longer signified a misdeed, at least in the context of fabric or clothing. Thus Jesus had to make his mistakes in another color range. In place of black, the versions from the end of the Middle Ages thus chose yellow, the color of lying and treason, of Judas and the synagogue, for the vat in which the boy dipped the various cloths before performing a miracle and turning each of them the desired color. At that time a vat of yellow was symbolically more disturbing and ominous than a vat of black.[23] That was something new.

DYEING IN BLACK

The two vats, it is true, were not to be found in the same workshops. For most of the urban textile industry—manufacturing cloth was the only real industry in the medieval West—the trade was strongly compartmentalized and strictly regulated. There were many texts beginning in the thirteenth century that laid out the organization and training for it, its localization in the cities, its rights and obligations, as well the list of legal and prohibited colorants.[24] Specialization was the rule everywhere, determined by the type of material (wool, silk, linen, and hemp, sometimes cotton in a few Italian cities) and by the colors or groups of colors. Regulations, in fact, forbade dyeing a type of material or working in a range of colors for which one was not licensed. For wool, for example, beginning in the thirteenth century a dyer who worked in red could not dye in blue, and vice versa. On the other hand, dyers who worked in blue often took charge of green and black tones, and dyers who worked in red, the range of yellows and sometimes of whites. In certain German and Italian cities (Erfurt, Venice, Lucca), specialization went further still; for a single color dyers were distinguished according to the single colorant material that they had the right to use (woad, madder, kermes). In other cities (Nuremberg, for example), for the range of a given color the ordinary dyers were distinguished from the luxury dyers (*Schönfärber*), who used very expensive colorant materials and knew how to make them deeply penetrate the cloth fibers.

Nevertheless, that had little bearing on black tones. Dyeing in this color long remained a difficult exercise and until the mid-fourteenth century for most fabrics and clothing black tones were not really black. They presented a grayish, bluish, sometimes brownish appearance; moreover, they were neither brilliant nor monochromatic. Dyers did not know how to produce bright, uniform blacks, as they had for a long time in the range of reds and for a few decades in the range of blues. To dye in black, the most common colorant materials were drawn from bark, roots, or fruits from various trees: alder, walnut, chestnut, certain oak. By using a mordant of products rich in iron oxide, gray or brown tones were obtained that successive baths helped to make increasingly darker. With walnut bark or roots the results were better than those achieved using products from other trees and the tones obtained were very nearly black. But the use of

colorant materials derived from walnut met with much resistance. In the Middle Ages, this tree was, in fact, considered evil. On that point, botanical knowledge and popular beliefs concurred. Not only were the roots of the walnut toxic, killing all the vegetation around them, but they caused the death of livestock when they grew too near the cowsheds. As for men and women, they too had much to fear from this harmful tree: to sleep under a walnut tree was to expose oneself to fever and headaches; moreover, it was to risk being visited by evil spirits, indeed even by the devil himself. There was already evidence of such beliefs in antiquity and they were still common in rural modern and contemporary Europe. They much demeaned a tree that otherwise provided quality wood and valued fruit. Its bark and roots were considered deadly. Following Isidore of Seville, many authors linked the Latin name of the walnut (*nux*) with the verb "to harm" (*nocere*) and thus explained why they were suspect.[25] In the Middle Ages the truth of beings and things was always to be found in the words that designated them.[26]

To improve the results obtained from vegetable dyes the dyers sometimes resorted to the *moulée*, even though this technique was condemned by all professional regulations. It was a matter of a dye with a base of iron filings collected from the forge or from under artisans' grindstones (*moulage*, grinding). Using a powerful mordant of vinegar, it produced a very beautiful black, but it was hardly permanent on fabric and sometimes proved to be corrosive. Thus, to mitigate the effect, it was combined with brown or gray tones obtained from decoctions of bark and roots. Added to the decoction, the mixture of iron filings and vinegar tended to blacken all the tones, especially after many baths and then a long exposure to open air.

Another technique used to improve the "bark blacks" consisted of giving the cloth a blue "foot" (*pié*). Before being immersed in a bath of walnut, alder, or chestnut, it was dipped into one or many baths of woad, the most common plant colorant material for blue dyes. This gave the piece of cloth a solid base color and an already more or less dark appearance. Despite all the taboos regarding the mixing of colors, this procedure was allowed by professional regulations because it was not considered to be a mixture but a simple superimposition. It was only legal for dyers working in blue

Dyeing in Black

For a long time, dyeing in black remained a difficult exercise. Only the use of oak apple, a very expensive colorant material, produced beautiful, uniform tones, deeply penetrating the wool fibers. In the sixteenth century, dyers made some progress, and beautiful black textiles gradually became more widely available.

Jost Amman, *Der Schwarzfärber* (the dyer of black), woodcut, 1568 (colors added later). In Hans Sachs, *Eygentliche Beschreibung aller Staende* (Frankfurt am Main, 1568).

because they also had permission to dye in black. A dyer working in red could have produced similar results by immersing cloth to be dyed black in a vat of madder, but that was strictly forbidden because a dyer working in red did not have the right to dye in black. Sometimes, especially in the fifteenth century, they did so nevertheless, and the results were often more successful with a madder foot than with a woad foot.

Some unscrupulous dyers did not even take the trouble to resort to iron filings or a woad bath to improve a black produced from bark or roots; they simply used lampblack or charcoal to blacken and unify the color obtained employing the usual methods. This was applied cold, on the surface, and it certainly produced a beautiful, uniform color, but it was volatile and very impermanent. The deception was soon exposed, which prompted quarrels, lawsuits, and for the historian many archives. Court cases involving costly dyes that proved to be unstable or superficial were common throughout Europe from the thirteenth to the seventeenth centuries. Moreover, these cases of fraud did not involve only wool and silk cloth, but also furs; a simple coat of lampblack was enough to transform a rabbit or fox hide into a superb fur resembling sable and thus sold for a very high price.

In fact, to obtain a truly uniform, solid, black black, the medieval dyer knew of only one product: the oak gall or oak apple (*granum quercicum*). It was a matter of small spherical growths found on the leaves of certain oaks, leaves on which various insects deposit their eggs. After the eggs are deposited, the tree's sap exudes a material that gradually envelops the larvae and encloses it in a kind of shell; that is the oak apple. Oak apples had to be collected before summer, while the larvae were still inside, then allowed to dry slowly; they were thus rich in tannins and possessed remarkable colorant properties in the range of blacks. As with bark and roots, they required a mordant of iron salts. This dye was an extremely expensive product: first, it took an enormous quantity of oak apples to obtain a small amount of colorant material; second, it had to be imported from eastern Europe, the Near East, or North Africa because western oaks provided very little of it, and of poor quality. At the end of the Middle Ages, when black had become the style in princely clothing, the dyers in the large urban textile industry used great quantities of it, despite its ever increasing cost.

The historian is entitled to wonder if the great rage for black tones at the end of the Middle Ages was due to technological advances in traditional dyeing or perhaps to the discovery of a new colorant material. Nothing in archival documents or in the collections of recipes provides support for this second hypothesis; we barely find mention of increasingly greater imports of oak apple, coming especially from Poland and eastern Europe. It does indeed seem that Western dyers developed their skills in the range of blacks solely because princely society, henceforth an enormous consumer of this color, demanded it of them. They perfected their techniques, forgot their old distrust of walnut, relied more heavily on mordants, more often resorted to the woad "foot," and above all increased their purchases of oak apple. By doing so, they produced very beautiful, brilliant, solid blacks, diversified their production, and increased their prices and their profits, but they did not truly break new ground. Their profession was not at all responsible for initiating the great rage for black clothing that swept all of wealthy Europe beginning in the mid-fourteenth century. On the contrary, social and ideological demand preceded advances in materials and technology. As is often, or always, the case, symbolism preceded chemistry.

Nigredo
et lucida

tra pa

Aqua

Caput

Corui

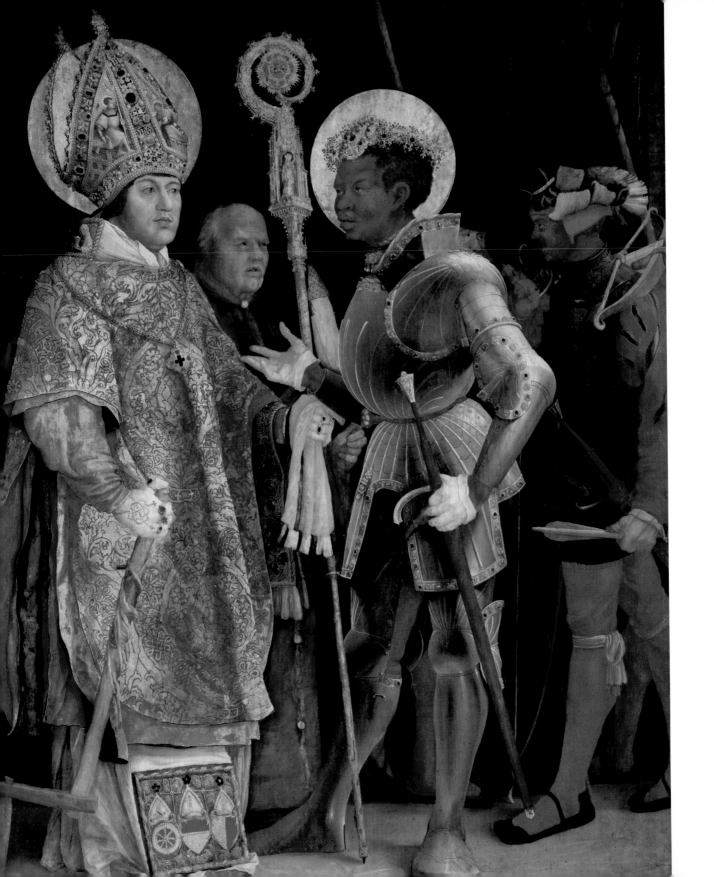

THE COLOR'S MORAL CODE

Saint Erasmus and Saint Maurice

Maurice was not only the patron of knights; he was also the patron of dyers, unappreciated artisans who found in this saint an "apostle of color." In chapels dedicated to him, they commissioned stained-glass windows and retables depicting his legend and his martyrdom. Matthias Grünewald, *Meeting of Saint Erasmus and Saint Maurice*, 1521–22. Munich, Alte Pinakothek, Inv. Nr. 1044.

The historian must ask himself another question: what is the precise chronology of this rage for black tones? When did it begin? Before or after the Great Plague of 1346–50, which witnessed the loss of more than one-third of Europe's population? One would be tempted to respond, "after," and to see the sudden new taste for the color black as a consequence of that tragic event accepted as divine punishment. An angry God might have been punishing the sinners. Black clothing could have been both the sign of a great misfortune and of a true collective penitence, a moral and redemptive, almost liturgical black similar to the black that draped the churches twice a year, during Advent and Lent. None of that is not true; the ethical dimension of black was everywhere apparent: in sumptuary laws, literary texts, artistic creations, and statutes and regulations of orders and institutions. However, looking more closely, it appears that the phenomenon preceded the plague. It was already observed at the end of the thirteenth and in the first decades of the fourteenth century, at least in certain circles.

It was, in fact, the lawyers, judges, and magistrates belonging to certain sovereign courts who seem first to have demonstrated a new attraction to this color: in France, beginning with the reign of Philip the Fair (1285–1314), in England, at the end of the reign of Edward I (1271–1307), and in many Italian cities in about the years 1300–1320. In their eyes, as for a great number of monastic and religious orders, black was not infernal or evil, but austere and virtuous. That was why it had to be the color of choice for signifying public authority, the law, and even the nascent government. All those who in some form or other held an office or served in a position of responsibility for the state began to dress in black, like the clerics whom they wished to resemble and with whom they worked closely. They were gradually imitated by certain university professors and then by all who possessed learning. Toward the middle of the fourteenth century, the various social and professional categories that began to be characterized as "long-robed"—because they remained faithful to long hems while short clothing triumphed among princes and nobles—were already wearing black. Of course, this was not a matter of a uniform or even a required color, worn in all circumstances; rather, black was the distinctive sign of a particular status and a certain civic moral code.[27]

In the second half of the century, merchants, bankers, and all men of finance also adopted the new black style. Perhaps in this case it was a consequence of the plague and a sincere desire for greater austerity and virtue after God had so cruelly displayed his wrath; the rich had to set the example of an honest, pious life, and dress was the primary external sign of that. But more likely it was a matter of responding to sumptuary laws that introduced drastic forms of social segregation, notably by forbidding certain colors or certain colorant materials, the most beautiful and most expensive ones, to all those who were not nobility. Mortified by such measures, which ran counter to economic and social developments, the rich urban patricians found in black a means of circumventing those laws and rendering them obsolete. More than the officials and the long-robed professors, it was the wealthy patricians, belonging to the world of commerce, who demanded that dyers improve the range of blacks, a color formerly neglected because it was drab and grayish. They asked them to produce truly black, solid, uniform, even brilliant blacks in wools and silks, capable of rivaling the most beautiful furs reserved for the princes. And, because this rich and powerful clientele demanded these advances, the dyers succeeded in two or three decades, first in Italy, then in Germany, finally throughout Europe. The black style was definitively launched in about the years 1360–80. It lasted until the mid-seventeenth century.

The new style was aided by sumptuary laws and the dictates on dress that accompanied them. Appearing as early as 1300, these laws multiplied throughout the Christian world immediately following the Great Plague.[28] They seem in answer to three motivating factors. First was economic necessity: to limit expenses involving clothes and accessories for all social classes because these were unproductive investments. In the second half of the fourteenth century, this type of spending among the nobility and the patricians reached a level of excess sometimes bordering on madness.[29] Thus it was a matter of curbing such ruinous expenses, ostentatious luxury, and permanent debts. It was also a matter of preventing the rise of prices, redirecting the economy, stimulating local production, and curbing imports of foreign luxury products, sometimes coming from as far away as the Far East. Then came ethical concerns: to renounce the

excesses of appearance and maintain the Christian tradition of temperance and virtue. In this sense, such laws, decrees, and regulations were part of a vast moralizing current that ran through all of the late Middle Ages and for which the Protestant Reformation would become the heir. By the same token, most of these laws appeared to be reactionary; they were hostile to changes and innovations, which disrupted the established order and transgressed accepted moral behavior, and they were often directed against youth and women, two social categories too eager for the pleasures of novelty. Finally, and most importantly, there were profoundly ideological reasons: to establish a system of segregation by dress, requiring each individual to wear the clothing of his sex, age, station, standing, or rank. It was necessary to maintain solid barriers, to prevent slippage between one class and another, and to see to it that clothing remained the patent sign of social classifications. To break down those barriers was to break down an order not only desired by the authorities but also by God, as certain normative texts proclaimed.

In matters of cloth and clothing, everything was thus regulated according to birth, fortune, age group, and occupation: the nature and size of the wardrobe one could possess, the articles of clothing it included, the fabrics from which they were cut, the colors they were dyed, the furs, finery, jewels, and all the accessories of dress. Of course these sumptuary laws also concerned other areas of ownership (dishes, silverware, food, furniture, real estate, carriages, servants, and even animals), but clothing was the principal stake among them because it was the primary medium for signs in a society then in full transformation and in which appearance played an ever increasing role. Such laws thus constitute a primary source for studying the dress

The Man in a Turban
This portrait, one of the most beautiful in the entire history of painting, has still not disclosed its mystery. Is this man in a red turban Giovanni Arnolfini, a rich merchant from Lucca established in Brussels? One of his relatives? Or rather the painter himself, Jan Van Eyck, or some other unknown figure? Jan Van Eyck, *Man in the Red Turban*, 1433. London, National Gallery.

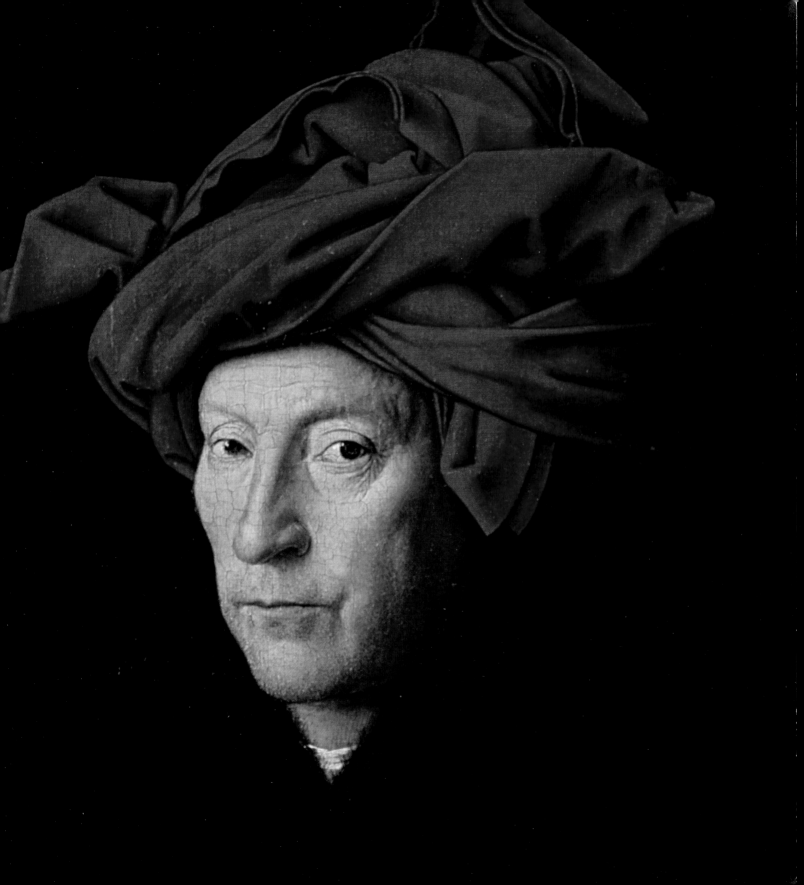

system of the late Middle Ages, even if they often went unheeded; their ineffectiveness led to their repetition and thus offers the researcher increasingly longer and detailed texts—with such precise numbers that in some cases it became absolutely extravagant.[30] These texts, unfortunately unpublished for the most part, speak at great length about colors.

Certain colors were forbidden to this or that social category not because of their immodest or garish tones, but because they were obtained by means of too costly materials, reserved for use in the wardrobes of individuals of high birth, fortune, or standing. Thus, in Italy the famous "Venetian scarlets," red fabrics dyed with a particularly expensive variety of kermes, were destined for the princes and great dignitaries. Throughout Europe colors that were too rich or showy were forbidden to all those who had to present a dignified, reserved appearance: clerics, of course, but also widows, magistrates, and all the long-robed professions. In a general way, polychromy, too violent contrasts, striped, checked, or rainbow-colored clothes were prohibited.[31] They were considered unworthy of a good Christian.

Sumptuary laws and regulations were not only long-winded on forbidden colors, however; they also said much about prescribed colors. Here it was no longer the quality of the colorant at issue, but rather the color itself, functioning almost in an abstract way, independent of its shade, material, or brilliance. It was not supposed to be discrete, but on the contrary to be noticeable because it constituted a distinctive sign, a required emblem, or an ignominious mark, designating this or that category of outcast or reprobate, everywhere the first targets. To maintain the established order, good moral standards, and ancestral traditions it was crucial not to confuse honest citizens with men and women on the margins of society, or indeed even outside them.

Thus the list of all those to whom these chromatic dictates applied was a long one. First of all, it included men and women who practiced dangerous, dishonest, or simply suspect occupations: doctors and surgeons, executioners, prostitutes, usurers, minstrels, musicians, beggars, vagabonds, and all orders of the poor and destitute. Then came those who were condemned in one way or another, from simple drunks guilty of disorderly public conduct to false witnesses, perjurers, thieves, and blasphemers. Then came various categories of the infirm, as infirmity—physical or mental—was always a sign of great sin in medieval value systems: the lame, cripples, lepers, outcasts, the "poor of body and cretinous of head." Last were the non-Christians, the Jews and Muslims, who had a great many communities in several regions and cities, especially in southern Europe.[32] Moreover, in the thirteenth century, during the Fourth Lateran Council (1215), it was essentially to them that these chromatic insignia seem first to have been assigned. They were linked to the prohibition against marriages between Christians and non-Christians, and to the necessity of clearly identifying the latter.[33]

However, regardless of what historians have managed to write on this subject, it is obvious that no single system of color marks existed throughout the entire Christian world to designate the different categories of exclusion. On the contrary, customs varied widely from one region to another, one city to another, even within a single city, and from one period to the next. In Milan and in Nuremberg, for example, cities where regulatory texts became numerous and detailed in the fifteenth century, the prescribed colors—for prostitutes, lepers, and Jews—changed from one generation to the next, almost from one decade to the next. All the same, here as elsewhere, we can observe a certain number of repetitions, the general patterns of which are worth noting.

Only five colors appeared in these discriminatory marks: white, black, red, green, and yellow. Blue was almost never used.[34] These five colors could occur in various ways: alone, the mark thus being monochromatic; or in combination, bicolored constituting the most frequent case. All combinations existed, but the ones that appeared the most frequently were red and black, red and yellow, black and white, and yellow and green. The two colors were combined as in the geometric figures of heraldry: *parti*, *coupé*, *écartelé*, *fascé*, *palé* (divided into halves, quarters, or stripes, horizontally or vertically). If a study of outcasts and reprobates by category were attempted, it could be noted (by simplifying terribly) that white and black designated especially the poor and infirm (lepers in particular); red, executioners and prostitutes; yellow, forgers, heretics, and Jews; green, either alone or combined with yellow, musicians, minstrels, clowns, and lunatics.[35] But many counterexamples existed.

Matthäus Schwarz

We owe to Matthäus Schwarz (1497–1576), a wealthy Augsburg banker, this curious collection of outfits showing him at different ages in his life and constituting a kind of autobiography. In 123 of the 137 images included in the collection, he appears dressed in black, his emblematic color, evoking his name.
The Book of Costumes of Matthäus Schwarz, Augsburg, 1520–60. Paris, Bibliothèque Nationale de France, ms. allemand 211.

THE LUXURY OF PRINCES

Let us return to black and its sudden promotion beginning in the mid-fourteenth century. This seems to be the direct consequence of those sumptuary laws and dress regulations. The phenomenon began in Italy and initially only involved urban circles. Certain merchants possessed great wealth but were still unable to force their way into the nobility or even the highest patrician classes.[36] They found themselves forbidden the use of too lavish reds (and thus the sumptuous Venetian scarlets, *scarlatti veneziani de grana*) or too intense blues (the famous "peacock" blues of Florence, *panni paonacei*).[37] They thus acquired the habit, as derision or provocation, of dressing in a color not affected by these prohibitions, a color with a modest reputation and little valued until then: black. But because they were rich, as we have said, they required the dyers to provide them with new tones of black, more solid, vibrant, and seductive. Stimulated by this demand, the dyers achieved these tones by the 1360s. This new fashion allowed a wealthy class that had not reached the top of the social ladder to obey the laws and regulations even while dressing according to its tastes. It also gave them the chance to circumvent the prohibition many cities established against their wearing the most precious furs, notably sable, the most expensive and blackest of all furs. Finally, it provided them the opportunity to display austere and virtuous attire and, in doing so, to satisfy the urban authorities and the moralists.

This is what the treatise on color of the Sicilian herald, recorded in 1430, has to say on the subject of black:

Even though the color black seems sad, it is of high standing and great virtue. That is why the merchants and rich bourgeois, men as well as women, are dressed and adorned in it. . . . Black is not more base nor scorned than the other beautiful colors that dyers make in their ovens and boilers. One sometimes even finds black fabrics of a price equal to that of precious scarlets. . . . And even though black might be prized only for its uses for funerals, that would be enough to put it in the ranks of honor among the colors, because the mourning of princes and high ladies is done in black.[38]

The black fashion did not please only the wealthy merchant class and the long-robed professions. Other classes soon began

CAROLUS V.
Imp. Philippi I. Hisp...
et Ioanna Aragonia Filius...
[...] Febr. A° 1500. obiit
[...] 1558. [...]

to adopt it, first the high patricians and then especially the princes. By the end of the fourteenth century the presence of black clothing was noted in the wardrobes of very grand individuals: the duke of Milan, the count of Savoy, the lords of Mantua, Ferrara, Rimini, and Urbino.[39] At the turn of the century the new fashion spread from Italy; foreign kings and princes also began to dress in black. At the French court, for example, it was during the madness of Charles, after 1392, that this color began to be worn by the king's uncles and especially by his brother Louis d'Orléans, no doubt influenced by his wife, Valentine Visconti, who brought with her the customs of the Milan court. The same phenomenon reached England in the last years of the reign of Richard II (1377–99), son-in-law of Charles VI; in his court black is ubiquitous. Northern Italy launched the fashion of princely black; France and England passed it on thereafter to the entire European world, throughout the countries of the empire, Scandinavia, the Iberian Peninsula, and as far as Hungary and Poland.

However, the decisive stage came a few years later, in 1419–20, when a young prince named to become the most powerful in the West also adopted this new fashion and remained faithful to it throughout his life: Philip the Good, Duke of Burgundy (1396–1467).[40] All the chroniclers stressed Philip's fidelity to black and explained that in wearing this color, the duke dressed in mourning for his father, John the Fearless, assassinated by the Armagnacs on the bridge of Montereau in 1419.[41] That is not incorrect, but it can be noted that this same John the Fearless was long faithful to black, perhaps from as early as 1396 and the failure of his crusade against the Turks in Nicopolis.[42] Dynastic tradition, princely fashion, political events, and personal history seemed to converge to make Philip the Good a devotee of black, and his personal prestige ensured its definitive promotion throughout the West.

The fifteenth century was in effect the great century for curial black. Until the 1480s, there was not a royal or princely wardrobe in which this color was not abundantly present in woolen cloth, furs, and silks. It could be used alone, the clothing or article of clothing thus being monochrome, or, more frequently, combined with another color, generally white, gray, or purple. Moreover, the fashion did not come to an end when the last of the great dukes

of Burgundy of the house of Valois died in 1477, Charles the Rash, who, like his father, was very attached to black. Nor did it conclude with the end of the fifteenth century. The century that followed remained doubly faithful to that color; in addition to the royal and princely black, a style that lasted well into the modern era, a moral black persisted and thrived, the black of religious figures and the long-robed professions. The Protestant Reformation saw this second black as the most dignified and virtuous of colors, as we will see further on.

Let us note here that princely black, originating toward the end of the fourteenth century, was still very much present in sixteenth- and even early seventeenth-century courts. Henceforth it was the Hapsburgs of Austria and Spain who, as fitting heirs of the Burgundy dukes, became the champions of black. Mary of Burgundy (1457–82), daughter of Charles the Rash, brought not only incomparable political power to her husband Maximilian of Hapsburg (1459–1519), backed by a vast network of territories, but also court etiquette and clothing styles that became those of the Spanish court within a few decades. By the 1520s, that court imposed its codes and customs upon the whole of Europe; until the mid-seventeenth century the famous "Spanish etiquette" triumphed everywhere. Black was part of this, as it had been part of the Burgundy protocol in the preceding century, all the more so because the emperor Charles V (1500–58), grandson of Mary and Maximilian, demonstrated a personal taste for this color in all areas. A man of great piety, he saw black as a majestic color worthy of his rank and power, but also a virtuous color, a symbol of humility and temperance. In the image of his ancestor Philip the Good, he remained faithful to it throughout his life, as stories, chronicles, the testimony of contemporaries, and nearly all surviving portraits make clear.

His son Philip II (1527–98), king of Spain at the height of its power, displayed the same taste for black. Perhaps even more than his father he seemed taken with the ethical dimension of the color. As a profoundly mystical man who liked to think of himself as Solomon's heir and defender of the faith, black was for him the symbol of all Christian virtues. In Spain the "golden century" was a great century for black.

Raccoglie Sterco di cavallo Stimolato dal di avalo

The Style of Black in Florence

After Savonarola's theocratic dictatorship, which lasted four
years (1494–98) and imposed strict reforms on Florence,
especially with regard to dress, the style of black menswear
lasted a few more years. But the humble, austere black desired
by the Dominican tyrant gradually transformed into a
sumptuous black, reserved for the very rich.
History of Antonio di Giuseppe Rinaldeschi. Anonymous
Florentine painting, c. 1500–1501. Florence, Musée Stibbert.

An Elegant Young Man (opposite page)

In Italy at the beginning of the sixteenth century, a wellborn
young man had to have his portrait done in black; black was
then the fashion. Although we do not know the identity of the
man in this portrait, painted by Lorenzo Lotto in 1508, we must
admit that this color confers upon the model a serious,
mysterious, captivating, and almost romantic air.
Lorenzo Lotto, *Portrait of a Young Man before a White Curtain*,
1508. Vienna, Kunsthistorischesmuseum.

THE GRAY OF HOPE

The Chamber of Images

At the end of the Middle Ages, the technique of grisaille allowed an image to be introduced within another image and thus to avoid the confusion of two iconographical planes. That was the process the illuminator used here to depict King Arthur discovering a room where Lancelot remained imprisoned for some time and where the latter had drawn pictures on the wall that told of his mutual love for Queen Guinevere. Miniature from a manuscript of *Lancelot en prose*, illuminated by Évrard d'Espinques, c. 1470. Paris, Bibliothèque Nationale de France, ms. fr. 116, fol. 688v.

The great rage for black in the princely courts in the late Middle Ages and the early modern period increased the popularity of two other colors akin to it on the tinctorial and symbolic planes. If browns remained absent from the curial and patrician worlds, relegated to peasants and the most humble artisans for several centuries still, that was not the case for gray and purple. Rare in European clothing before the fifteenth century, purple was essentially a liturgical color until that time, a substitute for black in times of affliction and penitence. As is clear from its Latin name (*subniger*), it was a kind of "sub-black," not obtained by mixing blue and red as it is today, but by mixing blue and black, or rather by the successive action on the fabric of dyeing in a bath of blue and then in a bath of black. The 1400s marked about the end of this traditional purple, at least in the world of dyeing. A new purple developed, or rather new purples that tended especially toward red henceforth. The lightest and most luminous were obtained beginning with a colorant material newly imported from Ceylon, Java, and the tropical Indies: brazilwood (*brasileum*), which also served to produce very beautiful pinks and even certain orange tones.[43] The darker and more solid purples were produced differently, not with brazilwood but by immersing the cloth into a bath of woad and then a bath of madder. To do this the dyers working in red began to break the rules according to which their profession had been organized for many centuries; in their workshops they hid vats of woad, which they used for giving undyed fabrics a solid blue "foot." By then immersing this blue cloth in a vat of yellow (weld, broom) they obtained very solid greens, and by immersing it in a vat of red (madder, orchil), dark purples. The princely world was captivated by these new purples, more red than blue henceforth; they recalled the ancient purples and no longer seemed at all related to the traditional symbolism of the color, which had long been negative: sadness, renunciation, bad omens, and even treason (purple passes for having been the color of Ganelon, the traitor in the *Song of Roland*). The new purple and crimson tones would remain the fashion in court circles until the first half of the seventeenth century.

But let us return to the fifteenth century. Even more than purple, it was gray that benefited from the immoderate popularity of black tones at that time. For the first time in the history of

Western clothing, that color, relegated until then to work clothes, the poor, and the habits of Franciscan monks—which were meant to be colorless but were characterized by the laity as "gray"—captivated princes and poets. In two generations the dyers succeeded in making gray a clear, uniform, even luminous color, which they had been trying to achieve for centuries, even millennia. To obtain these new gray tones they used a different mordant with the baths of birch and alder, adding iron sulfates and sometimes a little oak apple. The grays tended to darken but they became more uniform, solid, and brilliant. By the 1420s and 1430s, a few cloth makers in some towns (Rouen and Louviers, for example) specialized in the production of high-quality gray cloth, so great was the demand from princes and nobles. That would have been unthinkable a century earlier. In France gray became so highly esteemed that many princes of royal blood made it one of the colors of their livery, combining it with red (Jean de France, duc de Berry), black (Philip the Good, at the end of his life), white (King Charles VIII), and even black and white (René d'Anjou).[44] The white-gray-black triad was considered the most captivating, as proclaimed the treatise of colors attributed to the Sicilian herald, who died in 1435, leaving the last part to be written by an anonymous author in the 1480s and 1490s. Speaking of livery and "the beauty of colors with one another," that author wrote:

Blue with green and green with red are very common livery, but are hardly beautiful. And the three together only signify moderate joy. But black with white is beautiful livery. But more beautiful still is black with gray. And the three together is more beautiful still, and signifies well-tempered hope.[45]

Indeed many authors made gray the opposite of black. As black was sometimes the sign of mourning or despair, gray became the symbol of hope and joy, as often repeated in the songs of Charles d'Orléans, prince and poet "of the heart clothed in black."[46] Taken prisoner at the battle of Agincourt (1415), he remained in England for twenty-five years and despaired of seeing his "sweet country of France" again; but wearing gray clothing allowed him to remain hopeful:

He lives in good hope,
Since he is dressed in gray,
That he will have, at his will,
Again his desire.

How long he is far from France
On this side of Mount Senis,
He lives in good hope
Since he is dressed in gray.[47]

In another poem, this same Charles d'Orléans invites all those in France who believe him dead not to dress in black, the color of mourning, but in gray, the color of life and hope:

Let no one wear black for me,
Gray cloth sells for less,
Now take it up, each of you, for all to see,
That the mouse still lives.[48]

Young Woman

In the fifteenth century, the new fashion in gray tones did not affect only men's clothes. Elegant women adopted it as well, and like the men, combined these new shades of gray with blacks and whites, a choice both aesthetic and ethical, as these three colors had begun to be considered more virtuous than the others. Rogier Van der Weyden, *Portrait of a Young Woman*, c. 1445. Berlin, Gemäldegalerie.

For French lyric poetry in the fifteenth century, the gray of hope was not only contrasted to black but also to "tan" (a shade considered particularly ugly, an intermediary between brown and red) and sometimes to "lost green" (dark green); these were the three colors of sorrow and death. Let us cite Charles d'Orléans one last time:

> Black and tan are my colors,
> Gray I no longer wish to wear,
> Because I cannot bear
> My very great sorrows.[49]

This positive symbolism for the color gray did not only apply to clothing. It was also found in textile arts and some utilitarian objects. Pewter ware, for example, little valued until that time, became the sign of high rank in the fifteenth century and witnessed a considerable price increase. Its gray or grayish color seemed to liken it to silver and made pewter a precious metal. It was not until about the 1440s that horses with gray coats were the most sought-after mounts for jousts and tournaments, whereas before that time gray or dappled horses were not considered noble.[50] Everywhere gray became "valuable," paired with black, white, red, or even gold. However, this trend lasted only a few decades. It diminished at the turn of the century and died out in the 1530s. For many centuries gray became or returned to being a subdued color, one of sadness and old age. Not until the Romantic period would it return to the forefront of the social and symbolic scene.

Gray Opposed to Black

In the fifteenth century, gray experienced an astonishing promotion. Not only did it make its entry into the wardrobes of kings and princes, but symbolically it became the color of hope. Considered the opposite of black, gray took over a share of the virtues and feelings that contrasted with everything black embodied. Whereas black was a sign of affliction or despair, gray now became the symbol of hope and joy. Many poets, like the anonymous author of the *Dialogue entre le gris et le noir*, sang of this opposition between gray and black, conversing here in the forms of allegorical figures.

Miniatures accompanying the manuscript of an anonymous poem entitled *Dialogue entre le gris et le noir*, c. 1440. Paris, Bibliothèque Nationale de France, ms. fr. 25421, fols. 8v and 12.

Ie loue dieu auſſy amoure
Du grant ſcours
Quilz mont preſente en ceſte heure
Car par leffait de mes laboure
Iay en ces ſoure

O̅ q̅ dura premit miseros condicio vite. Nec mors humano subiacet arbitrio

Vado mori: mortem non hoc
non impedit illud, Quomecūq̄
ferat sors data: vado mori.

Vado mori presens transact
equiparando. Si non transi
transeo vado mori.

Le mort

Vous faitez lesbay se semble
Cardinal: sus legierement
Suiuons les autres tous emsēble
Rien ny vault ebaissement.
Vous auez vescu haultement:
Et en honneur a grant denis

Le mort

Venes noble roy couronne
Renomme de force et de proesse
Jadis fustez enuironne
De grant pōpez de grant noblesse:
Mais maintenāt toute hautesse
Lesseres: vous neste pas seul.

THE BIRTH
OF THE WORLD
IN BLACK AND WHITE

SIXTEENTH TO EIGHTEENTH CENTURIES

Beginning in the late fifteenth century black entered a new phase of its history. Like white, with which it was closely associated henceforth—previously that had not always been the case—it acquired a particular status within the chromatic order that gradually led to its no longer being considered a true color. The sixteenth and seventeenth centuries gradually witnessed the establishment of a kind of black-and-white world, first located on the margins of the color universe, then outside it, and even its exact opposite. This slow and gradual transformation—extending over two centuries—began with the appearance of printing in the 1450s and reached its height symbolically in 1665–66 when Isaac Newton carried out his prism experiments and discovered a new order of colors: the spectrum, which was not, of course, accepted immediately by everyone and in all domains, but which would remain to the present day the basic scientific order for classifying, measuring, studying, and monitoring colors. Now in this new chromatic order there was no longer a place for black or for white.

There were many reasons for these profound changes. The social and religious moral codes of the late Middle Ages, which the Protestant Reformation inherited to a large extent, probably provided the first impetus. With the Renaissance, artists seemed to take up the charge and sought to "make color into black and white." Then in turn they passed the torch to the men of science who prepared the ground for Newton's discoveries. But the crucial turn occurred earlier, in the mid-fifteenth century, when printing made its appearance in Europe. More than the concerns of moralists, the creations of artists, or the research of scientists, it was the circulation of the printed book and engraved images that constituted the principal vector for these mutations and led to black and white becoming colors "apart." And even more than the book itself, it was undoubtedly the engraved and printed image—in black ink on white paper—that played the primary role. All or almost all medieval images were polychromatic. The great majority of images in the modern period, circulated in and outside of books, were black and white. This signified a cultural revolution of considerable scope not only in the domain of knowledge but also in the domain of sensibility.

INK AND PAPER

Danse Macabre (page 112)

Death is ubiquitous in the texts and images from the late Middle Ages. A powerful pessimistic current, to be inherited by the Protestant Reformation, ran through the whole of society. Men and women lived in the expectation of divine punishment. The theme of the *danse macabre*, depicted in wall paintings and woodcuts, emphasized the vanity of social distinctions and announced the shared destiny awaiting all humans.

Danse macabre (le roi et le cardinal). Woodcut in an anonymous collection of various texts on death, printed without a title, in Paris by Guyot Marchant in 1486. Paris, Bibliothèque Nationale de France, Rare Book Collections, YE-189.

In Old and Middle French there are numerous expressions attempting to convey through simple comparisons the degree of blackness of an object or a living being: "black as a crow," "black as pitch," "black as coal," "black as a blackberry," "black as ink."[1] With printing, this last expression took on symbolic value and seemed to be used more frequently than all the others; ink became the black product par excellence. This was no longer the ink of handwritten manuscripts, pale, uneven, laboriously traced on parchment and sometimes becoming more brown or beige than black over the course of time. It was a heavy, thick, very dark ink that a mechanical press made penetrate the fibers of the paper and that perfectly resisted the various vicissitudes to which books were subject. Any reader or inquisitive person who opens a printed work from the fifteenth century will be struck by the whiteness of the paper and the blackness of the ink more than five centuries later.

If this dense, uniform, quick-drying, long-lasting ink had not been perfected, printing would undoubtedly not have known the rapid success it enjoyed. Of course, ink was not the only factor contributing to that success. The manufacturing of movable metallic type made of an alloy of lead, tin, and antimony, the availability of a mechanical press (inspired perhaps by Rhenish wine presses), and widespread use of a paper medium permitting the uniform printing of recto and verso pages all represented decisive advances as well, in contrast to handwritten manuscripts and xylographic reproduction processes.[2] But the creation of a specialized ink did play an important role and made the world of printing into a world with close ties—material, technical, symbolic, and even dreamlike—to the color black. The printing shop from its origin and for a long time resembled an infernal cavern; not only did it "smell" like ink in every nook and cranny, but all the objects found there were totally permeated with it. Everything was black, dark, heavy, and more or less viscous. Everything except the paper, which, on the contrary, was an immaculate white before being printed and was carefully handled to keep it that way ("accidents" and waste were nonetheless common). The book gradually created a world imagined in particular colors; the black of the ink and the white of the paper combined harmoniously there and occupied the entire space, or nearly. That was why later books printed with

par la multitude du peuple bellicqueux qui est dedãs/ãl
ne se soucient point de faire aultres murailles.Et dauan
taige/qui la vouldroit emmurailler cõme Strasbourg o
Orleãs/il ne seroit possible/tãt les frays serotẽt excessif
Voire mais/dist Panurge/si faict il bon auoir quelque ſ
saige de pierre quand on est enuahy de ses ennemys/et ñ
feust ce que pour demãder/qui est la bas.Et au regard de
frays enozmes ã dictes estre necessaires si lon la voulo
murer/ Si messieurs de la ville me veullent dõner ãlqu
bon pot de vin/ie leur enseigneray vne maniere bien nou
uelle/cõment ilz les pourront bastir a bõ marche. Et c̃
ment,dist Pãtagruel.Ne le dictes donc pas/respõdit Pa
nurge/si te bo⁹ lenseigne . ~~Je voy que les callibistrys de~~
~~femmes de ce pays/sont a meilleur marche ã les pierres~~
Diceulx fauldroit bastir les murailles en les arrangẽ
en bonne symmetrye darchitecture/~~& mettãt les plus grã~~
~~au premiers rancz/et puis en talvãt a doz dasne arrang~~
~~les moyẽs & finablemẽt les petitz.~~Et puis faire vng bea
petit entrelardemẽt a poinctes de diamens cõme la grof
tour de Bourges/~~De tãt de bitz quon couppa en ceste vil~~
~~ces poutres Italiens a lentrée de la Reyne~~.Quel diab
desseroit vne telle muraille.Il ny a metal qui tãt resista
aux coups. Et puis ã les couilleurines se y vinssẽt frote
Vous en verriez par dieu incõtinent distiller de ce benol
fruict de grosse verolle menu cõme pluye. Sec au nom ã
diables.Dauãtaige la fouldze ne tõberoit iamais dessu
Car pourquoy,ilz sont tous benistz ou sacrez . Je ny vã
quũg inconuenient. Ho ho ha ha ha/dist Pantagruel. Æ
quel,Cest que les mousches en sont tant friandes ã me

inks of different colors and on colored paper would never resemble real books. In a real book everything had to be "written in black and white"!

The ink perfected by the first printers, maybe by Gutenberg himself during his stay in Strasbourg in the 1440s or perhaps by his assistant Peter Schoeffer (who quarreled with him and started his own print shop), was certainly the result of slow trial and error. But this ink was already used for the nearly thousand pages of the famous 42-Line Bible, rolling off the Gutenberg presses in Mayence in 1455. Forty-nine copies of it survive—which is a considerable number—and on the paper of each one of them the ink has left perfect impressions. Thus the recipe was already in place and the metallic types (290 of them have been counted) perfectly coated. Subsequently that ink would hardly evolve until the beginning of the nineteenth century. Nevertheless, it remains poorly understood because each workshop had its own recipes and secrets. Chemical analyses tend to show that it was quite similar to medieval inks meant for handwritten books: a black pigment derived from charred products (vine wood and charred ivory produced the most beautiful blacks), dispersed in liquid (water, wine), to which was added a binding agent (gum arabic, egg white, honey, casein, oil) as well as various substances meant to stabilize the mixture obtained to make it adhere to the medium and to dry it. All the same, medieval inks meant for handwritten manuscripts remained suspensions, hardly washes; they penetrated the fibers of the medium poorly and prompted no chemical reaction with it. Not only did they fade, but, sometimes, notably on charters, simply scratching them was enough to erase them.[3] That was not at all the case with the first printing inks. The use of linseed oil as a medium rendered the ink heavy and viscous and made it adhere better to paper; the addition of iron or copper sulfate gave it a brilliant black appearance, and the addition of metallic salts facilitated its drying. Moreover, a chemical reaction took place between the ink and the paper that made any erasure impossible; this explains the great stability of ink in printed books.

Recourse to linseed oil, which was routinely used by painters by the mid-fifteenth century, constituted the crucial advance. It rendered the first printing inks extremely heavy and messy and helped to transform printers into creatures of the devil.

Black, dirty, foul-smelling, constantly rushed and agitated, often rebellious, they seemed, like the dyers and the coalmen, to come from the infernal abyss. In cities where printing was done, people feared and fled them and their workshops were banned from the city center and fine neighborhoods. Moreover, more cultivated and rebellious than others, bookmakers, in the eyes of the authorities, became a particularly dangerous class for several centuries.

Nevertheless, in the print shops all was not black. Paper introduced an element of white and, like ink, helped to create the black-and-white universe of the book. Appearing in China at the first century A.D., perhaps even a bit earlier, paper was imported to the West by the Arabs. It was found in Spain by the end of the eleventh century and in Sicily by the beginning of the twelfth century. Two centuries later it was in common use in Italy for certain notarial deeds and for most private letters, after which it made its appearance in France, England, and Germany. In the mid-fifteenth century it was present throughout Europe and for several decades already had been competing with parchment for use in some handwritten books. Numerous paper mills sprang up, particularly in cities with fairs; gradually the West ceased importing paper and began exporting it. The primary material, rags, came from various remnants of hemp and linen cloth, especially cloth that had been used for chemises, the only "underclothes" worn by both men and women and which had come into general use beginning in the thirteenth century. The textile industry made these shirts in very large numbers; their contributions to the scrap heap kept the paper industry well supplied. Nevertheless, paper remained an expensive product and would continue to be costly until the eighteenth century. Papermakers were rich men, and very often they funded the first printers. From the beginning, printing a book was primarily a moneymaking venture.[4]

The very first paper used in Europe for archival documents, written missives, academic writing, and later for woodcut images, was not really white. It verged on yellow, beige, or ecru, and tended to darken over time. With printing, which consumed enormous amounts of paper, it became less thick and grainy, better cohered, and especially lighter and more stable. Though we do not know the reasons or the means, paper rapidly

progressed from beige to off-white and then from off-white to true white. In the medieval handwritten book the ink was never completely black nor the parchment white. With the printed book, henceforth the reader's eyes beheld very black ink fixed on very white paper. That was a revolutionary change that would lead to profound transformations in the domain of color sensibility. Moreover it did not involve only books, but also and most importantly, images.

The Gutenberg Bible

Gutenberg's 42-Line Bible was the first book printed in Europe with the help of movable type. Most of the eighty surviving copies were decorated with ornamented or filigreed letters like those of contemporary manuscripts. In fact, until the first decades of the sixteenth century, color was still often present in printed books (typography, trademarks, imprints, decoration, and emblems). That would later become less common. Gutenberg 42-Line Bible, a page from the Prologue. Mayence, 1455. Bibliothèque Nationale de France, Rare Book Collections, Vélins 67.

COLOR IN BLACK AND WHITE

Historians can never emphasize enough the significance of the event that the diffusion of engraved and printed images represents in the history of Western culture. With regard to color it marked a crucial turning point; within a few decades, between the mid-fifteenth and early sixteenth centuries, the vast majority of circulated images, both in and outside of books, had become black and white. All medieval images, or almost all, were polychromatic; the majority of modern images were in black and white henceforth. It was very much a matter of a revolution, which would gradually alter the perception of colors and lead to a revision of most scientific theories related to color. To the medieval eye, in effect, black and white were full-fledged colors. Beginning in the late fifteenth century, and even more so by the mid-sixteenth century, that would no longer be the case; black and white began to be regarded not only as special colors, but even as noncolors, which Newton would finally confirm "scientifically" in the second half of the seventeenth century.[5] Let us look at this phenomenon more closely and let us pause to examine the issues posed by the engraved and printed image. That is where the most significant changes take place.

For images, the transition from polychromy to only black ink on white paper did not happen suddenly, neither with the invention of xylography in the second half of the fourteenth century nor with the appearance of the first woodcut engravings in printed books beginning in the 1460s.[6] For a long time after that washes or colors were still applied to such woodcuts to make them look like the illuminations in handwritten books, at least until the 1520s to 1530s. However, many questions remain to be answered regarding the presence of color in woodcuts. Where and when was it added? In the print shop or outside of it? Right off the press, or a few weeks later, or even several years later? Was it the book's owner who added the color? Was it the bookseller himself? Were all woodcuts meant to be colored from the first? If so, by whom? In some workshops, were there artisans who chose the pigments, devised the colors, and arranged their distribution in the images? Did a general rule of grammar exist for color? Or, rather, did it exist only within the practices of the workshop? And just as many questions have not yet even been posed.

Each book and each woodcut is a separate case. For some, the color seems to have been applied in a careless, arbitrary

Finito chela nympha cum comitate blandiſſima hebbe il ſuo beni
gno ſuaſo & multo acceptiſſima recordatióe, che la mia acrocoma Polia
propera & máſuetiſſima leuatoſe cum gli ſui feſteuoli, & facetiſſimi ſimu
lachri, ouero ſembianti, & cum punicante gene, & rubéte buccule da ho
neſto & uenerâte rubore ſuffuſe aptauaſe di uolere per omni uia ſatiſſare
di natura prompta ad omni uirtute, & dare opera alla honeſta petitionẽ.

The Dream of Poliphile

Very early, German and Italian wood engravers achieved remarkable virtuosity. The 172 anonymous woodcuts that accompany the first edition of the allegorical story by Francesco Colonna, *Hyperotomachia Poliphili*, printed in Venice in 1499 on the presses of Alde Manuce, number among the most beautiful in the whole history of engraving. They did not attempt in the least to imitate manuscript miniatures and were not conceived to be colored.
Woodcut from the first edition of the book by Francesco Colonna, *Hyperotomachia Poliphili* (Venice: Alde Manuce, 1499). Private collection.

manner; it ran outside the lines and did little to distinguish the figures, areas, and planes of the image. In other, less numerous woodcuts the color was applied more carefully and seems to respond to specific syntactic or iconographic intentions. We can observe, for example, that certain colors recurred consistently to color certain figures, not only in the same book but in all the books coming out of the same workshop.[7] Unfortunately, in almost every case, we are unable to tell today—at least not by laboratory analysis of the inks and pigments—if the colors were contemporary with the impressions of the wood or if they were added later, sometimes much later, in the nineteenth or twentieth century. For a long time colored woodcuts had more market value than uncolored ones, which explains the later addition of color and all kinds of fraud, which eventually led to the reverse relationship between the value of colored and uncolored engravings. Today collectors are more interested in the second than in the first, and that is even more true for prints and geography maps than for illustrated books.

For the historian of color, too, uncolored woodcuts are almost more valuable than colored ones, not for their market value but for their documentary value. Indeed, color is not just coloration; it is also light, brilliance, density, texture, contrast, and rhythm, all things that an image printed in black ink on white paper can convey perfectly well. From the outset engravers endeavored to do this, with more or less success according to their skill or the ambitions of the iconographic agenda with which they were working. They experimented not only with the quality of the inks and paper, but also and especially with lines, axes, contours, and the use of various hachures to create chromatic effects, notably effects of value and saturation. Black lines that defined figures, for example, could be thin or thick, straight, curved, or broken, continuous or discontinuous, single, double, or triple, drawn out or compressed. They could be horizontal, vertical, or oblique, parallel or perpendicular, crossed at various angles, overlapping, tangential to other lines, in the form of bunches or bundles. They could also be combined with patterns of dots or strokes to fill a surface, distinguish an area, contrast two planes, produce the effect of shadow or monochrome, create stasis or movement. Those dots or strokes could themselves be thin or thick, far apart or close together, regular or irregular, uniform or alternating. All

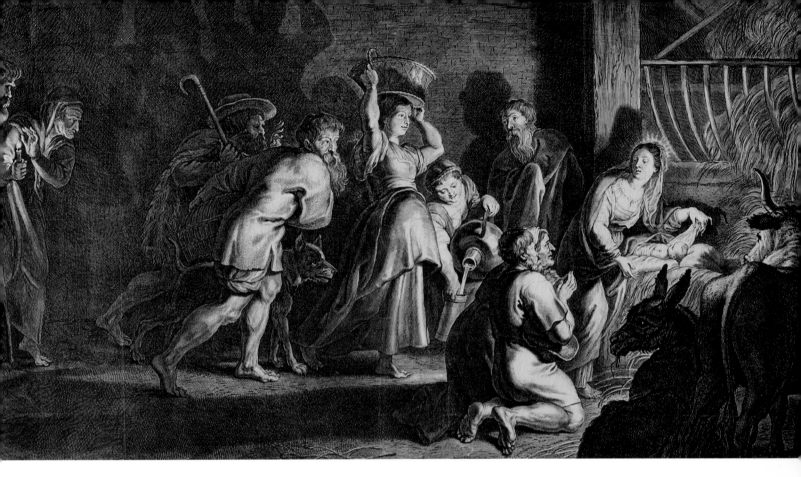

of this, traditionally within the realm of color, could henceforth be conveyed solely by black on white, and all the more so as over the course of the decades engravers became more and more inventive in expressing by this play of line, stroke, and dot not only what the chromatic syntax of the image would be if it were colored, but also actual pictorial effects. By the late fourteenth or early fifteenth century they knew how to make color in black and white by engraving wood or copper. Line engraving allowed for the play of even finer networks and dots and thus for more subtle and nuanced "chromatic" effects.

Historians of engraving take little interest in these questions, but the painters of the sixteenth and seventeenth centuries were very attentive to them.[8] They often asked the engravers who worked for them and who reproduced their paintings with knife or chisel to "truly respect the colors." With a painter like Rubens, a great colorist, such recommendations recur in the instructions he gave to various engravers who worked for him and made his paintings known throughout Europe. His correspondence with

Lucas Vorsterman (1595–1675), for example, is full of demands involving the faithful rendering of colors, a rendering in black and white.[9] The two men were in frequent conflict about this subject. Rubens reproached his engraver—one of the most skillful of his time—for badly translating this or that color, this or that effect of coloration, this or that pictorial method. Vorsterman, conscious of his art and sure of his craft, protested, grumbled, and argued. Sometimes he quarreled with the painter; sometimes, on the other hand, he produced, corrected, or reworked his "colors" according to the master's wishes.[10] At the beginning of the seventeenth century in Anvers and throughout Holland it was perfectly possible to make color out of black and white.

HACHURES AND GUILLOCHURES

Nevertheless, no matter how virtuosic the engraver, an image in black and white cannot assume all the functions of color. That presents insolvable problems for many fields of knowledge that depend upon color: cartography, botany, zoology, and heraldry, for example. The images they use are documentary, pedagogical, and even taxonomic; color plays an essential role in them for conveying information and classifications. Hence the problem of what to do when color is absent or rather, when it is reduced to simply black and white.

Let us examine the case of heraldry because that is the most crucial one. Indeed, the coat of arms is first of all a grammar of color. It cannot do without it; if the image does not make known the colors of the coats of arms it presents, the information is not only incomplete but also distorted, and the risks of misreading or confusion are very great. That explains the various attempts made by engravers and printers between the late fifteenth and early sixteenth centuries trying to translate the colors of coats of arms by means of conventional letters, typographic symbols, and small ornamental figures. Some procedures were directly inherited from the practices of handwritten books. That was why lowercase letters were used as initials for the names of colors employed in a particular scriptorium or workshop.[11] In the era of printing these terms were no longer Latin but vernacular, and thus they varied from one language to another; there were many errors or inversions. The same letter could be used, depending on the language, for two or three different heraldic colors: *g*, for example, generally designated gold (*gold*) in German-speaking countries, but red (*gueules*) in France and England; moreover, certain Swiss workshops also used it to designate the color green (*grün*).

Engraving on wood in its early stages sought to circumvent these difficulties by playing on the opposition between upper- and lowercase, or even by using not just the first initial but the first two letters for certain terms, but there were still many mistakes. In Germanic countries sometimes the idea arose of replacing the letters with small figures: stars, coins, fleurs-de-lis, roses, holly leaves, and so on, each referring to a color; or of using the conventional signs of the stars and planets, since the treatises on heraldry sometimes established correspondences between the stars and colors.[12] These different codes employed

throughout the sixteenth century did not prove to be much more effective than using letters. Despite their inadequacies, letters remained the most frequently used symbols until the end of the sixteenth century.

Beginning from that time, for works in which heraldry was the main subject and for those in which coats of arms appeared abundantly (works of history and genealogy, for example), engravers and printers began to resort to other procedures constructed around dot motifs and guilloche or hachure patterns. This was first done sporadically and then in a more systematic manner in the first decades of the seventeenth century. Dots and hachures had the advantage over letters of always appearing within the figures for which they indicated the color. In the cases of very small or complex images this clearly marked progress. The first examples of this new system for coding colors appeared on geography maps, large images full of signs, figures, and texts of all kinds. They were from Antwerp and date from the very end of the sixteenth century.[13] Nevertheless, such patterns were only used for coats of arms—present in great numbers on maps—not yet for actual geographic or cartographic elements.[14]

In the first decades of the following century this practice extended to books and prints. But it was still rare for a coherent system to be used throughout an entire work. Moreover, for a long time no system of hachures managed to escape the confines of one workshop or city to establish itself on a larger scale.[15] In the end it was a system proposed in about the 1630s by an Italian heraldry enthusiast, the Jesuit priest Silvestro Pietra Santa, that was adopted by other authors and then by engravers and printers throughout Europe. In his work *Tesserae gentilitiae*, a voluminous treatise on heraldry, printed and published in Rome in 1638, Father Pietra Santa boasts, in fact, of being the inventor of an ingenious system for coding colors.[16] Parallel vertical lines represented red (*gueules*); horizontal lines represented blue (*azur*); oblique lines descending from left to right, green (*sinople*); vertical and horizontal lines crossing perpendicularly, black (*sable*).[17] Finally, a pattern of small dots represented yellow (*or*), and the white surface of the paper left blank, white (*argent*). It was a simple, readable, effective system, if inelegant. Was Father Pietra Santa truly its author? Nothing could be less certain. The system he claimed to invent already appeared on many maps and works produced in Antwerp workshops between 1595 and 1625.[18] It seems likely that credit for this invention belongs to the Flemish engravers of the 1600s and not to the Italian Jesuit priest.

France was the European country where this new system of hachures was first used: in the royal print shop as early as the 1650s to 1660s.[19] In England and the United Provinces it would have to wait until the end of the century; in Germany, Italy, and Spain until the beginning of the next century. But from then on it was used continuously in books. Over the course of the eighteenth century it extended even to sculpture and certain metal arts, mainly silver workings, a misguided, even absurd development, since this system of coding originated in the engraving and printing media and had been conceived for paper and the graphic arts alone.[20]

THE COLOR WAR

The endlessly expanding distribution of printed books and engraved images no doubt constituted the major factor leading, between the end of the fifteenth century and the mid-seventeenth century, to black and white first becoming colors in a class of their own and then noncolors. But it was not the only factor. Religious and social moral codes also played an important role, notably the Protestant moral code, which was particularly attentive to chromatic issues. Originating in the early sixteenth century, at the moment when a "black and white" culture and sensibility were being generated by the book and image, Protestantism, from the outset, showed itself to be both heir to the moral color codes of the late Middle Ages and attuned to the value systems of its time. In all areas of religious and social life (worship, dress, art, domestic life, business) it recommended or established practices and codes almost entirely constructed around a black-gray-white axis. War was declared against colors that were too vivid or too showy.[21]

This Protestant chromoclasm involved the church first of all. For the great reformers the place of color was excessive there; it had to be diminished or eliminated. Like Saint Bernard in the twelfth century, Zwingli, Calvin, Melanchthon, and Luther himself denounced too richly painted sanctuaries.[22] In their sermons they repeated the biblical words of the prophet Jeremiah losing his temper with King Joachim and they railed against "those who construct temples like palaces, cutting windows in them, paneling the walls with cedar and painting them with vermilion."[23] Red—the most vivid color for the Bible and all medieval theology—was in their eyes the color that symbolized the height of luxury, sin, and "human folly."[24] Luther saw it as the color emblematic of papist Rome, scandalously decorated in red like the infamous Whore of Babylon.

Such were the general ideas of the great reformers. The precise chronology and geography of the expulsion of color from the churches is more difficult to study in detail. What part did violent destruction play and what part dissimulation or decoloration: stripped surfaces, monochromatic black hangings over paintings, whitewashing? It is difficult to say. Was a total absence of color the aim everywhere or was there more tolerance, less chromophobia in certain cases, in certain areas, at certain times (as among some Lutherans at the end of the

seventeenth century)? Moreover, exactly what is a total absence of color: white, gray, black, stripped surfaces?[25] Furthermore, in the case of destruction, it is difficult to distinguish chromoclasm from iconoclasm. Sculpted polychromy, for example, especially when it was a matter of statues of saints, certainly helped to transform such statues into idols in the eyes of the Protestants, but it was not solely responsible. Similarly, in the case of stained glass, widely destroyed, what was the target: the image, the color, the subject (anthropomorphic representations of divine beings, the life of the Virgin, saints' legends, clerical figures)? Here again it is difficult to answer precisely.

More drastic still was the Protestant attitude toward liturgical colors. In the ritual of the Mass color played an essential role; the objects and vestments were not only coded by the calendric color system, but they were also closely associated with light, architectural and sculpted polychromy, painted images in the holy books, and all precious ornamentation in order to create a veritable theater of color. Like the gestures and sounds, the colors were an essential element in the proper unfolding of the ritual. Waging a war against the Mass and this theatricality that made useless display of finery and riches, that "transformed the priests into players" (Melanchthon), the Reformation could only wage war against color as well, both for its physical presence in the churches and for its role in the liturgy. For Zwingli the superficial beauty of the rituals subverted the sincerity of the worship.[26] For Luther the church had to be purged of all human vanity. For Calstadt it had to be "as pure as a synagogue."[27] For Calvin its most beautiful ornament was the word of God. For them all it had to lead the faithful to godliness and so be simple, harmonious, and unadulterated, the purity of its appearance thus furthering the purity of souls. Consequently, there was no longer a place for the liturgical colors that appeared in the Roman Church, nor even for color playing any role at all in Protestant worship services.

A similar rejection of colors, or at least vivid colors, is found again in artistic creation, notably in painting. The palette of Protestant painters was not the same as the palette of Catholic painters; that is undeniable. In the sixteenth and seventeenth centuries it answered strongly to the discourse of the reformers on matters of artistic creation and aesthetic sensibility, a discourse that was sometimes tentative and changeable.[28] In Zurich, for example, Zwingli (1484–1531) seemed less hostile to the beauty of colors at the end of his life than during the years 1523–25. It is true, as with Luther, that music preoccupied him more than painting.[29] It is undoubtedly with Calvin that we find the greatest number of considerations or consistent dictates regarding art and color. They were scattered throughout many of his works. Let us try to summarize them without misrepresenting them too badly.

Calvin did not condemn the plastic arts, but they were to be exclusively secular and aim to instruct, to "delight" (in the theological sense), and to honor God, not by representing the Creator (which was an abomination), but Creation. Thus the artist was to shun artificial, gratuitous subjects, which invited intrigue or lasciviousness. Art had no value in itself; it came from God and was meant to further an understanding of him. By that same token, the painter was to use moderation in his work, to seek harmony of form and tone, to draw his inspiration from Creation, and to represent what he saw. For Calvin, the constituent elements of beauty were clarity, order, and perfection. The most beautiful colors were those of nature; he even seemed to prefer the blue tones of certain plants because they had "more grace."[30]

If it is not very difficult to draw a connection between these recommendations and the works of sixteenth- and seventeenth-century Calvinist painters with regard to their choice of subjects (portraits, landscapes, animals, still lifes), it is harder to do so with regard to color. Did a Calvinist palette truly exist? And, more generally, was there a Protestant palette? For my part, I believe so. The Protestant painters' palette seems to me to possess something dominant and recurring that gives them an authentic uniqueness: a general temperance, a horror of bright, busy colors, a predominance of black and dark tones, grisaille effects, the play of monochromes, an avoidance of all that offends the eye by altering the chromatic economy of the painting through disrupting the tonality. For many Calvinist painters, we can even speak of a true puritanism of color, these principles are applied so radically. That is the case with Rembrandt, for example, who often practices a kind of color asceticism, relying on dark tones, restrained and limited in number (to the point that he is sometimes accused of "monochromy"), to give precedence to

A Calvinist Church
Seventeenth-century Dutch painting often shows churches void of all image and color, as Calvin had dictated a century earlier: "The most beautiful ornament in the church must be the word of God."
Emmanuel de Witte, *Interior of a Church*, c. 1660. Private collection.

The Anatomy Lesson (following page spread) Rembrandt's famous painting was commissioned by the surgeons' guild of Amsterdam. In their emblematic black clothes, they conduct a public dissection of the corpse of a criminal executed that same day (January 16, 1632).
Rembrandt, *The Anatomy Lesson of Doctor Tulp*, 1632. The Hague, Mauritshuis.

the powerful effects of light and resonance. From this very particular palette emerges a strong musicality and an undeniable spiritual intensity.[31]

Protestant painters do not have a monopoly on this chromatic austerity, however. It can be observed as well among Catholic painters, principally in the seventeenth century among those involved in the Jansenist movement. Thus we can notice that Philippe de Champaigne's palette became more spare, stripped down, and also darker beginning from the time (1646) when he became associated with the Port-Royal abbey and then actually converted to Jansenism.[32] Over the long term, the various artistic moral codes for color in the West showed surprising continuity. Between twelfth-century Cistercian art and seventeenth-century Calvinist or Jansenist painting, by way of fourteenth- and fifteenth-century grisaille miniatures and the chromoclastic wave at the beginning of the Reformation, there was no rupture but, on the contrary, a continuous, unanimous discourse: color was makeup, luxury, artifice, illusion.

The artistic chromophobia of the Reformation was, in fact, hardly innovative; it was even somewhat reactionary. But it played a crucial role in the development of Western sensibility with regard to color. On the one hand, it helped to accentuate the opposition between the world of black and white and the world of colors; on the other, it provoked a chromophilic Catholic reaction and participated indirectly in the genesis of Baroque art. Indeed, for the Counter-Reformation, the church was an image of heaven on earth, a sort of celestial Jerusalem, and the dogma of the true presence justified all the magnificence within the sanctuary. Nothing was too beautiful for the house of God: marble, gold, precious fabrics and metals, glass, statues, frescoes, images, paintings, and resplendent colors; all things rejected by the Protestant churches. With Baroque art, the church again became the sanctuary of color it had been in the Cluniac liturgy and aesthetic of the Romanesque period.

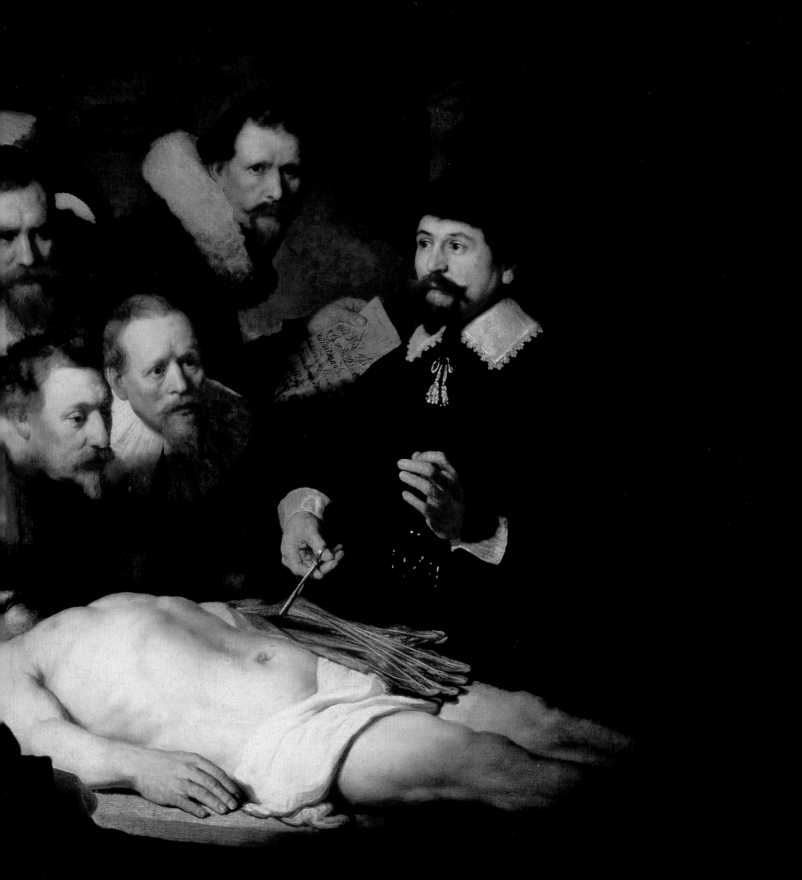

THE PROTESTANT DRESS CODE

Savonarola

Rigid moralist preacher and lugubrious prophet, the Dominican brother Girolamo Savonarola (1452–98) established a republic in Florence and for four years (1494–98) ruled as de facto dictator, passionately preaching moral reform, as the great Protestant reformers would subsequently: condemning luxury, holidays, and games, destroying books and works of art, dictating dark, severe clothing for everyone. Moretto da Brescia, *Portrait of Savonarola*, 1524. Verona, Museo di Castelvecchio.

More than through painting, however, it was undoubtedly through engravings and prints that the Reformation exerted its strongest influence over the changes in sensibility in the modern period. By relying upon the book, by using engravings and prints on a large scale for propaganda purposes, the Reformation contributed to the wide distribution of black-and-white images. In doing so, it actively participated in the profound cultural transformation that overturned the world of colors and—well before Newton—helped to give black and white a special status. And these changes involved not only art and images, but social customs as well.

Indeed it was in relation to dress that Protestant chromophobia exerted its greatest and most enduring influence. This was also one of the areas in which the precepts of the great reformers were most in agreement. On the relationships between color and art, images, the church, and the liturgy, they tended to agree in general, but they diverged on a good many points. On clothing that was not the case; the discourse was almost unanimous and the practices similar. The differences were only in nuance and degree, each denomination, each church, as always, having its moderates and its radicals.

For the Reformation clothing was always a sign of shame and sin. It was linked to the Fall, and one of its principal functions was to remind man of his depravity.[33] That was why it had to be a sign of humility and contrition, to be made dark, simple, subdued, and to be adapted to nature and activities. All Protestant moral codes had the deepest aversion to luxury in dress, makeup and finery, disguises, changing or eccentric fashions. For Zwingli and Calvin to adorn oneself was an impurity, to wear makeup an obscenity, and to disguise oneself an abomination.[34] For Melanchthon, excessive concern for the body and clothing placed humans below animals. For all of them luxury was corruption; the only ornament to be desired was the soul. Inner being had to constantly take precedence over outward appearance.

A consequence of these commandments was an extreme austerity in clothing and appearance: simplicity of forms, sobriety of color, suppression of accessories and artifices that could mask the truth. The great reformers set the example both in their everyday lives and in the painted or engraved representations

This Protestant palette differed little from the one prescribed by medieval dress codes during previous centuries. But with the Reformation it was very much the colors—by which we should understand the colorations—and the colors alone that were called into question, no longer the colorant materials. Certain colors were forbidden, while others were prescribed. The dress codes and sumptuary rules decreed by most Protestant authorities are very clear on this subject, as much in sixteenth-century Zurich and Geneva as in mid-seventeenth-century London and eighteenth-century Pennsylvania. Many Puritan or Pietist sects even increased the severity and uniformity of Reformation dress—the uniform, which the Anabaptists already advocated in Münster in 1535, already held a great attraction for Protestant sects—out of hatred for worldly vanities.[36] In doing so they helped to give Protestant dress in general an image not only dark and austere but also backward-looking, almost reactionary, hostile to fashions, novelty, and change.

Moreover, it is not necessary to evoke the most extreme puritanism to demonstrate how the use of dark clothing, advocated by all the great reformers, helped to prolong the great rage for black already sweeping fifteenth-century Europe. Indeed Protestant black and Catholic black seemed to converge (if not merge) to make black the most popular color in men's clothing in Europe between the fifteenth and nineteenth centuries; that was not at all the case in antiquity or for most of the Middle Ages. During those periods men could dress in red, green, yellow, in short, any light, bright color. Henceforth that was a thing of the past; except for a few exceptional circumstances—festive or transgressive rituals—men would never dress that way again. All good Christians, all good citizens, whether Protestant or Catholic, were obliged to wear dark-colored clothes on an everyday basis: blacks, grays, browns, and, later, navy blue. But black dominated and it had a dual nature. On the one hand, there was the black of kings and princes, luxurious black, originating in the Burgundy court in the period of Philip the Good and transmitted to the Spanish court with the rest of the Burgundian heritage; on the other, the black of monks and clerics, of humility and temperance, the black of all those movements as well that claimed, in one way or another, to rediscover the purity and simplicity of the primitive church. It was

they had made of themselves. All of them were portrayed in dark, sober, even sad clothing.

This quest for simplicity and severity was conveyed by a palette of dress from which all vivid colors, considered immodest, were absent: red and yellow primarily, but also pinks, oranges, most greens, and even purples. On the other hand, dark colors were used in abundance, in the first order of which were blacks, grays, and browns. White, the pure color, was recommended for children's and sometimes women's clothing. Blue was tolerated to the extent that it remained subdued. Any medley of colors, which clothed "men like peacocks"—this expression is used by Melanchthon in the famous sermon of 1527—was severely condemned.[35] As with the decoration of the church and the liturgy, here again the Reformation repeated its hatred for polychromy.

the black of Wycliffe and Savonarola; it was the black of the Protestant Reformation; it was also the black of the Counter-Reformation.

With regard to color, the Counter-Reformation clearly distinguished between the church and worship on the one hand, and the devout masses on the other: rich, profuse colors for the former; discretion and sobriety for the latter. If the Mass was a theater of colors, the good Catholic was not to display vivid hues, even if he was a king or prince. When Charles V dressed in black—and he did so almost his entire life—it was thus not always a matter of the same black. Sometimes it was the princely black, inherited from the magnificence of the Burgundy courts; sometimes, on the other hand, it was a humble, monastic black, inherited from all the medieval moral codes of color. It was this second black that connected him to Luther and showed that Catholic and Protestant ethics tended to converge to embrace Christians—all Christians—within the same chromatic value systems. In the mid-sixteenth century black held the highest position, and it would retain it for many long decades.

Martin Luther (opposite page)
The great Protestant reformers had a deep aversion to too bright or lively colors, which they considered unworthy of good Christians and virtuous citizens.
Lucas Cranach, the Elder, *Portrait of Martin Luther*, c. 1530. Florence, Galleria degli Uffizi.

Katherina Bora
For the Reformation, all clothing recalled original sin. Adam and Eve lived naked in paradise; they were expelled, and the clothes they received on that occasion were the sign of shame and punishment. By the same token, any clothing worn by a man or woman had to be dark, subdued, and austere. Black was the most suitable color.
Jorg Scheller, *Katherina Bora, Wife of Luther, in Widow's Attire*, colored woodcut, 1546. Gotha, Kupferstichkabinett Schlossmuseum.

A VERY SOMBER CENTURY

The seventeenth century was a great century for black, as much on the social as on the moral and symbolic planes. The European populations had probably never been so miserable. In the face of current barbaric behavior, archaic forms of intolerance, and appalling crimes and scourges, today's popular language sometimes employs the expression "You'd think we'd returned to the Middle Ages." That is in error, as historians well know; it would be more accurate to say "You'd think we'd returned to the seventeenth century." That century, the century of Louis XIV and Versailles, the century of arts and letters, was a dark and deathly one. Despite the life of the court and gallant festivities, despite artistic and literary creations, despite the progress of science and knowledge, intolerance was everywhere, despotism the rule, and poverty ubiquitous. Added to the miseries of war, religious conflicts, and burdensome taxes were climatic disturbances, economic and demographic crises, plagues and epidemics, and the return of fear and famine. Death was omnipresent. Not since the height of the Middle Ages had life expectancy been so short, never had men, women, and even animals been so small in stature, never had the crime rate been so high. The reverse side of the "Great Century" was dark, very dark.[37] In all domains black was its color.

Beginning with the religious domain, this century, so brilliant in one way and so frightening in another, was intensely religious. In Protestant Europe chromatic austerity continued to be the rule, perhaps even more so than in the preceding century. In Scandinavia and the United Provinces black clothing was almost a uniform, at least for men. The painters provide much evidence of this. In England in the middle of the century, under the dictatorship of Cromwell and the Roundheads (1649–60), it was even worse. Puritanism affected all aspects of political, religious, social, and practical life; everything became black, gray, and brown. But Catholic Europe was not to be outdone. If nothing was too beautiful for the house of God, if Baroque art made golds and polychromy resplendent, it was not the same for common mortals. As with the Protestants, the good Catholic had to be dressed in black, and, within his home and in his daily life he had to avoid vivid colors, makeup, and finery. Thus estate inventories all showed a predominance of dark clothes and fabrics from the late sixteenth century to the first decades of the

eighteenth century. In Paris, for example, about 1700, 33 percent of noble clothing—men's and women's alike—was black, 27 percent brown, 5 percent gray. Among officers the proportion of dark clothes was greater still: 44 percent was black, 13 percent gray, 10 percent brown. And for domestics, it was even higher: 29 percent black, 23 percent brown, 20 percent gray.[38]

Moreover, in the public sphere as in the private sphere, the clergy proved to be intrusive and tended to find error or sin everywhere. It was necessary to confess, to mortify oneself, and to dress in black as a sign of penitence. That was what Jesuits and Jansenists alike recommended; divided by their quarrels over dogma and discipline, they agreed at least on one point, the color of clothing. In his short worldly period in the early 1660s, Racine recounted with humor how he had scandalized the "Messieurs of Port-Royal"—his patrons and spiritual family— by appearing in a very dark green suit; in their eyes only black was acceptable.[39] Moreover, black was the color that the newly created orders also recommended. In the seventeenth century these were numerous and they all set the example of choosing black, gray, or brown clothes, sometimes two-toned, but always dark. Only the monks continued to show a certain fidelity to white.

But clothes were not the only thing that became darker; so did the home, especially in the first half of the century. For the rich window glass became thicker and was covered with patterns or decorations that let through less light. Smaller rooms, dark closets, and secret nooks multiplied; one hid, spied, and plotted in the dark. At the same time the style in furniture was for heavy, voluminous pieces, most often in walnut, a noble but dark wood that diminished the space and darkened the atmosphere. Among the poor, poverty persisted, filth accentuated it (in London, doing laundry was twice as expensive in 1660 as it had been in 1550), and lighting remained an almost inaccessible luxury.[40] In certain cities industrial pollution made its appearance and added to the traditional pollutants of medieval cities. Life remained dirty, gray, and sad, and the burin engravings we have offer much evidence of this, expressing the miserable aspects of life through increasingly dark, thick, dense marks. The image itself was growing very dark as well.

Death itself arrived on the scene with a vengeance, not only in the morbid works of painters and engravers but also on the streets and in the home. This was the beginning of widespread mourning practices that involved drapery and dress. Of course such customs had existed prior to this time, but they were reserved for the most privileged classes and primarily involved southern Europe. Moreover, black had not always been the only color used to drape homes and dress those close to the deceased; gray, dark blue, and especially purple appeared beside or instead of black in earlier funeral practices. Certain sovereigns even wore bright colors for the occasion: thus the kings of France for a long time dressed in red for mourning, and later in crimson or purple, and the queens in white. For a long time a few great lords within the realm and in neighboring countries did the same. Beginning in the seventeenth century that came to an end; black definitively became the color of mourning. Practices until then limited to Spain, France, and Italy expanded to the north and henceforth affected all of western Europe, not only the aristocracy but also the patricians and part of the middle class.[41] Increasingly codified customs were put into place: the articles of clothing involved, the dimensions of the cloths, paintings, or hangings for the home and furnishings, the length of the mourning period, with a calendar that sometimes shifted from black to purple (half-mourning) and then to light gray (quarter-mourning). But it would not be until the nineteenth century that such color coding really entered into mourning practices. Before that time it appeared primarily in compendia of customs, etiquette books, and tracts on (good) manners.[42] Death itself remained black.

THE RETURN OF THE DEVIL

Blackness found expression in other domains as well, for example in the area of beliefs and superstitions, where the devil and his creatures, subdued for several decades, made a disturbing return in the second half of the sixteenth century. The period of 1550–1660 saw matters of witchcraft multiply and the battle against all supposedly heretical or demonic behavior intensify. Here again it would be a mistake to believe that witchcraft trials belonged only to the medieval world and its supposed "darkness." No, these trials, originating in the late Middle Ages, were much more prevalent in the sixteenth and seventeenth centuries. In spreading a pessimistic view of human existence the Protestant Reformation furthered popular beliefs in supernatural forces and the possibility of becoming allied with them to better profit from life, to acquire certain gifts (clairvoyance, the evil eye), cast spells, make potions, kill livestock, ruin harvests, burn houses, and thus harm one's enemies. Beginning in the 1550s the printed book did the rest by allowing for widespread distribution of collections of spells as well as demonology tracts. These were all bookstore successes, and sometimes enlightened minds wrote them. That was the case with Jean Bodin (1529–96), philosopher, jurist, and author of remarkably modern works on law, economy, and political science. In 1580, he published a book entitled *De la démonomanie des sorciers*, in which he affirmed the existence of malefic powers, gave credence to pacts with demons, described witches in detail, listed fifteen categories of crimes committed by them (including the sacrifice of children, cannibalism, and copulation with the devil), and recommended torture and execution to eradicate such scourges.[43] His book, which went through many printings, was copied by many other authors well into the seventeenth century. Everywhere witchcraft trials multiplied, especially for women, accused of sexual union with Satan or his creatures. Witchcraft became the domain of women, demonic possession resurfaced, the sabbat reappeared on the scene, and witch hunts occurred on an unprecedented scale, especially in Germany, France, and England. Protestants often proved themselves to be more ferocious and intolerant than Catholics.[44]

These witch hunts had one color: black. In the trial records, in the detailed accounts of satanic rituals, in the various chapters

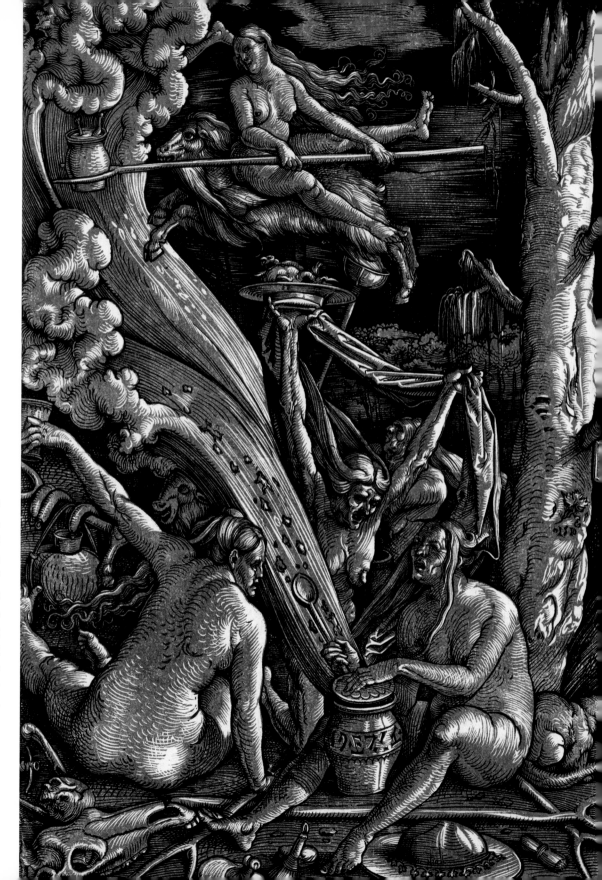

Witches

Inconspicuous for many decades, witches made their reappearance at the end of the Middle Ages and then became pervasive at the beginning of the modern period. Their ubiquitous presence was largely linked to the wide distribution of engravings and printed books. Engraving could represent their world much better than medieval illumination, a world of night and the sabbat, entirely cast in the color black.
Hans Baldung Grien, *Les Sorcières*, burin engraving, c. 1525. Paris, Musée du Louvre, Rothschild collection, Inv. 784 L.R.

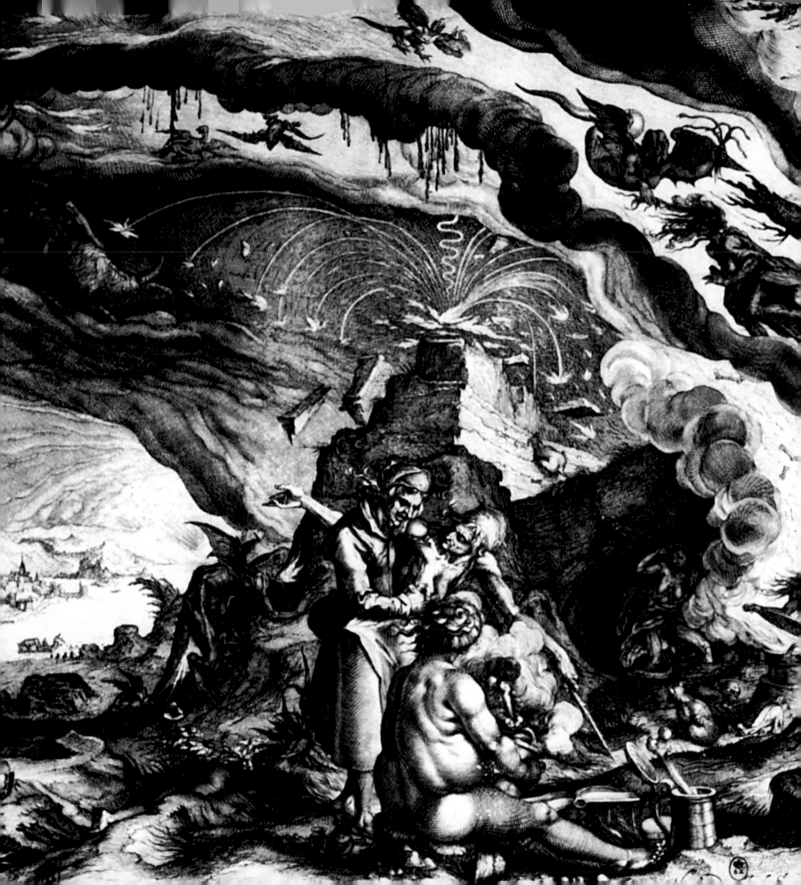

of demonology tracts and exorcism manuals, this color constantly recurred. Let us take the example of the sabbat, which seemed to obsess all of Europe in the 1660s. It took place at night, in the darkness, near ruins or in the heart of the forest, sometimes in particularly dark, underground places. The participants went there in dark clothes, covered in soot (to go to the sabbat, some of them had to climb through chimneys), clothes that they removed to take part in the black mass, banquets, sacrifices, and orgies. The devil himself appeared in the form of a large black animal, horrible and base, horned, hairy, or clawed. It was often a goat, sometimes a dog, wolf, bear, deer, or rooster. A whole entourage of black furred or feathered animals accompanied him: cats, dogs, crows, owls, bats, basilisks, scorpions, serpents, dragons, hybrids and monsters, more rarely horses, donkeys, pigs, foxes, hens, rats, vermin, and insects. Over the course of the "black" mass—practically and symbolically, it was one—said in reverse and with blasphemous, sacrilegious power, various objects of this color were manipulated or exchanged. The host, or at least what substituted for it (often a root like rape or turnip), was also black or became so, as did the blood of the sacrificed children; there were many blasphemous formulas to make them change color. After the mass and orgies the "prince of darkness" and his attendant demons practiced all sorts of black magic in order to instruct their henchmen and harm the just and innocent.[45]

From the sabbat and belief in the devil undoubtedly came the fear of black animals, very widespread in European countries: wild cats and other wild animals, crows, ravens, and birds of prey, but also simple domestic animals like dogs, cats, roosters, hens, and even cows, goats, and rams. Being black, they all brought misfortune, especially if they were encountered along the road or seen in an unexpected or unusual manner. Crossing the path of a black cat early in the morning was a very bad sign; it was best to return to bed. Seeing crows fighting in the sky foretold great evil. The same was true when a black rooster began to crow in an untimely way. As for eating eggs laid by a black hen, that was taking a mortal risk; such eggs had to be destroyed, and likewise all black chicks.[46] Of course such fears and superstitions went far back to the Middle Ages or even earlier, but at the beginning of the modern period, when

insecurity became widespread, they seemed to be accentuated. Many proverbs, adages, and expressions that encouraged distrust of black furred or feathered animals date from this period. They testify to beliefs and behaviors very pervasive throughout all of modern Europe and show clearly the extent to which the color black was then perceived by the great majority as disturbing, negative, and evil.[47]

The color black was not only present in the sabbat and the world of darkness and night. It also pervaded the world of law. Prisons, dungeons, trials, inquisitions, torture: the legal system loved black and flaunted it to make an impression, dramatize rituals, emphasize judgments, and intensify punishments. In witchcraft trials everything was black, including the clothes of the judges and the executioners, which were normally red. The two colors only appeared together at the stake, where the flames introduced a vivid, colored note. Not always, however: to make the torture last longer certain courts recommended the use of green wood, which burned slowly and poorly. For their part, a few less severe judges, who believed in the symbolism of colors or perhaps in a certain form of redemption through color, recommended that witches wear white when led to the stake.

The Witches' Kitchen

The sabbat was entirely the province of black. It took place at night, in the darkness, either near ruins or in the heart of the forest, sometimes in particularly obscure underground locations. Before leaving to participate in black masses, banquets, sacrifices, and orgies, witches concocted a vile, magic salve that allowed them to fly on their brooms.
Jacques de Gheyn II, *La Cuisine des sorcières*, c. 1600–1605. Burin engraving. Paris, Bibliothèque Nationale de France, Print Collection, Ec 77 in-fol.

NEW SPECULATIONS, NEW CLASSIFICATIONS

The seventeenth century, which witnessed the continuance and sometimes even the intensification of religious intolerance, belief in demons, and witchcraft trials, was also a great century for science. In many areas knowledge was supplemented or transformed and replaced by new theories, definitions, and classifications. That was the case with the physical sciences, especially optics, which had progressed little since the thirteenth century. There was much speculation on light beginning in the 1580s, and as a consequence, on colors, their nature, hierarchy, and perception. At the very time when painters were discovering empirically a new way of classifying them, which would result a few decades later in the theoretical opposition between primary colors (blue, yellow, red) and complementary colors (green, purple, orange), men of science were also proposing new hypotheses and equations that would prepare the way for Newton and the discovery of the spectrum.[48]

On these questions—the nature and perception of colors—medieval and Renaissance science had progressed very little beyond the knowledge of antiquity, dominated by the theories of Plato and Aristotle. On the problem of color perception in particular knowledge remained mired in very ancient ideas.[49] Either scientists still believed, as Pythagoras had in 500 B.C., that rays left the eye to find the substance and "qualities" of the objects seen, and that among these "qualities" was color; or, more frequently, they concurred with Plato that the perception of color resulted from the encounter of a visual "fire" leaving the eye (or, for certain authors, acting in the eye itself) and particles emitted from the bodies being seen. According to whether the particles composing this visual fire were larger or smaller than the ones composing the rays emitted by the body, the eye perceived this or that color. Despite the contributions Aristotle made to this composite theory of color perception (the importance of the ambient environment, the material of the objects, the identity of the viewer), and despite the advances in knowledge involving the structure of the eye itself, the nature of its various membranes and humors, and the role of the optic nerve (demonstrated by Galen), it was still this ancient theory that dominated the late Middle Ages and even the mid-sixteenth century.[50] It was gradually called into question, notably by Kepler, who affirmed that colors took form not on the surface

of objects nor within the light but in the eye itself, each part of which played a specific role, the most important being that of the retina (previously, the crystalline lens had been considered more important).[51]

On the nature of color itself many authors continued to think, as Aristotle did, that color came from light—from light that diminished or darkened by crossing through different objects or environments. Its diminishing occurred in quantity, intensity, and purity, and, in doing so, gave birth to the various colors. That was why if colors were placed along an axis they were all situated between two poles, black and white, which were fully part of the system. White and black were colors in their own right. But along this axis between the two poles the other colors were not organized at all in the order of the spectrum. Of course there were many variations, but the order most often proposed throughout the Middle Ages and still in the late sixteenth century was the Aristotelian order: white, yellow, red, green, blue, black. Whatever the area in question, these six were the basic colors. If one wished to create a system of seven more functional on the symbolic plane, a seventh color, purple, could be added, which was located between blue and black. In 1600 the normal order of colors when placed along an axis was always and forever white, yellow, red, green, blue, purple, black. Black and white remained true colors; green was not the intermediary between yellow and blue; neither was it the opposite of red; as for purple, it was considered to be a mixture of blue and black and not of red and blue. The spectrum still seemed far off, even if the painters were the first to question this age-old classification, to give white and black a special status, and to discover empirically that a great number of colors and shades could be obtained just by mixing the three "pure" colors—red, blue, yellow—either among themselves or in combination with black or white.

In the two or three decades that followed, scientific experiments and speculations multiplied. A few scientists adopted many of the artists' ideas regarding the nature, classification, and even the perception of colors. That was the case with the Parisian doctor Louis Savot, who questioned painters, dyers, and glass artists and constructed his hypotheses on their empirical knowledge.[52] It was also true of the Flemish naturalist Anselme De Boodt, a friend of the court of Emperor Rudolf II and privy to his cabinet of curiosities. He focused his research on the color gray and demonstrated that the mixture of all colors (as was done by dyers) was not necessary for obtaining it; mixing black and white (which painters had been doing for many centuries) sufficed.[53] But it was especially François d'Aguilon, Jesuit writer and friend to Rubens, who formulated the clearest theories and who would have the most influence on midcentury authors. He distinguished the "extreme" colors (white and black), the "medium" colors (red, blue, yellow), and the "mixed" colors (green, purple, orange). In a magnificent diagram of astonishing simplicity he showed how colors combined to engender others. Nevertheless, black and white remained full-fledged colors for him; they had the status of "extreme colors" but were not yet removed from the color order. Moreover, adding black or white to a "medium" color did not alter its coloration but only its intensity.[54]

At the same time several scientists developed the idea—still very Aristotelian—that color was movement; it moved like light and set into motion all that it touched. By the same token color perception was intensely dynamic, resulting from an encounter between three elements: light, an object upon which that light fell, and a gaze that functioned both as emitter and receptor. This idea was simpler and closer to our present conception than Aristotle's, which was constructed upon the interaction of the four elements: the luminous fire, the substance (= earth) of the objects, the humors (= water) of the eye, and the air playing the modulating role of optic medium. A few seventeenth-century authors (Kepler in particular) would go further, seeming to admit that a color no one sees does not exist.[55] This was a very modern idea that Goethe would develop in the following century. With regard to the classification of colors, this theory of movement led many authors to arrange them in a circle rather than along an axis. That was what was done, for example, by the English doctor Robert Fludd (1574–1637), a learned physician but also a Rosicrucian philosopher. In the *Medicina catholica*, a work published in 1631 and strongly imbued with spiritualism, he proposed, elaborated upon, and reproduced a splendid "ring of colors" (*colorum annulus*) that probably constituted the first chromatic circle ever printed. The colors were still seven in number and arranged as on the Aristotelian axis: white, yellow,

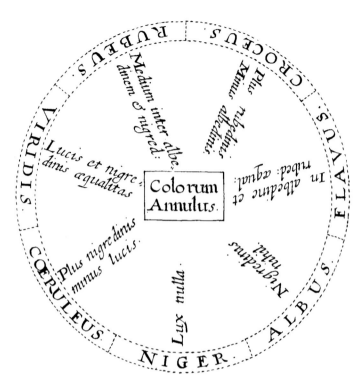

Within the diagram:

RUBEUS · CROCEUS · FLAVUS · ALBUS · NIGER · CŒRULEUS · VIRIDIS · RUBEUS

Medium inter albedinem & nigred:

Lucis et nigredinis aqualitas

Plus rubedinis

Minus albedinis

In albedine et rubedine æqual:

Colorum Annulus.

Plus nigredinis minus lucis:

Nigredinis nihil.

Lux nulla.

The First Printed Chromatic Circle

In 1631, the English doctor Robert Fludd (1574–1637) published and provided commentary for an innovative "ring of colors." Of course, the seven colors represented there followed the same order as along the traditional Aristotelian axis, but for the first time, they were arranged in a circle. By the same token, the two extremities—black and white—touched. R. Fludd, *Medicina catholica . . .* , vol. 2 (London, 1631), 123.

orange, red, green, blue, black. To the six basic colors orange was added here and not purple. But the most significant difference in relation to earlier systems and schemas came from the axis being curved and joined at the ends so as to form a perfect circle. Thus, black and white touched. To really understand how the ring functioned it was necessary to imagine an impermeable barrier between these two colors. The other colors, on the contrary, were arranged around the circle in sections with permeable boundaries. This was not yet Newton's spectral continuum, but it already prefigured it. On the other hand, as in the ancient theories, each of the colors on the ring was considered a mix to varying degrees of light and dark. The two "median" colors, red and green, still adjacent in this arrangement as they had been in all previous systems inherited from Aristotle, represented an equilibrium between light and dark. On the side of yellow and orange, light was dominant; on the side of blue, dark.[56]

In such a circular arrangement, both new and traditional, black and white were still part of the system, and from their fusion, according to various proportions, arose the other colors. The same was true for most of the diagrams, schemas, figures, and systems of representation proposed by other authors in the first half of the seventeenth century. One of the most audacious was reproduced by the famous Jesuit Althanase Kircher (1601–80)—a learned writer interested in everything, including colors—in his great work on light, *Ars magna lucis et umbrae*, published in Rome in 1646. He may not have been the author of this diagram, which perfectly reflected contemporary attempts to break with the rectilinear simplicity of the axis and convey through an image the complex relationships between the colors themselves. Here, it was a matter of a kind of genealogy expressed through seven interwoven half-circles of various sizes. The diagram's structure and lexicon are close to those proposed by François d'Aguilon some thirty years earlier. The "medium" colors (yellow, red, blue) arose from the union of the two "extreme" colors (black and white), and the "mixed" colors (pink, orange, purple, green, gray, and brown) from the union of either white or black with one of the three medium colors.[57] There were even two "marginal" colors, half-white (*subalbum*) and dark blue (*subcaerulus*), the first resulting from the mix of white and yellow,

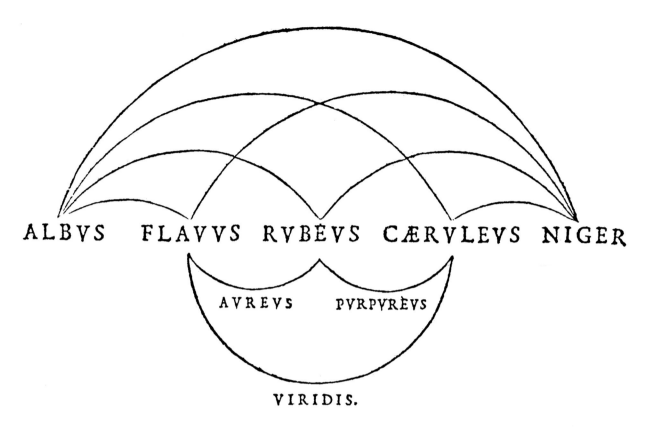

ALBVS FLAVVS RVBĚVS CÆRVLEVS NIGER

AVREVS PVRPVRĚVS

VIRIDIS.

the second from blue and black.[58] In such a schema, as in Aguilon's and others developed by many artists in the same period, green, presented as the mix of yellow and blue, was no longer a principal color, a color of the first order. This was a great novelty that broke with all social and symbolic practices and already foreshadowed the theory of primary and complementary colors.

The Genealogy of Colors

In the first half of the seventeenth century, many diagrams were proposed for classifying colors and showing how they could engender one another. One of the most audacious was proposed in 1613 by the Jesuit scholar François d'Aguilon, friend of Rubens and ally of painters.
F. d'Aguilon, *Opticorum libri sex* (Antwerp, 1613), 8.

A NEW ORDER OF COLORS

Despite the inventiveness of such schemas, artists' discoveries involving the mixing of pigments, and new theories on color perception, the principal work that prepared the way for Newton and the discovery of the spectrum was situated elsewhere in speculation on the rainbow.

In the seventeenth century the rainbow attracted the attention of many great scholars (Galileo, Kepler, Descartes, Huyghens) and even some theologians. They all discovered or rediscovered Aristotle's *Meteorologics*, Arab optics, in particular Alhazen's, and the Latin authors of the Christian thirteenth century, many of whom had written on the rainbow: Robert Grosseteste,[59] John Pecham,[60] Roger Bacon,[61] Thierry de Freiberg,[62] Witelo.[63] By the 1580s research intensified, breaking free of the poetic, symbolic, or metaphysical digressions that had encumbered treatises for three centuries and concentrating on meteorological, physical, and optical issues alone: the sun, clouds, raindrops, the curve of the arc, and especially the phenomena of reflection and refraction of light rays.[64] Giambattista della Porta (1535–1615) seems to have been the first to return to scientifically conducted prism experiments initiated by the Arabs and to propose more or less new hypotheses, explaining why a ray of sunlight crossing through a glass prism "gave" colors.[65] Other authors responded to him, proposing other experiments and other more innovative explanations.[66] Not all of them agreed—far from it—but their desire to understand, prove, and calculate was intense. They strove especially to determine the number of colors visible in the rainbow and the sequence they formed. Opinion was divided between four, five, or six colors, as in antiquity and the Middle Ages.[67] Black was never present among them. All the scholars saw in the rainbow an attenuation of solar light crossing through an aqueous medium, denser than air. Opinions diverged on the phenomena of refraction or absorption of light rays, on the measurement of their angles, and on the sequence of the colors formed.

Then came Isaac Newton (1642–1727), perhaps the greatest scientist of all time. Over the course of the 1665–66 academic year, while the plague kept him away from Cambridge and forced him to take an involuntary vacation at his mother's home in Woolsthorpe in Lincolnshire, he made many exceptional discoveries within a few months: the dispersion of white light and

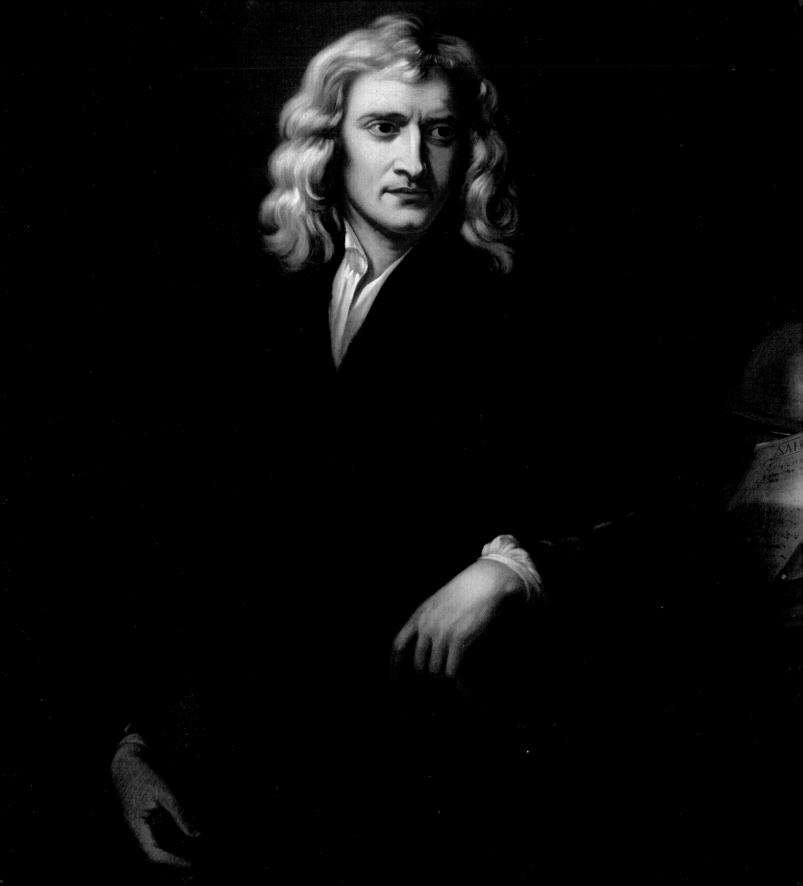

the spectrum, for one; terrestrial attraction and universal gravitation for another. For Newton the colors were "objective" phenomena; to concentrate on the problems of physics alone questions concerning vision had to be set aside because they were too linked to the eye (which seemed to him "deceptive"), as well as questions of perception, too subject to various cultural contexts. That is what he did, by cutting glass and repeating the old prism experiments again in his own way. He took as his starting point the hypotheses of his immediate predecessors, principally Descartes: color was nothing other than light that in moving and encountering bodies was subject to various physical modifications.[68] Knowing the nature of that light—undulatory or corpuscular—was not important to him, although it was a question debated by all the physicists of his time.[69] For him the essential thing was observing its modifications, defining them, and, if possible, measuring them. By multiplying the prism experiments he discovered that the white light of the sun did not diminish at all, nor darken, but that it formed an elongated, colored patch, inside of which it was dispersed into many rays of unequal length. These rays formed a chromatic sequence that was always the same: the spectrum. Not only could the white light of the sun be broken down in this way through experiments, but it could also be recomposed beginning with the colored rays. By these means Newton proved that light did not weaken to give rise to colors, but was itself, innately, formed from the union of different colored lights. This was a very important discovery. Henceforth light and the colors it contained were identifiable, reproducible, controllable, and measurable.[70]

These essential ideas, which constituted a decisive turning point not only in the history of colors—especially that of black, absent from this new system—but also in the history of science in general, had difficulty gaining acceptance, principally because Newton kept them secret for many years and then only revealed them partially and gradually beginning in 1672. It was not until his general survey of optics was published in English in 1704, summarizing all of his earlier work, that the whole of his theories on light and colors became definitively known by the scientific world.[71] Newton explained that white light was made up of lights of all colors, and that by crossing through a prism it was dispersed into colored rays, always the same, formed by minute

particles of matter, possessing great speed, and variously attracted or repelled by bodies.

In the meantime, other researchers, beginning with Christian Huyghens (1629–95), had made progress in the study of light and proposed that its nature was more undulatory than corpuscular.[72] Newton's work met with overwhelming acceptance, however, and to gain an even wider audience was immediately translated into Latin.[73] Great scientist that he was, Newton admitted not being able to provide answers to all the queries he had posed and left to posterity thirty questions to resolve.

What nevertheless hurt the reception of his discoveries and led to a certain number of misunderstandings for many decades was the vocabulary he used; he employed the vocabulary of painters but gave the words different meanings. For example, for him, the word *primary* had a particular meaning and was not limited to the three "primary" colors (red, blue, and yellow), although that is how most painters used it in the second half of the seventeenth century. Thus arose confusions and misunderstandings that would last well into the seventeenth century and be echoed in Goethe's treatise *Theory of Colors*, nearly a century later. Similarly, on the number of colored rays dispersed by the white light crossing through the prism, Newton's position was a little fluid and earned him various criticisms. His detractors were sometimes acting in bad faith, but he himself did not offer any very stable opinion.[74] First, in late 1665, he seemed to identify five colors in the spectrum: red, yellow, green, blue, and purple. Then, perhaps in the years 1671–72, he seemed to add two more, orange and indigo, to form a septet and thus promote the reception of his ideas by not verging too far from traditional thinking, accustomed to chromatic ranges containing seven colors. Moreover, he himself proposed a comparison with the seven notes in music, which subsequently earned him reproach; Newton himself recognized that dividing the spectrum into seven colors was artificial. The spectrum was, in fact, a colored continuum, which could easily be divided otherwise and in which could be seen a considerable number of colors. It was too late; the spectrum—and with it, the rainbow—retained its seven colors.

Nevertheless, for the historian of color that was not the essential thing. Newton had developed a new chromatic order, an order unrelated to earlier ones, forming a sequence unknown until that time, and which would remain the basic scientific classification up to the present: violet, indigo, blue, green, yellow, orange, red. The traditional order of the colors was overturned. Red was no longer at the center of the sequence but at the end, and green appeared between yellow and blue, thus confirming what painters and dyers had been doing for many decades— producing green by mixing blue and yellow. But, most importantly, in this new order of colors there was no longer a place either for black or for white. That constituted a revolution; black and white were no longer colors, and black perhaps even less so than white. White, in effect, was indirectly part of the spectrum since all the colors were contained within it. But black was not. Henceforth it was situated outside of any chromatic system, outside the world of color.

Rainbow (preceding page spread)
Until the seventeenth century, as much in texts as in images, rainbows were never represented as they are today. Sometimes they had three colors, sometimes four, rarely five, and these colors formed different sequences within the arc than they do in the spectrum.
John Constable, *Landscape with a Double Rainbow*, c. 1811–12. London, Victoria and Albert Museum.

Goethe and Color

A model of the Enlightenment, Goethe was as interested in the sciences as in literature and poetry. In the domain of optics, he refused to accept, with Newton, that colors originated in the dispersion of white light into colored rays. Goethe, *Theory of Colors*, 2nd ed. (Tübingen, 1827), figs. 16, 17, 18. Paris, Bibliothèque Nationale de France, Rare Book Collections, Z-35726.

ALL THE COLORS
OF BLACK

EIGHTEENTH TO TWENTY-FIRST
CENTURIES

Even if they had no immediate effect on the daily life of the common man, Newton's discoveries represented a major turning point in the history of knowledge and uses of color, perhaps the most significant since the Neolithic and the first practices of dyeing. By demonstrating that color originated and inhered in the transmission and dispersion of light and that, like light, it could be measured, the English scientist resolved a share of its mysteries. Henceforth produced and reproduced at will, controllable and measurable through optics and physics, color seemed to be more or less domesticated. By the same token, the everyday relationships that not only scientists and artists, but also philosophers and theologians, indeed even simple artisans and practitioners maintained with color were gradually transformed. Attitudes changed, and dreams as well. Certain questions debated for centuries—the symbolism of colors, for example—became less pressing. New preoccupations, new modes took center stage, such as colorimetry, which invaded the arts and sciences beginning in the 1700s. In many areas chromatic scales, schemas, and sample charts were developed to demonstrate the standards and rules color had to obey.[1] Henceforth color was no longer rebellious or uncontrollable. By the end of the seventeenth century color had entered a new phase in its history, which, by following various rhythms and accommodating different modes would last until the present day.

THE TRIUMPH OF COLOR

The Silence of Colors (page 150)
Painter of quiet atmospheres, empty rooms,
and women lost in reverie, Vilhelm Hammershoi
(1864–1916) used a restrained palette
dominated by gray and brown tones; its
luminous subtlety is almost unequaled
in the entire history of painting.
Vilhelm Hammershoi, *Seated Woman Seen
from Behind*, 1905. Paris, Musée d'Orsay.

One of the first consequences of these new interests and sensibilities was to ensure the victory of color in the old controversy that over the course of generations had set the partisans of drawing against those of color: in the plastic arts, which came first, form or color, drawing or coloration? This sometimes violent debate had been going on a long time and was not just the concern of artists.

Indeed its earliest manifestations dated from the fourteenth century, when the first grisaille miniatures appeared in illuminated manuscripts, images no longer polychromatic but solely composed of blacks, grays, and whites. The combination of these three colors, considered to be more dignified or moral than the others, was beginning to be seen as better suited for painting certain images, the most significant or the most ordinary ones. In certain devotional books (breviaries, books of hours, missals), for example, all the scenes of the cycle of the Virgin or the Passion were painted in grisaille except for two of the most sacred: the Annunciation and the Crucifixion were polychrome. In others all the decoration was painted in grisaille, artistic concerns taking precedence over moral or religious ones. Through this new art of grisaille the illuminators could demonstrate their expertise. The process rapidly expanded to painting on canvas and panel, notably the retables for concealing too brightly colored scenes during Advent and Lent, scenes henceforth considered inappropriate for these times of the year; for the liturgy, painting in grisaille, which gave priority to line over color, was more virtuous than polychromatic painting. At the end of the Middle Ages many painters also saw the practice of grisaille as a way of demonstrating their skill as draftsmen.[2]

Subsequently, in Renaissance Italy some artists who were particularly interested in theory began to pose the question of the status of colors in painting and then the question of the comparative merits of drawing and coloration to express the truth of beings and things. In Florence, where painters were often also architects and where Neoplatonic ideas dominated all forms of artistic creation, drawing was considered to be more exact, precise, and "true." In Venice it was the reverse. The debate had begun.[3] It would last almost two centuries and impassion artists and philosophers, first in Italy and then in France, especially in the Royal Academy of Painting

and Sculpture in the last third of the seventeenth century.[4]

The opponents of color did not lack arguments. They considered color to be less noble than drawing because unlike the latter it was not a creation of the mind but only the product of pigments and material. Drawing was the extension of an idea; it addressed the intellect. As for color, it addressed only the senses; it did not aim at informing but only at seducing. In doing so it sometimes obstructed the gaze and kept the viewer from discerning contours or identifying figures. Its seductiveness was reprehensible because it was a diversion from the true and the good. In short, it was only makeup, falsity, deceit, and treason—all ideas already developed by Saint Bernard in the twelfth century, adopted again by the great Protestant reformers, and then, between 1550 and 1700, evoked by the partisans of *disegno* over *colorito*. To these old reproaches was sometimes added the idea that color was dangerous because it was uncontrollable; it rejected language—to name colors and their shades was a dubious exercise—and escaped all generalization, if not all analysis. It was a rebel, to be avoided whenever possible.[5]

On the other side, the partisans of color pointed to all that drawing alone, deprived of color, failed to truly convey: not only the emotional dimensions of the painting, but also and more basically the distinction between areas and planes, the hierarchy of figures, the play of echoes and correspondences. Color was not only sensual or musical, it also performed a classifying function indispensable to the teaching of certain sciences (zoology, botany, cartography, medicine). Nevertheless, for most painters, color's true superiority lay elsewhere: color alone gave life to beings of flesh and blood; color alone constituted painting because only paintings of living beings were worthy of the name—a powerful idea current throughout the Enlightenment and taken up again by Hegel, who considered it at length in his works on aesthetics.[6] The model, then, was not Leonardo da Vinci or Michelangelo but the Venetian masters—especially Titian—because they were the ones who excelled in rendering flesh tones and flesh.[7]

It was ideas such as these that prevailed in the early eighteenth century, and with them color lost its dangerous character, since henceforth science knew how to measure, control, and reproduce it at will. Newton's theories opened the

Stained Glass in Grisaille

In artistic creation, the technique of grisaille accompanied the moralizing current that ran throughout the late Middle Ages. It found expression first in stained glass, as early as the 1300s, before establishing its place in painting and then illumination. *The Magi before Herod*. Stained glass, c. 1420–25. Paris, Musée National du Moyen Âge, Inv. Cl. 23532.

Grisaille Miniature (opposite page)

First appearing in illumination about 1325–30, the technique of grisaille rapidly found its favorite means of expression there, especially in France and the Netherlands. Moral preoccupations gradually gave way to aesthetic ambitions and pictorial virtuosity. *Pilgrims at Mont-Saint-Michel Saved by the Intervention of the Virgin*. Miniature from a collection of *Miracles de Notre-Dame*, c. 1460–65. Paris, Bibliothèque Nationale de France, ms. fr. 9199, fol. 37v.

way to new discoveries. In the area of books and prints, for example, a German engraver of French origin, working in London, Jakob Christoffel Le Blon (1667–1741), perfected an ingenious process for color engraving in about 1720–25: the superimposed and localized printing of three plates inked respectively with red, blue, and yellow. The use of these three colors, combined with black, was enough to obtain all the other colors on the white of the paper.[8] This technical innovation was of considerable importance; not only did it allow the engraved image to fulfill artistic and didactic functions that had previously been denied it, but it confirmed a new hierarchy of colors, discovered empirically by the painters many decades earlier, and prepared the way for the future theory of primary and complementary colors. This theory was not yet definitively formulated, but three colors henceforth took precedence over the others: red, blue, and yellow.[9] By the 1720s, after the reclassifications of painters and the discoveries of Newton and Le Blon, the universe of colors no longer tended to be organized around six basic colors, as it had been since the central Middle Ages, but around three. Not only did black and white depart the color order, but green, produced by yellow and blue (as it had never been in ancient societies), moved down a rung in the chromatic genealogy and hierarchy. These were the major innovations that had consequences in all areas of social, artistic, and intellectual life.

The Promotion of Drawing

In the late Middle Ages, drawing no longer meant simply a sketch or a model to be transformed by painting; it tended to take on autonomous artistic value. Soon the question of whether drawing or color was primary would be posed, which would occupy artists and art theorists for almost two centuries. Matthia Grünewald, *Saint Anthony in Prayer*, drawing with white accents, c. 1500. Berlin, Kupferstichkabinett.

THE AGE OF ENLIGHTENMENT

Between two particularly dark centuries, the Age of Enlightenment represented a kind of colored oasis. Enlightenment influenced not only the mind, but also daily life. There was an almost universal retreat from the brown, purple, and crimson tones, the dark, saturated shades, and the sharp contrasts that dominated the preceding century. In dress and furniture, light, luminous tones triumphed: gay colors and "pastel" tones, principally in the range of blues, pinks, yellows, and grays. Of course, these changes were not consistent throughout all social classes and occupations; they involved especially urban life and upper levels of society. But they reflected a general ambience that persisted throughout a good part of the century, from the 1720s to the 1780s, at least in France, England, and Germany. Spain and Italy remained faithful longer to the style of dark tones, as did northern Europe, where Protestant morals forbade too vivid or frivolous colors. In the Spanish court, despite the dynastic change and the ascension of a Bourbon to the throne early in the century, black remained dominant. Likewise it remained dominant in the Austrian Hapsburg court until the early nineteenth century.[10] In Venice visitors to that city were struck by its ubiquitous presence, particularly during Carnival.[11]

Elsewhere, black gave way to other tones. If unobtrusive in the preceding century, blue became pervasive. The massive importation of American indigo made the fortune of ports like Nantes and Bordeaux and, conversely, caused the ruin of cities that specialized in the commerce or production of woad: Toulouse, Amiens, Erfurt. The uses of blue diversified at the same time as its shades lightened; henceforth, dyers became successful in the range of light and luminous blues, which they had barely known how to produce previously.[12] White was also in style, especially for women's clothing and private rooms; but through the medium of lace, it was also featured in men's clothing. In décor it was rarely used alone, but in combination with other light colors, first pinks and yellows, then later in the century, blues, greens, and grays. This last color, very obscure since the late Middle Ages, made a remarkable and lasting comeback to the fashion scene beginning in the 1730s. It was not a matter of the dark, austere grays of officeholders and long-robed professionals, still less the dirty, unwashed grays of work

Chardin, Painter of Grays

Certain painters liked gray tones, others did not. Eugène Delacroix declared, "The enemy of all painting is gray," while Paul Klee responded, "For a painter, gray is the richest color, the one that makes all the others speak," an affirmation that Chardin would not have refuted. Jean-Baptiste Chardin, *Nature morte au canard*, 1764. Paris, Musée du Louvre.

clothes; no, this was a matter of bright, splendid grays on cotton fabrics and shimmering grays on silks. Similarly, yellow tones took on a life of their own; they were no longer gold or bronze as in the two preceding centuries, but gaining a distance from gold became both colder and lighter, and in doing so more easily combined with other colors. As for green, it owed its promotion to the definitive end of the taboo against mixing; henceforth no painter or dyer worried about mixing yellow and blue to obtain green. Moreover, the ever growing importation of American indigo and the accidental discovery of Prussian blue by the Berlin pharmacist Dippel in 1709 profited the range of greens just as much as blues.[13] As with blues, greens lightened and diversified throughout the century. Beginning in the 1750s, decorating bedrooms with this color began to be fashionable, a trend that would become almost the rule by the end of the century. Goethe echoed this in his treatise on colors, which recommended green as the most perfectly balanced hue and best for restoring the body and easing the soul.[14]

In the Age of Enlightenment in France black withdrew everywhere, as much in furnishings as in dress.[15] Even those who had worn black for traditional or professional reasons for many generations (those in positions of power, officers, nobility) turned away from it. Of course they continued to dress in dark colors, but they ventured wearing gray, brown, blue, or dark green. Scientific discoveries rapidly had consequences in the dyeing workshops; each decade saw the development of new colors and new shades.[16] Some remained in fashion for many years, other only a few months. That was the case with the astonishing shade of brownish yellow, quite poetically named *caca-dauphin* (dauphin poop), very much in vogue in the last weeks of the year 1751 to celebrate, first in the court and then in the city, the birth of the first grandson of Louis XV, Louis de France, duke of Burgundy, who died in 1761. That shade, which today we call "mustard" or *caca d'oie* (goose poop), had been considered since the Middle Ages the ugliest of all colors.[17] The inventiveness and frivolity of the Age of Enlightenment nevertheless gave it a few weeks of glory in the mid-eighteenth century.

All travelers who visited France at that time were captivated by the diversity of colors and the rapidity with which the fashions changed.[18] Certainly the same phenomenon could be observed elsewhere in Europe—in the German courts, for example—but not to so great an extent. For several decades France was the country of vivid, luminous colors, and Paris the most unrestrained and elegant of cities. That would last until the eve of the Revolution, when the years 1785–88 marked a turning point that witnessed the return of darker colors, black in particular, almost worshipped in the years that followed, the years of revolutionary turmoil.

But that was not until the end of the century. Until then, painting, even if it never offers a faithful reflection of reality, suggests the light and colorful ambience of the Age of Enlightenment. Henceforth Caravaggio, La Tour, and Rembrandt seemed very far away; the play of chiaroscuro, the subtlety of dark tones was abandoned, the pervasive browns and blacks rejected. The Baroque and Rococo artists made different choices. Even in Venice, Guardi and Canaletto lightened their palettes. Among all the painters black was in decline, as though once it was excluded from the spectrum and restricted in everyday use artists had to follow suit. In the theater as well black quit the scene; actors refused to wear it, whereas in the previous century they had refused to wear green—a practice they would adopt again in the Romantic period. In the eighteenth century it was not green that brought performances bad luck, it was black. In many areas there seemed to be a desire to turn away from this color that science no longer considered to be one. Even in mourning practices, which gradually extended to all of society, the use of black subsided, but only to the advantage of other dark tones, purples in particular.[19] The trend even reached the farmyards, where common domestic pigs, mostly black in Europe for millennia, started to turn pink; bold crossbreeding

The Plague of the Eighteenth Century

The expression *Black Death* ordinarily refers to the great epidemic that swept Europe between 1346 and 1350 and killed nearly one-third of its inhabitants. But all the plagues fall under the sign of the color black, like the particularly dramatic one that struck Marseilles in 1720.
Doctor Chicogneau, Dean of the University of Montpellier, Sent to Marseilles in 1720 to Fight the Plague.
Anonymous colored engraving, c. 1725.

with Asian pigs made them fatter and lightened their coats. This transition from black to pink in pig pigment seems to epitomize the chromatic changes in the Age of Enlightenment.

Such a withdrawal of black could not last, however. There came a moment toward the end of the eighteenth century when the fashion pendulum had to swing in the other direction. In France in particular it had gone too far in rejecting a color that had occupied center stage for nearly four centuries. Heraldry, for example, the only color domain that offers the historian actual statistics, provides instructive evidence: at the end of the Middle Ages the color black—*sable* in the language of heraldry—appeared in 27 percent of French coats of arms; that proportion was still about 20 percent at the end of the seventeenth century, at least if we believe the numbers provided by the huge *Armorial général de France* of 1696, but it fell to 14 percent two generations later, in the mid-eighteenth century! The new possessors of coats of arms (newly conferred nobility, nouveaux riches, the middle class, and wealthy artisans) had totally abandoned this color to the profit of *azur*, which appeared so frequently it exceeded all the records henceforth.[20]

Thus the rejection of black had gone too far. After 1760, exoticism offered the color a way to return to the artistic and literary scene. Long-distance voyages, discoveries of unknown lands, and new horizons for international trade changed the scale of European interests and knowledge. Greater attention was given to Africans, both for despicable mercenary reasons—the cruel triangle of commerce between Europe, Africa, and America—and for ethnological and philosophical reasons: why did different skin colors exist in different latitudes, dark skin colors in particular? To this question, hardly even asked in the Middle Ages, the responses varied, but most of them implicated the climate and the sun's rays. The vocabulary reflected these new preoccupations; dark-skinned Africans who until then had been called *Moors*, like the inhabitants of the Maghreb, or *Ethiopians*, a vague term, became *Negroes*, or *Blacks*, not yet *colored people*.[21] That expression would have to wait for the century's end and the aftermath of the first abolition of slavery by the French Convention in 1794. This lexical shift from "black" to "color" seems to prepare the way for the future return of black to the chromatic order, even before white.

A few decades earlier, about 1760, the slave trade, practiced for ten generations, reached its height. The Europeans carried textiles, arms, and alcohol to Africa; they left for America with many slaves; those who survived the appalling conditions of the crossing were exchanged for cotton, sugar, and coffee, brought back to Europe. It was estimated that between seven and nine million men and women were thus deported from Africa to the Americas in the eighteenth century.[22] Attempts were made to denounce such practices, indeed even to condemn slavery, but they remained tentative. Questions were raised about the social status and legal standing of the tens of thousands of black men and women who lived in the various countries of western Europe.[23] Over the course of the decades, their numbers grew: where was their place in society? In France most blacks were domestics; some were artisans (carpenters, cooks, wigmakers, and dressmakers). Few succeeded in becoming integrated into high society. The famous knight of Saint-Georges (1745–99), born a slave in Guadeloupe to become a celebrated musician and fencer, was the exception.

At the same time, beginning in the 1760–80s, art and literature made the black man fashionable. Under the guise of exoticism he became a favorite subject of painters and sculptors, while many novelists made the African coasts and their islands the sites of their fiction, for which the sentimental *Paul et Virginie*, published by Jacques-Henri Bernardin de Saint-Pierre in 1787, was the archetype.[24] In this escapist literature the black man remained unobtrusive, and colonial paternalism went hand in hand with the myth of the noble savage. Rare were the authors who denounced the exploitation of blacks by whites.

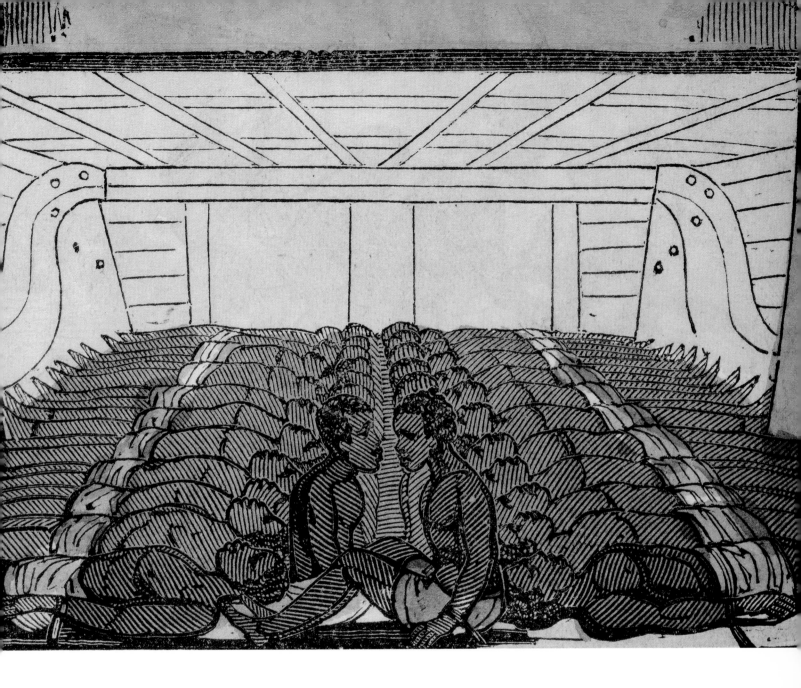

The Slave Trade

It was in the mid-eighteenth century that the slave trade, practiced for a dozen generations, reached its height. Europeans sent textiles, weapons, and alcohol to Africa; they left again for America with many slaves; those who survived the horrible conditions of the crossing were exchanged for cotton, sugar, and coffee. *Ship Transporting Black Slaves to America*. Anonymous English engraving, 1826. London, British Library.

THE POETICS OF MELANCHOLY

The Artist's Melancholy

In the nineteenth century, two attributes often accompanied the representation of the Romantic artist or poet: black clothes and a "melancholic" stance: the body more or less leaning, the elbow bent, and the hand resting against the temple, cheek, or forehead. This was the characteristic attitude of suffering or tormented figures, already encountered in ancient and medieval iconography. *Portrait of an Artist in His Studio.* Anonymous French painting, mid-19th century. Paris, Musée du Louvre.

This new interest in Africans and the colonies remained limited and was not sufficient to restore to the color black the prestige it had lost many generations earlier. That would occur a few years later, when the Romantic wave began to lead artistic and literary Europe into its dark imaginings and gradually reassign black the position it had formerly held: the first and foremost. The transition did not take place all at once, but in many phases. The first generation of Romantics was not so much attracted by night and the macabre as by nature and dream. By the same token, in terms of colors their preferences were first for green and blue, and only then for black. In the second half of the eighteenth century, for the first time in the West, the idea of nature was no longer systematically associated with the four elements (air, water, earth, fire), as it had been almost ever since Aristotle, but with vegetation. Henceforth nature was made up of fields and woods, trees and forests, leaves and branches. It became a place of repose and meditation and even took on metaphysical value. In the country the Creator seemed to be more present than in the city and to manifest himself there differently, both more directly and more peaceably. Certainly such ideas were not really new, but in about the years 1760–80, they took on enough importance to begin to alter sensibilities, especially with regard to color. Green, neglected or disliked until then by the poets, became the favorite color of nature lovers, those "solitary walkers" whose praises Jean-Jacques Rousseau sang.[25] Not only was green a favorite, but so was blue, as these strollers lost themselves in their dreams and aspired to inaccessible worlds. The mysterious "blue flower" introduced by Novalis (1772–1801) in his unfinished novel, *Heinrich von Ofterdingen*, is perhaps the most perfect symbol of these impossible quests.[26] But it constitutes an end, not a point of departure. The fashion of Romantic blue began a generation earlier, probably in 1774, when Goethe published his epistolary novel, *The Sorrows of Young Werther*, and gave his hero a blue coat combined with yellow breeches. The work enjoyed immense success in bookstores—one of the biggest best-sellers of all times—and "Werthermania" spread throughout Europe and then America; not only did artists take to representing the principal scenes of the novel in paintings and engravings, but for at least two decades young

men dressed "à la Werther," in the famous blue coat.[27]

Another color, however, was lurking in the shadows, awaiting its hour. Early in the next century, which marked nearly the end of Romantic or Pre-Romantic blue and green, black began to take over. Following the joys of communing with nature, the dreams of beauty and infinity, came ideas that were distinctly darker and that would dominate the artistic and literary scene for almost three generations. Rejecting the sovereignty of reason, proclaiming the reign of emotion, dissolving in tears and being consumed with self-pity were no longer enough; the Romantic hero had become an unstable, anguished individual who not only claimed "the ineffable happiness of being sad" (Victor Hugo) but believed himself marked by fate and felt an attraction for death. The English gothic novels had launched a trend in the macabre as early as the 1760s, with *The Castle of Otranto* by Horace Walpole, published in 1764. This trend continued into the turn of the century—*The Mysteries of Udolfo* by Ann Radcliffe (1794), *The Monk* by Matthew G. Lewis (1795)—and with it, black made its great comeback. This was the triumph of night and death, witches and cemeteries, the strange and fantastic. Satan himself reappeared and became the hero of many poems and stories—in Germany, those of Hoffman; in France, those of Charles Nodier, Théophile Gautier, and Villiers de L'Isle-Adam. Similarly, Goethe's *Faust* exerted considerable influence, especially the first part, published in 1808. Inspired by a historical figure—a small-time magician who lived in the sixteenth century and quickly became a figure of legend—Goethe's hero makes a pact with Mephistopheles (one of the names for the devil, "one who does not love light"): in exchange for his soul the devil promises to restore Faust's lost youth and with it all the pleasure that could satisfy his senses. The story unfolds in a particularly black atmosphere. Nothing is missing: night, prison, cemetery, castle ruins, dungeon, forest, cavern, witches and sabbat, Walpurgis Night, on the heights of Blocksberg, in the mountains of Harz. The time of Werther seemed like the distant past and under Goethe's pen his blue suit was replaced by a darker palette.

With romanticism the night took on a temporality all its own: the poets sang of how it was both gentle and ghastly, a place of refuge and nightmares, of fantasies and obscure travels. The *Hymnen an die Nacht* (1800) by Novalis and Musset's *Nuits* (1835–37) echoed back to *Night Thoughts* by Edward Young, published many decades earlier (1742–45). These meditations, in which the idea of death dominated, were translated into all European languages and then engraved in a hallucinatory style by William Blake in 1797. In his *Nuits de décembre*, Musset is haunted by a mysterious figure who assumes a series of different appearances (a poor child, an orphan, a stranger) but who is always "dressed in black" and resembles the poet "like a brother." Chopin did the same thing in many of his *Nocturnes* (1827–46) by translating into music this theme of the appearance of the double in the night. Everywhere the sense of melancholy triumphed; that century's ill, which was for the Middle Ages a true illness—etymologically, an excess of black bile—became for the Romantic poets a required condition, almost a virtue. All poets had to be melancholic, to die young (Novalis, Keats, Shelley, Byron), or to retreat into everlasting mourning. Gérard de Nerval did this better than anyone, at the beginning of his sonnet *El Desdichado* (1853), in the most famous quatrain of all French poetry:

> *I am the shadowed—the bereaved—the unconsoled,*
> *The Aquitainian prince of the stricken tower:*
> *My one star's dead, and my constellated lute*
> *Bears the Black Sun of Melancholia.*[28]

This black sun, which reappeared many times in Nerval's work and which undoubtedly had its pictorial origin in a fourteenth-century miniature, replaced Novalis's blue flower.[29] It constituted the symbol of a whole generation that delighted in morbid states, and it prefigured the frightening verse in the haunting voice of Baudelaire a few years later: "Oh Satan take pity on my pain."[30] Faust's pact with the devil remained more than ever a matter of current events.

Moreover, a current of the "fantastic" ran through the nineteenth century. Even if this adjective did not become a noun in French until 1821, what it designated predated it.[31] It no longer had anything to do at all with the magical supernatural of early romanticism, but was of a much darker nature, bringing together the strange, occult, frenetic, and even the satanic. Esotericism and spiritualism were the fashion; some poets met in cemeteries,

The Elegance of Black

In the second half of the nineteenth century,
black was ubiquitous not only in clothing,
but also in artistic creation. Pre-Raphaelite
painters almost worshipped it and used
it to depict legendary figures and create
strange, disturbing atmospheres.
Edward Burne-Jones, *Sidonia von Bork*.
Watercolor and gouache,
1860. London, Tate Gallery.

The Modernity of Black

Immediately after World War I, painters and graphic, industrial, and fashion designers restored black's status as a true color by making it one of the symbols of modernity. Art deco assigned it an important place, and expressionism frequently combined it with white and red, thus rediscovering the primitive color triad, its potency having lost nothing of its violence.

Tamara de Lempicka, *The Duchess of La Salle*, 1925. Oil on canvas. W. Joop collection.

others attempted to practice black magic, still others belonged to secret societies or enjoyed taking part in funeral banquets and drinking alcohol from empty skulls. At the end of the century, in his novel *À rebours* (1884), Joris Karl Huysman (1848–1907) began his account by evoking such a "feast of mourning": "While a concealed orchestra played funeral marches, the guests were waited on by naked black women, wearing stockings and slippers of silver cloth sprinkled with tears." Over the course of this meal only black, brown, or purple foods were eaten, and only drinks of these same colors consumed:

From black-rimmed plates they ate turtle soup, Russian rye bread, ripe Turkish olives, caviar, salted mullet roe, smoked Frankfurt black puddings, game in gravies the colour of liquorice and boot-blacking, truffled sauces, chocolate caramel creams, plum puddings, nectarines, preserved fruits, mulberries, and heart-cherries; from dark-coloured glasses they drank the wines of Limagne and Rousillon, of Tenedos, Val de Peñas, and Oporto, and, after the coffee and the walnut cordial, they enjoyed kvass, porters, and stouts.[32]

A similar taste for death and mourning appeared in the theater by the 1820s; there was no longer any hesitation about showing scenes of violence and crime. The late eighteenth century had rediscovered Shakespeare; romanticism would go further and appropriate many of his characters, making tutelary figures out of them. Hamlet, especially, became a Romantic hero, and his famous black costume, a veritable uniform, was more in keeping with the sensibility and style of the era than Werther's too sensible blue suit, henceforth totally obsolete.[33]

Society was not to be outdone, making black the dominant color for men's clothing and for the duration. The phenomenon began in the last years of the eighteenth century, grew during the French Revolution—an honest citizen had to wear a black suit then—triumphed in the Romantic period, lasted throughout the nineteenth century, and only exhausted itself in the 1920s. It involved elegant clothing as well, the dress of dandies and worldly gentlemen, made fashionable in England by Brummel about 1810, and also the limited wardrobes of men of modest means, who believed (naively?) they had found in black a color upon which the increasing filth and pollution seemed to have less impact.[34]

THE AGE OF COAL
AND FACTORIES

The Factory (opposite page)
Like the world of the mine, the world of the
factory long remained a world where gray and
black dominated. Vivid colors did not make
their entry there until very recently.
A Factory for Making Stainless Steel Plates,
Normandy, 1965.

Indeed by the mid-nineteenth century black no longer only permeated the dress of dandies and the hearts of poets. Henceforth it affected the common man and became ubiquitous in everyday life; this was the beginning of the second industrial revolution, which, in Europe and America, would gradually blacken all urban spaces and a share of the countryside until the mid-twentieth century. It was the time of coal and tar, railways and asphalt, later of steel and oil. Everywhere the horizon became black, gray, brown, dark. Coal, the principal source of energy for industry and transportation, was the symbol of this new world. Worldwide production of coal, which was 172 million tons in 1858, grew to 928 million tons in 1905, an increase of more than 500 percent in less than half a century![35] In the palette of blacks, henceforth there was little room left for poetry and melancholy; coal brought with it smoke, soot, grime, and pollution. The urban landscape was profoundly transformed, factories and workshops multiplied, the streets changed in appearance, and the contrast between rich and poor neighborhoods increased: white stone and greenery on one side; filth and poverty on the other. Moreover, a whole underground world was opened to the presence of men and their occupations; not only the mines, which became the symbolic place of industrial change and social tensions, a particularly obscure and dangerous place where the miners or *gueules noirs* (black mouths) were victims of firedamp and silicosis, but also the underground tunnels, galleries, workshops, and even the first subways.[36] London's subway was inaugurated in 1863, Paris's in 1900. One moved about underground, worked in a factory, lived indoors, lit with gas, and later with electricity; light itself was transformed as well, and with it the eye and sensibility. At the same time as the sun and the open air became an inaccessible luxury to a part of the urban population, new value systems were developing. The attitude with regard to tan and bronze tones is an unusual example, worth examining. It shows how at the end of the nineteenth century the dangerous, mistrusted class was no longer the peasant class but the workers, both dirty and pallid.

Indeed, in many ways the evolution of tanning practices constitutes an instructive document for the historian of colors. It obeys cyclical rhythms and swings of the pendulum that are not

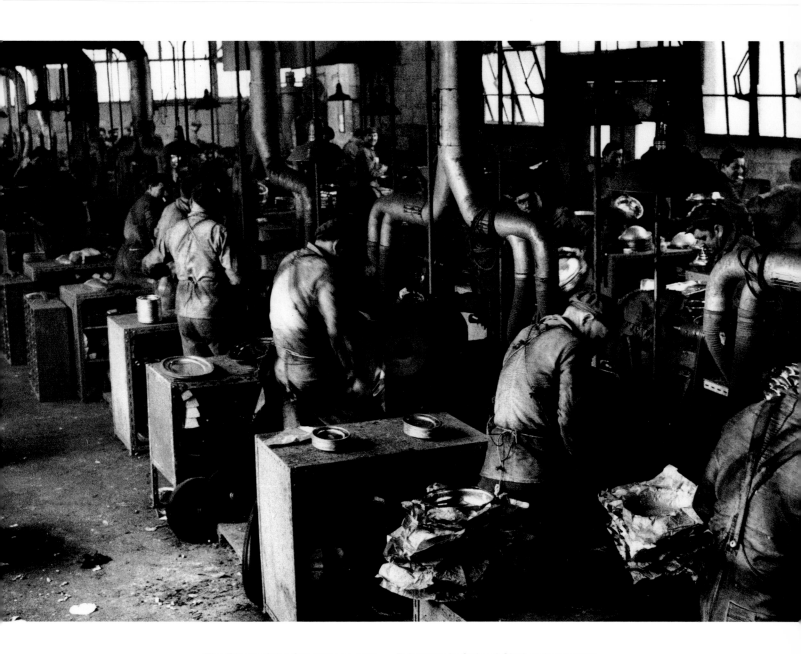

The Black of the Court (page 172)

Since the Middle Ages, black and red have been the colors of justice: red for the judges and executioners, black for the prosecutors, lawyers, and clerks. This black, which could seem a sinister omen, was meant to convey wisdom, fairness, and integrity. Honoré Daumier, *A Skillful Defender*. Pen drawing with gouache and chalk accents, c. 1855–60. Private collection.

Prisoners in Striped Clothes (page 173)

For a long time, dressing in stripes constituted a mark of infamy, a sign of exclusion or punishment, or else the degrading attribute of slaves and servants. In prison clothing, it also served an identifying function. If a prisoner escaped, stripes could be seen better than a uniform color. *Prisoners Dressed in Stripes*. Anonymous photograph, United States, c. 1930. Wauconda (Illinois), Lake County Museum.

very different from those affecting clothing fashions: long cycles interspersed with shorter cycles and value systems changing from one social circle to another. In modern Europe the history of tanning can be divided into three periods. Under the ancien régime, and still in the first half of the nineteenth century, individuals belonging to the aristocracy and to "good society" had to have the palest, smoothest skin possible in order not to be confused with the peasants. Rural peasants, working outdoors in the sun, had a bronzed tone and ruddy skin, sometimes flecked with dark freckles: hideous! In literary works a peasant was often a red-faced individual, and an old wealthy farmer could not hide his origins because of the indelible color of his skin. Being well-born thus meant having "blue blood," that is to say, having skin so pale and translucent that it let the veins show

through. But everything changed in the second half of the nineteenth century; the important thing was no longer to distinguish oneself from the peasant, but from the worker who worked within or under the earth and whose skin never saw the rays of the sun. His tone was pale, grayish, and disturbing. That same "good society" thus sought the open air, began to frequent the seashore (and later the mountains); it became fashionable to display a suntan, and smooth, bronzed skin. These new practices and values would become more pronounced over the course of the decades and gradually affect the affluent middle classes: above all, above all, not to be mistaken for a worker! This lasted several decades. Nevertheless, after World War II, when seashore vacations and winter sports gradually democratized and then expanded in the 1960 and 1970s to include a portion

of the less affluent classes, "good society" increasingly turned its back on tanning, henceforth within the reach of just about everyone. The great fad once again became not being tanned, especially upon returning from the seashore or the mountains. Only the nouveaux riches and starlets—two ridiculous social categories—and very common people continued to be tanned. Perhaps this will be true for the long term, because today the increase in skin cancers and diseases caused by voluntary exposure to the sun has made tanning unpopular. It has become dangerous if obtained through natural methods and grotesque if obtained artificially.[37]

But let us return to the second half of the nineteenth century, when a new industrial landscape was sweeping Europe and entire regions were changing in appearance in the grip of the mine, coal, iron, and metallurgy. Black penetrated everywhere, into the heart of the great cities such as London, which, in the words of Charles Dickens, in 1860 possessed "the dirtiest and darkest streets that the world had ever seen" and which "soot and smoke enveloped continually with a grimy suit of mourning."[38] The English capital did not have a monopoly on filth and darkness, however. In all the industrial cities smoke coated buildings, objects, and people with more or less thick, more or less grimy layers of soot, which were practically impossible to remove. Hence the permanent fashion of dark colors for men's clothing, especially black, too expensive to be worn by workers—their work clothes were blue or gray—but constituting a kind of uniform in offices and the business world.[39]

Black clothing was meant to be serious and austere. That

was due in part to a solid work ethic that reigned in the world of banking and finance, government departments and state agencies, administrative and commercial offices for many decades, until World War I and even sometimes much beyond. Too vivid or showy colors were prohibited and according to this ethic only black was evidence of authority and seriousness. By the same token this color also marked the dress of all those possessing power or a field of knowledge: judges, magistrates, lawyers, professors, doctors, and public officials. Moreover, throughout Europe the professions that required a regulation uniform—police, firemen, customs officers, postmen, sailors, and so on—adopted black and retained it until the first decades of the twentieth century, when navy blue gradually began to replace it, considered less severe or less easily soiled.

Until that time, in the world of work good form imposed black on five or six consecutive generations. This color seemed to abolish or diminish social barriers because it was as proper to the middle class as to worldly gentlemen, to ceremonial attire as to servants, so much so that the ubiquitousness of the color became unbearable to men smitten with the idea of change or freedom. To them it even seemed unnerving, the enemy of all poetry, as Alfred de Musset forcefully declared as early as 1836: "Let us not be deceived: that vestment of black which the men of our time wear is a terrible symbol; before coming to this, the armor must have fallen piece by piece and the embroidery flower by flower. Human reason has overthrown all illusions; but it bears in itself sorrow, in order that it may be consoled."[40] Oscar Wilde, who so loved vivid colors, especially reds and purples, echoed him at the end of the century, when in 1891 he wrote to the *Daily Telegraph* to denounce this "black uniform that is worn in our time . . . , a gloomy, drab, and depressing color . . . , lacking any beauty whatsoever."[41] Again, later, in 1933 Jean Giraudoux commented ironically on the black landscape that awaited schoolboys about to enter their first classroom: "From now on you will have a blackboard! And black ink! And black clothes! In our lovely country, black has always been the colour of youth."[42]

Those were the attitudes of the poets. In the business world black was the norm, even an ethic, inherited in part from the chromophobic values of the Protestant Reformation. By the sixteenth century, as we have seen, the latter had declared war

on vivid colors, principally red, yellow, and green, considered immodest, and a black-gray-white axis, more dignified and virtuous, was recommended for all good Christians, even for all good citizens.[43] Now these values still held sway in the second half of the nineteenth century, when European and American industries began to produce on a very large scale objects for mass consumption. Most of these objects fell within a chromatic range from which vivid colors were excluded; white, black, gray, and brown dominated. This was not through chance, nor was it a palette imposed by the chemistry of colorants. No, it was one of the enduring effects of the Protestant ethic, which, as the philosopher and sociologist Max Weber (1864–1920) demonstrated early on, exerted a decisive influence on the development of capitalism and economic activities.[44]

In fact, in the second half of the nineteenth, and still well into the twentieth century, on both sides of the Atlantic the great industrial and financial enterprises were for the most part in the hands of Protestant families, who imposed their values and principles. For many decades the standardized production of everyday objects in England, Germany, the United States, and elsewhere had to answer to social and moral considerations largely grounded in this ethic. It was due to this ethic that the first objects of mass consumption were produced in such a colorless palette. Since for a long time previously the chemistry industry had been able produce and reproduce any color whatever, or almost any color, it is striking to note that between 1860 and 1920 the first household appliances, the first instruments for writing and communicating, the first telephones, cameras, pens, and cars (to say nothing of textiles and clothing) produced in mass quantities all fell within the range of white to black, by way of grays and browns. It was as if the palette of vivid colors perfectly authorized by the chemistry of colorants was forbidden by the Protestant moral code.[45] The most famous example of such chromophobic behavior was that of the very stubborn Henry Ford (1863–1947), founder of the automobile company with the same name and puritanical with regard to ethics in all domains; despite the wishes of the public, despite the two-tone and three-tone vehicles offered by his competitors, despite the growing place for colors in daily life, he refused for

moral reasons to sell any but black or primarily black cars up until the end of his life.[46] The famous Model T Ford, the company's trademark, produced from 1908 to 1927, can serve all by itself as the symbol of this rejection of color.

Henry Ford

Founder of the automobile company bearing his name, Henry Ford (1863–1947), with puritanical concern for ethics in all domains, long resisted selling cars in any color but black, even though the public demanded vehicles in other colors and the competition offered them. *Henry Ford in One of the Famous Model T Fords*. Anonymous photograph, c. 1910.

REGARDING IMAGES

Chiaroscuro

An admirable painter of blacks, Manet felt the
influence of Velázquez and Rembrandt. His
Clair de lune sur le port de Boulogne
constitutes something of an homage to the
chiaroscuros of the great Dutch artist. Under the
wan light of the moon, women in black await
the return of a boat at nightfall.
Édouard Manet, *Moonlight on the Bologna Port*,
1869. Paris, Musée d'Orsay.

Painters were the first to revolt against this omnipresent and omnipotent black. By the Romantic period many of them were militating for a general lightening of the palette and a greater imitation of the colors of nature; greens, yellows, and oranges made their great comeback while the darker tones retreated. The impressionists took over from there, and with them, plein air landscapes multiplied, their luminous colors hardly leaving room for true blacks. The artists at that time were increasingly attracted to the experiments and discoveries of scientists, which confirmed their intuitions and gave their feelings an almost scholarly status. In the area of painting the theories of the chemist Eugène Chevreul influenced most of the color practices for four generations—it is true that Chevreul (1786–1889) lived for a very long time. In 1839 he published a long dissertation entitled *De la loi du contraste simultané des couleurs et de l'assortiment des objets colorés consideré d'après cette loi dans ses rapports avec la peinture*, in which he showed that every colored object finds itself altered in proximity with other colored objects.[47] The phenomenon followed two principal laws: first, each color tends to color neighboring colors with its complementary color; second, if two objects share the same color their juxtaposition greatly tones down that color. By the same token, artists could dispense with a certain number of pictorial traditions, notably the predominance of drawing, overly geometric perspective, and even the lighting of the studio; forms were created or suggested by the resonance and contrast of colors.

Not all the painters of the impressionist and then the postimpressionist generations followed Chevreul's theories to the letter, but in the second half of the nineteenth century most artists were directly or indirectly subject to his influence; many lightened their palettes, some arranged their colors according to the law of contrasts, others worked only outdoors and sought what was moving and changing, notably water and light. Chevreul published a new work in 1864, complementing the first and proposing models of chromatic harmony: *Des couleurs et de leur application aux arts industriels à l'aide des cercles chromatiques*.[48] In his wake the distinction between primary and complementary colors, the dispersion of white light according to the laws of the spectrum, and the rejection of black as a true

color became standard practice. Again and as always, Leonardo da Vinci's famous words, pronounced three and a half centuries earlier, were happily evoked, "Black is not a color."[49] Now painting was first of all about color; if black was not a color there was no place for it in a painting. Moreover, that was what Paul Gauguin recommended: "Reject black and that mixture of black and white called gray. Nothing is black, nothing is gray."[50] In fact, a certain number of painters, beginning with Gauguin in his Provençal period and then in his Polynesian exile, no longer used the traditional pigments for the range of blacks (carbon black,

lampblacks, blacks from bone and ivory) or even a synthetic pigment recently put on the market (aniline black), but preferred mixing colors that came from blue (artificial ultramarine, Prussian blue), red (cochineal, madder lacquer), and green (emerald green, malachite) pigments to obtain the "near-blacks," rich in multiple shades.

In the meantime, the invention of photography and its rapid diffusion throughout the art world freed painters from traditional attitudes and partially changed their perspective on forms and colors. Photography allowed them to reduce subjects to

surfaces, to discover new optical effects, and to oppose once again, more clearly than before, the world of black and white and the world of color. Of course, engraving had already been doing this for more than three centuries, but with photography and the codification of colors through chemistry and physics that opposition became more pronounced over the course of the nineteenth century. Even if, until the 1900s, photographic blacks were not absolutely black and photographic whites not really white, even if grays and browns also found their way into this new process, henceforth there were tens, even hundreds of millions of black-and-white images circulating in Europe and throughout the world. True color photography remained uncertain for a long time—the first autochrome plates by the Lumière brothers only date from 1902—and would not be widely adopted for an even longer time still.

For more than a century, then, the world of photography was a world of black and white, providing representations of current events and everyday life that were limited to these two colors, to the point that over the course of decades states of mind and sensibilities also developed the tendency to limit themselves to black and white and had a hard time escaping it. In the area of information and documentation in particular, despite considerable progress in color photography beginning in the 1950s, the idea persisted until almost the present day that black-and-white photography was precise, accurate, and faithful to the reality of beings and things, whereas color photography was unreliable, frivolous, and distorting. In many countries, for example, until very recently official documents and identity papers had to be accompanied by black-and-white photographs and not color ones. In France, when I was an adolescent in the early 1960s, identity photographs in color, however easy to obtain in automatic booths on street corners, were strictly forbidden for passports and identity cards. They were characterized as "not true" likenesses. The authorities were suspicious—and no doubt still are—of color, considered deceptive, unstable, and artificial.

Black and white exercised its tyranny among historians as well for many long decades. It is true that in the area of documentary information early photography took over from engraving, which since the end of the fifteenth or beginning of the sixteenth century had largely been responsible for the wide diffusion, within and outside of books, of images almost exclusively in black and white. Thus photography only prolonged and intensified practices that were more than three centuries old. For historians color did not exist and for four or five generations still, it found no place in their research. That explains why in areas where specialized studies on the problems of color might have been expected—the history of art, dress, everyday life—such studies were never undertaken before the end of the twentieth century. Even with regard to the history of painting, color long remained conspicuously absent. From 1850 until about 1970 to 1980, there were many such specialists—some of them very famous—who published thick, scholarly books on the work of a painter or a pictorial movement without ever discussing colors!

A MODERN COLOR

The Face of Death

The true hero of *The Seventh Seal*, Ingmar Bergman's masterpiece, is Death. In fourteenth-century Sweden, ravaged by the Black Death, Death comes to find a knight returning from the Crusades. In order to postpone his fate, the knight proposes a game of chess to Death. Ingmar Bergman, *The Seventh Seal*, 1957 (Bengt Ekerot in the role of Death).

Beginning in the 1900s, with regard to this "tyranny" exercised by black and white over the world of images, photography was no longer only to blame; cinema took up the charge and expanded this hegemony. The first public projection of cinematography by the Lumière brothers (who charged an admission fee!) took place in Paris, at the Grand Café on the boulevard des Capucines on December 28, 1895. By the following year and for three decades thereafter intense research was undertaken to develop color films. Some experiments proved fruitful but had no impact on commercial cinema; the animated images presented to the general public would remain black and white for a long time to come. The technical difficulties of producing films in color, it is true, were enormous. The first attempts involved coloring by hand, with the help of transfers, one per color, cut in positives. The colors were applied with a brush, extremely time-consuming and painstaking work, impossible for long footage, and even more so as such productions had to involve scenery, costumes, and makeup, all in a range of grays. Then films were colored by immersing them in colorant baths. That created atmospheres, and even codes since the same colorations were always chosen for the same types of scenes: blue for night, green for exteriors, red for danger, yellow for happiness; but this was still not color cinema. Subsequently, color filters were used, first during the projection, later during the shooting. Finally, as in engraving and photography, three films of three different colors were superimposed to obtain all the other colors. The first cartoon film in color (Walt Disney's famous *Silly Symphony*) was released in 1932. But it would be three years before the release of a true color film, Rouben Mamoulian's *Becky Sharp*, in 1935.[51]

In fact, the Technicolor process, which dominated the first days of color cinema, was developed as early as 1915. It continued to be perfected until the mid-1930s and before World War II allowed for the shooting of masterpieces like *The Adventures of Robin Hood* (1938) and *Gone with the Wind* (1939). But the process was in place much earlier. Technically, it could have used in the production and marketing of films as early as 1915. What delayed its dissemination to the general public were not primarily technical and financial reasons, but moral ones. In 1915–20, for the puritanical capitalists we have

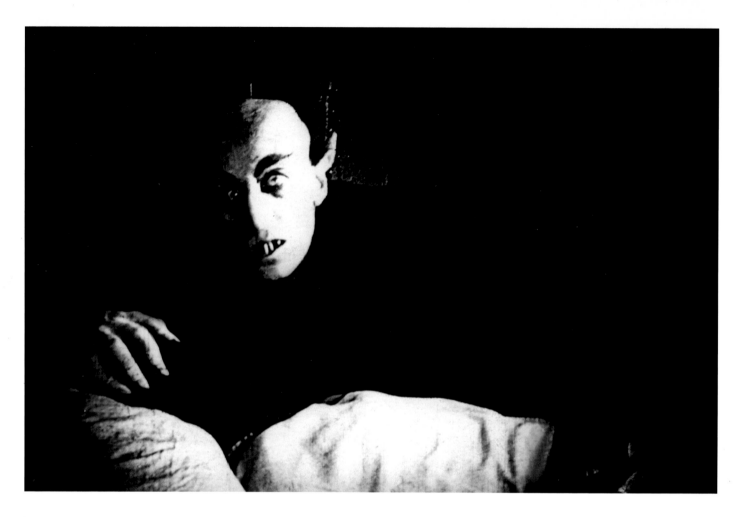

discussed earlier who then controlled part of the production of images as they controlled the production of objects for mass consumption, animated images already represented a frivolity, even an indecency; to go even further and offer to the public animated images in color would have been truly obscene. Hence the delay of two decades between the technical capability for color film and the first screenings of it.

After World War II, color films were distributed more widely, but they did not outnumber black-and-white films until the end of the 1960s. The attempt then, if not very successful, was to avoid giving cinematographic images a "postcard" look. There were many aesthetes and film artists who denounced the intrusion of color and its unrealistic nature. In the cinema, as indeed in television and magazines, color occupied an exaggerated and

The Expressionism of the Cinema

In *Nosferatu*, a silent film by Friedrich W. Murnau, the director used the play of shadows and special effects to create a disturbing atmosphere. Moreover, blue filters helped to distinguish nighttime scenes from daytime scenes.
Friedrich W. Murnau, *Nosferatu the Vampire*, 1922.

Citizen Kane (opposite page)

The encounter between cinema and the world of the press made *Citizen Kane* not only an innovative movie in every way but also a veritable hymn to black and white, the black and white of ink, paper, and film.
Orson Welles, *Citizen Kane*, 1941.

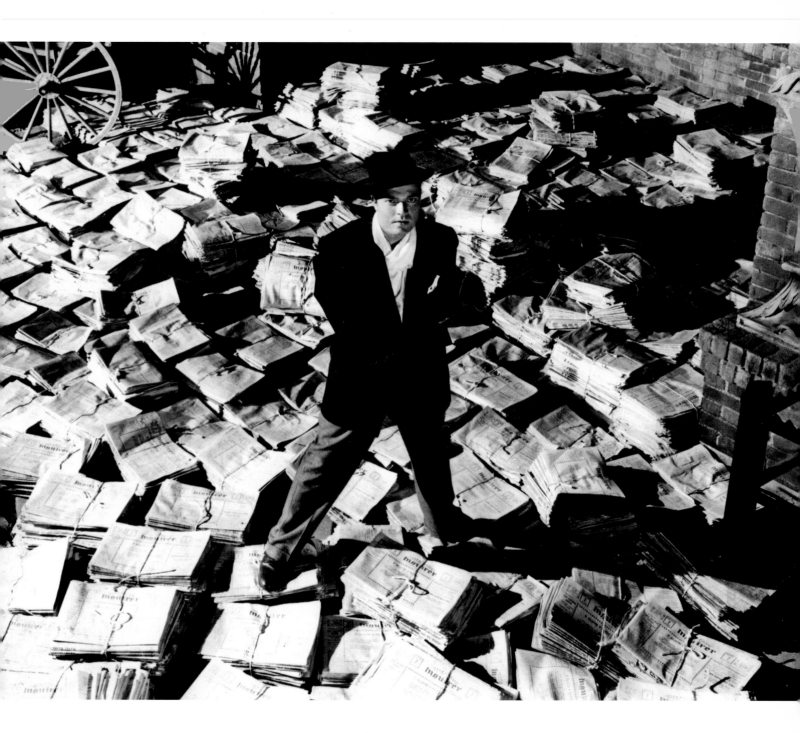

distorted place in relation to its place in natural vision and everyday life. But the general public did not agree and rejected the return to black and white (though true film buffs demanded it for certain categories of films). The recent practice of "colorizing" old films shot—and conceived—in black and white reflects this taste among the general public for color, especially in the United States; American television viewers (and European ones next, no doubt) refuse to watch old films in black and white! Thus, they have to be "colorized" (the word itself is an abomination) so that they can be shown on television. That process began in the 1980s and 1990s, and it has prompted legitimate polemics, both legal and ethical, as well as artistic. Today, shooting a black-and-white film is more expensive than shooting a film in color (the same is true for photography). Hence, among creators, through the usual swing of the pendulum with regard to trends and value systems, black and white has clearly regained value, as more seductive, more atmospheric, and more "cinematographic." Among a few rare film buffs a certain snobbery even encourages the boycotting of color cinema. We cannot all share such convictions, but are forced to recognize that cinema is historically and mythologically tied to a universe of black and white. Colorizing old films will do nothing to change that.

Let us go back a few decades. Despite all the progress and transformations, despite the immense distribution of photography and cinema throughout the twentieth century, it was not photography or film that first restored black's status as a true color; once again, it was painting. Toward the end of the century, increasing numbers of painters became captivated by black, as Manet, Renoir, and a few others had been a generation earlier. Henceforth, for many it became the dominant color in their palettes. This return to black expanded after World War I, when abstraction proved fertile ground for it. Russian Suprematism, in particular, gave black a significance too often misunderstood because of Malevich's too famous *White on White* (1918). This painting was certainly a radical culmination of the abstract movement, but in no way did it restore white's status as a true color, very much the opposite, nor did it recognize all the inquiries into black by the constructivist painters

and then by theoreticians of the De Stijl movement.[52] By the 1920s to 1930s, black became or returned to being a fully "modern" color, as did the (so-called) primary colors: red, yellow, blue. On the other hand, white and especially green were regarded differently and were never granted that status. For certain abstract artists (let us think of Mondrian or Miró, for example), green was no longer a basic color, a color in its own right. This was a new idea, contradicting all the social and cultural uses for the color green for centuries, even millennia.

With regard to black, it would be a few decades before a painter arrived on the scene who would devote nearly all his work to it: Pierre Soulages (born in 1929). From the 1950s, black applied with a spatula and the line traced with a knife constituted his principal means of expression. The gesture of the painter took on considerable importance because it determined how the material spread across the canvas became a form. Black was largely dominant, but it was often combined with one or many other more discreet colors. Beginning in the years 1975–80, Pierre Soulages moved from black to *outrenoir*, a term he himself invented to characterize "a beyond of black." Henceforth most of his canvases were entirely covered in a single, uniform ivory black, worked with fine and coarse brushes to give it a texture that according to the light produced a great variety of luminous effects and colored nuances. It was not at all a matter of monochromy, but of an extremely subtle mono-pigmentary practice, producing through reflections an infinity of luminous images interposed between the viewer and the canvas. This was a unique case in the whole history of painting, a magnificent extreme case, which had nothing to do with the harrowing *Black Squares* of the minimalist artist Ad Reinhardt (1913–67), uniform black rectangles devoid of any texture and lacking any aesthetic ambition.[53]

Nevertheless, even if the painters were the first to restore black's full modernity, well before World War I and throughout the century there were also the "designers," the industrial and fashion designers who ensured its presence and its popularity in the social world and everyday life. "Designer black" was neither the luxurious, princely black of earlier centuries nor the dirty, miserable black of the large, industrial cities; it was

Pierre Soulages (preceding page)
In the works of Pierre Soulages (born in 1929),
notably those involving *l'outrenoir* (beyond
black), the color applied with spatula and the
line traced with knife constitute the principal
means of expression. The painter's gesture
takes on considerable importance because
it determines how the material spread
across the canvas becomes a form.
Pierre Soulages, *Painting June 19, 1963*. Paris,
Musée National d'Art Moderne.

Ink on Paper
Ink has always occupied an important place in
artistic creation, not only in the East but also in
the West. India ink allows effects of density and
light that printing inks cannot produce. In the
nineteenth and twentieth centuries, some artists
created very subtle effects with it, like Henri
Michaux (1899–1984), who in addition to his
work as writer and painter developed original
graphic work in which ink played a major role.
Henri Michaux, untitled India ink drawing.
Paris, Musée National d'Art Moderne.

simultaneously a sober and refined black, an elegant and functional black, a joyous, luminous black, in short, a modern black. Even if between design and colors there has been a long history of failed dates (let us think of the ugly pastel shades of the 1950s or the chromatic vulgarities of the 1970s), the relationship between design and black has been a successful one.[54] For many designers and for much of the general public over the course of the decades black has increasingly become the emblematic color of modernity.

This same modern dimension is found again, and to an even greater extent, in the world of fashion. From the beginning of the century, many fashion designers devoted to art and innovation (Jacques Doucet and Paul Poiret, for example) took up black— which had become a full-fledged color again in textiles and dress—and made it their favorite medium of expression. In 1913, Marcel Proust had already testified for this new fashion and dressed Odette de Crécy in black—an elegant, modern woman, even if she belonged to the demimonde. He also describes an old concierge, received in society because she was the aunt of a young pianist, "she wore a black dress, as was her invariable custom, for she believed that a woman always looked well in black and that nothing could be more distinguished."[55] After the war, in the 1920s, this modern aspect of black became more pronounced. Henceforth it captivated most clothes designers and involved not only haute couture. The famous "little black dress" of Gabrielle "Coco" Chanel, created in 1926 and lasting through the decades, certainly has symbolic value in this domain, but it is not at all an isolated case.[56] The black suit, symbol of discreet and practical elegance, produced by all the couture houses beginning in the 1930s, turned into a competition and remained the style until the 1960s and even well beyond.[57] Over time black has remained the darling color of clothes designers and the world of fashion. Moreover, even today, in an event where fashion designers come together (presentations, fashion parades, conferences) the observer—I have had this experience many times—is struck by the omnipresence of black. All the women, absolutely all of them, are dressed in this color; only a few men sometimes dare to wear vivid colors. A similar domination of black can be observed in other creative professions (among architects, for example) or in those connected with money (bankers) and power ("decision makers"). Black is simultaneously modern, creative, and powerful.

A Dress by Sonia Rykiel

Designer of black, queen of knits and the démodé, Sonia Rykiel has always had a taste for provocative remarks. Her famous line, "Black is an indecent color when one wears it well," has made its way around the globe. Sonia Rykiel, spring–summer collection, 2007.

A DANGEROUS COLOR?

The Black Flag

Born in the French Revolution, the red flag accompanied popular uprisings and workers' revolts throughout the nineteenth century. Beginning in the 1880s, it was gradually outflanked on the left by the black flag, emblem of anarchists' movements and symbol of despair. *Meeting at the Charléty Stadium*, Paris, May 27, 1968.

Black can also show itself to be rebellious or transgressive. The *blousons noirs*, the "rockers," the Black Panthers, and all the movements or factions that in the second half of the twentieth century flaunted their revolts by wearing black clothing had many ancestors, some very distant. For example, there are the pirates; from as early as the fourteenth century in the Mediterranean, a few Barbary pirates chose as their banner a piece of white cloth decorated with the white-banded head of a black Moor.[58] At the beginning of the modern period, on port guides and geography maps this same insignia was always associated with pirates, but the Moor's head tended to become a death's head and the colors were reversed: black for the background, white for the figure. Toward the end of the eighteenth century the death's head became more rare or disappeared and all that remained were skull and crossbones, henceforth the emblem of all the pirates, not only in the Mediterranean but on most of the seas worldwide. Subsequently, the Jolly Roger made its appearance on solid ground; various movements with anarchist or nihilist tendencies adopted it as their emblem. Inconspicuous in the nineteenth century—for example, it was absent from the great revolutions of 1848–49, which flaunted only the revolutionary forces' red flag—the black flag was more prominent the following century, often outflanking the red flag on its left, as was the case in France during the great student demonstrations of May 1968.[59]

On the political plane this rebel, anarchist black must not be confused with two other blacks. First, there was the clearly conservative black of the church, active and influential in nineteenth-century Europe, but much less so afterward; this was the black of parish priests' cassocks and the traditional garb of the clergy. Second, there was the police and totalitarian black of the militia of the Italian fascist party (the Blackshirts—*camicie nere*—organized beginning in 1919 to support Benito Mussolini's rise to power), and the more deathly black of the SS (*Schutzstaffel*) and the Waffen-SS of the Nazi regime, outflanking on their right the brown shirts of the SA (*Sturmabteilung*), eliminated in 1934. Or it may be that these various blacks—reactionary, anarchist, nihilist, fascist, Nazi—finally merge to unite the most extremist tendencies under one and the same color. Indeed, one of the most consistent features of Western symbolism is aligning

or merging the extremes. Does the same hold true on the ideological and political plane?

Today, rebel and transgressive black is fairly harmless, if not hackneyed. Wearing black to proclaim revolt, rejection of social conventions, or hatred of authority is no longer enough to draw attention. Only a few restless adolescents still do this, combining black leather clothing, various piercings, and eccentric or provocative behavior. But that no longer attracts anyone's interest, not even the sociologists'. Better for rebellious youth to dress in Sunday clothes or in their first Communion outfits; they would be more noticeable. There is nothing aggressive or taboo about black clothing. Today, in the range of blacks and dark colors we witness behaviors that would have horrified our grandparents and great-grandparents: wearing black material directly against the skin, wiping our mouths with black napkins, sleeping in dark sheets, and even dressing very young children in black or brown. That would have been impossible a century ago; in our age it has become commonplace. In this regard the history of women's underwear is particularly instructive and helps to explain how value systems have reversed themselves.

For centuries all clothing or fabrics touching the body had to be white or undyed. This was true for both hygienic and practical reasons—they were boiled, which decolored them—and especially for moral ones: vivid colors, as we have stressed repeatedly, were considered impure and immodest. Then, between the end of the nineteenth and the middle of the twentieth centuries, the white of underclothes, towels, sheets, napkins, bathrobes, and so on gradually became colored, as either pastels or stripes took over.[60] What was still unthinkable about 1850 became relatively routine three generations later: wearing a blue petticoat, a green undershirt, pink underwear, using a red napkin, or sleeping in striped sheets. Regarding undergarments, this new palette gradually took on social and moral connotations. Some colors were considered more feminine, others more well behaved, still others more erotic. Beginning in the 1960s, advertising sometimes made a veritable code of them: "Tell me what colors you wear under your dress and I will tell you who you are." In contrast to white, a well-behaved, hygienic color, black long had the reputation for being indecent or immoral, reserved for libertine women, or even

Black Jacket

Appearing in the United States among motorcyclists and rock stars as early as the 1950s, the black leather jacket invaded Europe in the following decade. Simultaneously rebellious, violent, and libertarian, it became the symbol of juvenile delinquency and the gang phenomenon. *Biker in Black Jacket*, London, 1960.

professional debauchers. Today, that is absolutely not the case. Not only does black no longer even hint at prostitution, or even naughtiness, but for about the last twenty years in western Europe it has taken the place of white as being the most popular color for women's underclothing. Many women who wear black prefer to wear underclothes of this color beneath their skirts, pants, or blouses, rather than white, which would be more noticeable. Others consider black very well behaved or better suited to their skin color. Still others—most importantly—have noted that among today's synthetic fabrics black is the tone that stands up longest to repeated washing. Today it is colors other than black, now totally mundane, that have taken over the erotic dimension—or what remains of it—for underwear. It is no longer so much red, which formerly played the enticing or degenerate role, but rather mauve, the same flesh tone, or even white. The latter is no longer as innocent as it used to be. In any case, it is the tone men now cite most often when asked what color excites them, displayed against pretty female flesh.

The only domains in which black seems to remain a dangerous or transgressive color are those of verbal expressions and superstitions. They serve as vehicles for past beliefs and value systems, which neither social change nor technical progress, nor even changes in sensibilities have managed to transform or eradicate. In all European languages there thus exist many locutions in current use that emphasize the secret, forbidden, threatening, or harmful dimension of the color black. Let us cite for French *marché noir, travail au noir, mouton noir, bête noire, liste noire, livre noir, trou noir, série noire, messe noire, avoir des idées noires, broyer du noir, jour à marquer d'une pierre noire* (black market, moonlighting, black sheep, pet peeve, blacklist, black book, black hole, crime thriller, black mass, to have gloomy thoughts, to be down in the dumps, black day), and so on. Expressions highlighting a negative or disturbing black are found as well in all Western languages. Sometimes, however, for the same expression, the color changes from one language to another; for drunkenness, for example, French uses *être noir* (to be black), while the German uses *blau sein* (to be blue); similarly French characterizes a police novel as a *roman noir* (black novel) while Italian calls it simply *giallo* (yellow), a metonym alluding to the yellow paper cover on such works. These changes in color

Referees

On soccer fields, referees were for a long time the "men in black." This color signified their authority. Today, by abandoning black to don other colors, they have lost a good part of that authority.
Stéphane Reix, *UEFA Cup: The Referees*, June 2004.

from one language to the next are not very numerous, but constitute significant evidence for cultural historians.

Proverbs and sayings are not to be outdone in even now conveying a certain number of superstitions related to the color black. They are evidence of the survival of sometimes very ancient behaviors and beliefs. Hence the bad luck that can result from encountering a black animal (cat, dog, hen, sheep, and especially raven or crow): "black cat in the morning, trouble in the evening," "he who sees the crow sees his end"; or even from simply encountering a person dressed in that color: "black cape in the distance, change your course." If the encounter takes place nevertheless, formulas exist for conjuring away the bad luck: crossing oneself, crossing one's fingers, making horns, wearing a black stone or amulet. Indeed, a very old idea holds that black fends off black, or even that the devil, black himself, is afraid of black.[61] In rural Europe these superstitions, still very much alive in the 1950s, have today disappeared. The symbolism of black has faded everywhere. Even death and mourning are less and less often associated with this color, which is sometimes replaced with gray or purple, or even totally abandoned.[62] What is true of negative black is also true of positive black. The chic once represented by the black frock coat, dinner jacket, dress, or suit has lost its magic, so ubiquitous has this color become in everyday wear as much for women as for men. Authority itself is hardly expressed anymore by black, neither in the law courts nor in the sports grounds. Police dress in blue, judges usually wear their street clothes, and referees have abandoned black to adopt vivid colors. Moreover, in doing so, they have lost a share of their power: the decisions of a referee dressed in black are respected, but the decision of a referee dressed in pink, yellow, orange . . . ?

Today, the luxury of black, arising at the end of the fourteenth century and still very much present two or three generations ago, hardly finds expression anymore in anything but caviar and the packaging of certain very costly products (jewelry, perfumes). As to the primacy of black over the other colors, that is reserved for judo belts and ski runs, two domains belonging to sports. Elsewhere, everywhere else, black seems to have returned to the ranks, as polls conducted on favorite colors show. Since the end of World War II, as much in Europe as in the United States, these polls have almost always reported the same results, no matter the sex, age, or social class of the individuals surveyed. Now among the six basic colors—blue, green, red, black, white, yellow, listed here in order of preference—black is neither the most popular (blue) nor the least popular (yellow); for the first time in its history it is situated in the middle of the gamut.[63] Is it possible that black has finally become an average color? A neutral color? A color like all the others?

From Black to Yellow by Way of Gray
In painting as in society, black and gray rarely appear alone. They only take on meaning and assert their power insofar as they are combined or contrasted with one or many other colors. Serge Poliakoff, *Composition in Gray and Black*, 1950. Paris, Musée National d'Art Moderne.

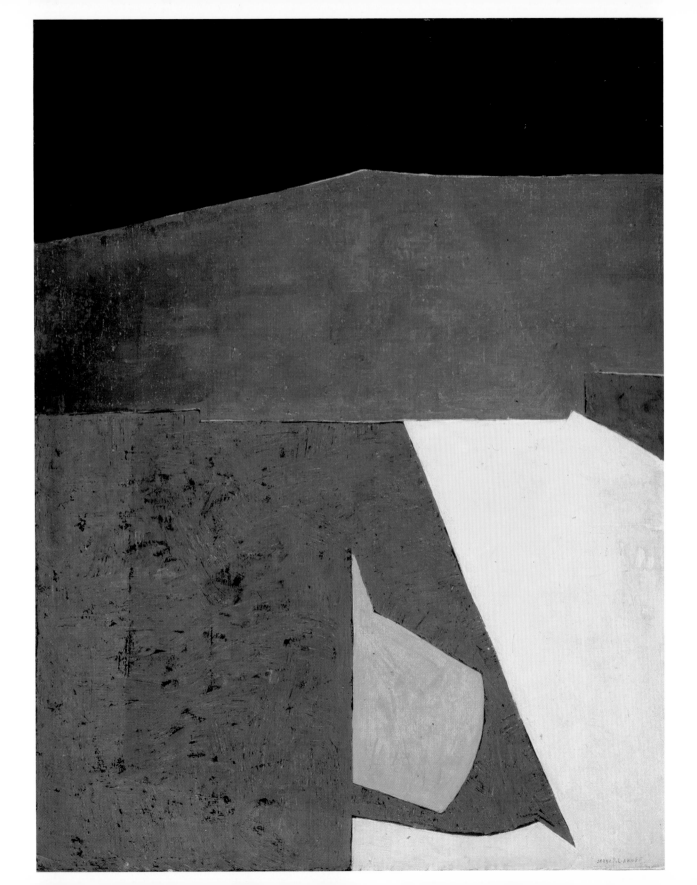

NOTES

IN THE BEGINNING WAS BLACK

1. Gen. 1:1–5.

2. Clearly I am using the expression *dark matter* here in a somewhat clichéd and intentionally imprecise way, as opposed to the meaning astrophysics gives it.

3. At least according to the Orphic theogony. Hesiod's theogony is slightly different, adding an intermediary generation between Nyx and Uranus. See P. Grimal, *Dictionnaire de la mythologie grecque et romaine*, 11th ed. (Paris, 1991), 320 and 334.

4. M. Salvat, "Le traité des couleurs de Barthélemy l'Anglais (XIIIe siècle)," *Senefiance* 24 (Aix-en-Provence, 1988): 359–85.

5. Beginning in the late Middle Ages, blue began to replace white as the color for air and was definitely established in this role by the modern period.

6. G. Dumézil, *Rituels indo-européens à Rome* (Paris, 1954), 45–61. The formula is borrowed from the historian Jean le Lydien (sixth century), who used it to characterize the tripartite division of the Roman people in early Roman history.

7. For example, in the *Republic*, Plato stresses that the city's stability depends upon the just division of occupations according to three castes, each possessing its emblems: the rulers, the soldiers, the artisans.

8. G. Dury, *Les Trois Ordres ou l'Imaginaire du féodalisme* (Paris, 1978).

9. J. Grisward, *Archéologie de l'épopée médiévale* (Paris, 1981), 53–55 and 253–64.

10. Dumézil, *Rituels indo-européens à Rome*.

11. M. Eliade, *Le Symbolisme des ténèbres dans les religions archaïques: Polarité du symbole*, 2nd ed. (Brussels, 1958).

12. Plato, *Republic* 7:514 a–b.

13. See the beautiful book by G. Bachelard, *La flamme d'une chandelle*, 4th ed. (Paris, 1961).

14. On the Niaux grotto, J. Clottes, *Les Cavernes de Niaux* (Paris, 1995).

15. On Roman painting and the role of blacks, among abundant sources, see A. Barbet, *La Peinture romaine: Les styles décoratifs pompéiens* (Paris, 1985); A. Rouveret, *Histoire et imaginaire de la peinture ancienne* (Paris, 1989); R. Ling, *Roman Painting* (Cambridge, 1991); L. Villard, ed., *Couleur et vision dans l'Antiquité classique* (Rouen, 2002); A. Rouveret, S. Dubel, and V. Naas, eds., *Couleurs et matières dans l'Antiquité: Textes, techniques et pratiques* (Paris, 2006).

16. J. André, *Étude sur les termes de couleur dans la langue latine* (Paris, 1949).

17. E. Irwin, *Colour Terms in Greek Poetry* (Toronto, 1974); P. G. Maxwell-Stuart, *Studies in Greek Color Terminology*, vol. 1 (Leyden, 1981).

18. *Rubeus* is only a form of *ruber*: it does not add any particular nuance.

19. The other terms Latin offers for naming the various shades of black are more rare: *fiscus* characterizes what is dark but not completely black; *furvus* is closer to brown than to black; *piceus* and *coracinus* signify "black like pitch" and "black like the crow"; *pullus, ravus, canus*, and *cinereus* belong more to the range of grays than to the range of blacks. On the Latin lexicon for black, see André, *Étude sur les termes de couleur*, 43–63.

20. Ibid., 25–38.

21. For the Romance languages, see A. M. Kristol, *Color: Les langues romanes devant le phénomène de la couleur* (Bern, 1978).

22. A. Ott, *Étude sur les couleurs en vieux français* (Paris, 1900); B. Schäfer, *Die Semantik der Farbadjektive im Altfranzösischen* (Tübingen, 1987).

23. H. Kees, *Farbensymbolik in ägyptischen religiösen Texten* (Göttingen, 1943); P. Reuterswärd, *Studien zur Polychromie der Plastik: Aegypten* (Uppsala, 1958); G. Posener, S. Sauneron, and J. Yoyotte, *Dictionnaire de la civilisation égyptienne* (Paris, 1959), 70–72 and 215; I. Franco, *Nouveau dictionnaire de mythologie égyptienne* (Paris, 1999), 60–61.

24. Song of Sol. 1:5.

25. John 8:12, 12:46; Matt. 17:2; 2 Cor. 6:6; and so on.

26. Matt. 13:43; Acts 21:23, 22:4, and so on.

27. Matt. 8:12, 22:13; Luke 13:28.

28. L. Luzzatto and R. Pompas, *Il significato dei colori nelle civiltà antiche* (Milan, 1988), 63–66.

29. André, *Étude sur les termes de couleur*, 71–72.

30. In Classical Latin, the adjective *cinereus*, the color of cinder, is reserved for plants and minerals.

31. There are many examples in Virgil, Horace, and Tibullus.

32. Aulu Gelle, *Noctes Atticae*, ed. C. Hosius (Leipzig, 1903), 19:7.6.

33. On sin, the devil, and the Christian hell, see chapter 2 of this book.

34. On Hel, daughter of Loki and goddess of hell in Nordic mythology, see G. Dumezil, *Loki* (Paris, 1948), 51–54. For a more general overview, see also R. Boyer, *La Mort chez les anciens scandinaves* (Paris, 1994); P. Guerra, *Dieux et mythes nordiques* (Lille, 1998).

35. Often Odin is characterized as Rabengott, "god of the crow."

36. *Gesta regis Canutonis* in *Monumenta Germaniae Historica, series Scriptores rerum Garmanicarum* 18 (Leipzig, 1865), 123 and following.

37. G. Scheibelreiter, *Tiernamen und Wappenwesen* (Vienna, 1976), 41–44, 66–67, 101–2. There are many masculine names derived from that of the crow (*hrabna* in Proto-German; *hraban* in Old High German): Berthram, Chramsind, Frambert, Guntrham, Hraban, Ingraban, Wolfram, and so on. The missionaries, setting out to evangelize Germany in the period of Charlemagne and then Scandinavia two centuries later, condemned them as too "wild" and tried to impose the names of apostles or saints as christened names. But once Latinized many of these Germanic names endured until the height of the Christian Middle Ages. Subsequently, a few even recovered a vernacular form and were handed down through generations into the contemporary period. The French first name *Bertrand*, for example, is heir to the distant Germanic *Berthram*, meaning "strong, skillful (or shiny) as the crow."

38. Ibid., 29–40. See also G. Müller, "Germanische Tiersymbolik und Namengebung," in *Probleme der Namenforschung*, ed. H. Steger (Berlin, 1977), 425–48.

39. B. Laurioux, "Manger l'impur: Animaux et interdits alimentaires durant le haut Moyen Âge," *Homme, animal et société* 3 (Toulouse, 1989): 73–87; M. Pastoureau, *L'Ours: Histoire d'un roi déchu* (Paris, 2007), 65–66.

40. Cited by M. A. Wagner, *Le Cheval dans les croyances germaniques: Paganisme, christianisme et traditions* (Paris, 2005), 467–69.

41. At least this is the interpretation given by the church fathers and the medieval theologians.

42. Gen. 8:6–14.

43. In the Bible, the only positive crows seem to be the ones that, following orders from the Almighty, come to feed the prophet Elijah, who has withdrawn to the wilderness (1 Kings 17:1–7). They will serve as modes for the many nurturing crows appearing in medieval hagiography.

44. The light/dark opposition is natural, but the white/black opposition is totally cultural. Furthermore, the two do not perfectly coincide.

45. The best-known version of the story of the beautiful Coronis is the one recounted by Ovid in his *Metamorphoses*, 2:542–632. See J. Pollard, *Birds in Greek Life and Myth* (New York, 1977), 123 and following; Grimal, *Dictionnaire de la mythologie*, 100–101.

46. On the role of crows in Greek and Roman divinatory practices: A. Bouché-Leclercq, *Histoire de la divination dans l'Antiquité*, 4 vols. (Paris, 1879–82); R. Bloch, *La Divination dans l'Antiquité*, 4th ed. (Paris, 1984); J. Prieur, *Les Animaux sacrés dans l'Antiquité* (Rennes, 1988).

47. Pliny, *Histoire naturelle*, book 10, chap. 15, 633, J. André, ed. (Paris, 1961), 39.

48. Many articles stressing the intelligence of the raven and crow have recently been published in British and American scientific journals. A summary of them can be found in T. Bugnyar and B. Heinrich, "Ravens (*Corvus corax*)," *Proceedings of the Royal Society* (London) 272 (2005): 1641–46.

49. *Regula sancti Benedicti*, chap. 55 (*De vestiario vel calciario fratrum*), art. 7: "De quarum rerum omnium colore aut grossitudine non causentur monachi"

50. See chapter 2 of this book.

51. *De sacrosancti altaris mysterio*, in J.-P. Migne, *Patrologia latina*, 217:774–916 (colors: 799–802).

52. A fourth color for ordinary days is sometimes added to this basic triad: green, considered as intermediary for the other three.

53. M. Pastoureau, *Bleu: Histoire d'une couleur* (Paris, 2000), 49–65.

54. For the chansons de geste, see the beautiful book by Grisward, *Archéologie de l'épopée médiévale*.

55. J. Berlioz, "La petite robe rouge," in *Formes médiévales du conte merveilleux*, ed. J. Berlioz, C. Brémond, and C. Velay-Vallantin (Paris, 1989), 133–39.

56. In *Snow White*, for example, for which no medieval version seems to exist, a *black* witch offers a poisoned red apple to a young girl, *white* as snow.

57. On the chess game's arrival in the West, and color changes for the pieces and the board, see M. Pastoureau, *Une histoire symbolique du Moyen Âge occidental* (Paris, 2004), 269–91.

58. X. R. Marino Ferro, *Symboles animaux: Un dictionnaire des représentations et des croyances en Occident* (Paris, 2004), 118–21 and 324.

IN THE DEVIL'S PALETTE

1. J. Le Goff, *La Naissance du Purgatoire* (Paris, 1991).

2. Job 1:6–12 and 2:1–7.

3. On the medieval iconography of hell, see J. Baschet, *Les Justices de l'au-delà: Les représentations de l'enfer en France et en Italie, XIIe–XVe siècle* (Rome, 1993).

4. In the late Middle Ages, avarice was sometimes associated with yellow.

5. Raoul Glaber, *Histoires*, ed. M. Prou (Paris, 1886), 123; E. Pognon, *L'An mille* (Paris, 1947), 45–144.

6. R. Gradwohl, "Die Farben im Alten Testament: Eine terminologische Studie," *Beihefte zur Zeitschrift für die alttestamentliche Wissenschaft* 83 (1963): 1–123; H. F. Janssen, "Les couleurs dans la Bible hébraïque," *Annuaire de l'Insititut de Philologie et d'histoire orientale* 14 (1954–57): 145–71.

7. M. Pastoureau, *Bleu: Histoire d'une couleur* (Paris, 2000), 22–47.

8. M. Pastoureau, "*Ceci est mon sang*: Le christianisme médiéval et la couleur rouge," in *Le Pressoir mystique: Actes du colloque de Recloses*, ed. D. Alexandre-Bidon (Paris, 1990), 43–56.

9. M. Pastoureau, "Les cisterciens et la couleur au XIIe siècle," *L'Ordre cistercien et le Berry* (colloquium, Bourges, 1998), *Cahiers d'archéologie et d'histoire du Berry* 136 (1998): 21–30.

10. Nevertheless a few vestiges of the crow's ancient prestige among the Celts and the Germans survive in the medieval West: first of all, in anthroponymy, which grants this bird a considerable place; then in hagiography, which presents many nurturing crows (in the image of the crow of the prophet Elijah), companions of more or less important saints; and finally in symbolism, which maintains until very late the ancient primary role this bird played in barbarian insignia. When heraldry created its first animal representations, during the course of the twelfth century, it fused into a single figure (body facing forward, head in profile) the German crow with the Roman eagle.

11. 1 Sam. 17:34, 2 Kings 2:24, Prov. 28:15, Dan. 7:5, Hos. 13:8, Amos 5:19, and so on.

12. "Ursus est diabolus." *Sermones* 18:34 (old edition in *Patrologia latina* 39:1819: commentary on David's combat against a bear and a lion).

13. M. Pastoureau, *L'Ours: Histoire d'un roi déchu* (Paris, 2007), 123–210.

14. L. Bobis, *Le Chat: Histoires et légendes* (Paris, 2000), 189–240.

15. Augustine, *Ennaratio in Psalmum 79, Patrologia latina* 36:1025.

16. *Aper a feritate vocatus, ablata f littera et subrogata p dicitur.* "The wild boar (*aper*) is thus named after its ferocity (*a feritate*) by substituting F with P." Isidore of Seville, *Étymologiae*, ed. J. André (Paris, 1986), 37 (chap. 1, §27). This etymology *per commutationem litterarum* will be taken up by Papias, and then by all authors until the thirteenth century.

17. Thomas de Cantimpré, *Liber de natura rerum*, ed. H. Böse (Berlin, 1973), 109.

18. This lovely expression comes from François Poplin.

19. M. Pastoureau, "Chasser le sanglier: Du gibier royal à la bête impure. Histoire d'une dévaloisation," in *Une histoire symbolique du Moyen Âge occidental* (Paris, 2004), 65–77.

20. M. Pastoureau, *L'Étoffe du Diable: Une histoire des rayures et des tissus rayés* (Paris, 1991), 37–47.

21. This idea was already present in Aristotle and Theophrastus, and endured throughout the Middle Ages, reinforced by the discoveries of Islamic scholars. All the same, the idea that color was a substance, likening it to an envelope, did not disappear. In the thirteenth century, for example, most of the Franciscan scholars at Oxford who speculated on and wrote about color, made it both a material substance and a part of light. For a history of theories involving the nature of colors, see J. Gage's work *Colour and Culture: Practice and Meaning from Antiquity to Abstraction* (London, 1993) (very extensive bibliography). On the evolution of Aristotelian theories: M. Hudeczek, "De lumine et coloribus (selon Albert le Grand)," *Angelicum* 21 (1944): 112–38; P. Kucharski, "Sur la théorie des couleurs et des saveurs dans le 'De sensu' aristotélicien," *Revue des études grecques* 67 (1954): 355–90; B. S. Eastwood, "Robert Grosseteste's Theory on the Rainbow," *Archives internationales d'histoire des sciences* 19 (1966): 313–32.

22. On Suger's attitude toward art, color, and light: Paul Verdier, *Réflexions sur l'esthétique de Suger*, in *Mélanges E.-R. Labande* (Paris, 1975), 699–709; E. Panofsky, *Abbot Suger on the Abbey Church of St. Denis and Its Art Treasure*, 2nd ed. (Princeton, 1979); Louis Grodecki, *Les Vitraux de Saint-Denis: Histoire et restitution* (Paris, 1976); S. M. Crosby et al., *The Royal Abbey of Saint-Denis in the Time of Abbot Suger (1122–1151)* (New York, 1981).

23. Edited and translated by J. Leclercq (Paris, 1945), replaced by F. Gasparri's edition: Suger, *Oeuvres*, vol. 1 (Paris, 1996), 1–53.

24. See the lexicons and indices accompanying the Mabillon (1690), Migne (*Patrologia latina* 182 and 183), which essentially repeats Mabillon, and Leclerc-Talbot-Rochais (from 1957) editions. All the volumes, unfortunately, do not include them. Also consult C. Mohrnmann, *Observations sur la langue et le style de saint Bernard*, in *Sancti Bernardi opera*, vol. 11, ed. Leclerc-Talbot-Rochais (Rome, 1958), 9–33.

25. On Saint Bernard and color, Pastoureau, "Les cisterciens et la couleur."

26. General histories of clothing offer little accurate information on the dress of monks and religious figures. The only work specifically devoted to this subject dates from the seventeenth century; it can still be of some use: P. Helyot, *Histoire complète et costume des ordres monastiques, religieux et militaires*, 8 vols. (Paris, 1714–21).

27. *De quarum rerum omnium colore aut grossitudine non causentur monachi. Regula sancti Benedicti*, chap. 55 (*De vestiario vel calciario fratrum . . .*), art. 7.

28. M. Pastoureau, *Jésus chez les teinturiers: Couleur et teinture dans l'Occident médiéval* (Paris, 1998), 121–26.

29. The reforming work of Benoît of Aniance and the great *Capitulare monasticum* of 817 did not legislate at all on the subject of color, however. "Monks' black" appeared in current speech, and not in statutes or regulations.

30. That is, for example, how Ordéric Vital repeatedly characterized them in his chronicle. Similarly the early constitutions of the order, as they are reflected in the 1114 charter of Charity, prohibited dyed and unusual fabrics (*panni tincti et curiosi ab ordine nostro penitus excluduntur*).

31. There are a few useful remarks however in J.-O. Ducourneau, "Les origines cisterciennes (VI)," *Revue Mabillon* 23 (1933): 103–10.

32. The text of this letter, essential on many points, can be found in the fine edition by G. Constable, *The Letters of Peter the Venerable*, vol. 1 (Cambridge, Mass., 1967), 55–58 (letter no. 28). Also see the conciliatory letter of 1144 (no. 111), 285–90.

33. A recurring theme in many letters from the years 1124–25, and taken up again in the *Apologia ad Gulielmum*. The debate on the merits and meanings of white in comparison to black also enters into the anonymous response to the *Apologie à Guillaume de Saint-Thierry*, written by an English Benedictine monk about 1127–28 (see *Revue bénédictine* [1934]: 296–344).

34. This conflict between Cistercians and Cluniacs gave rise to an extensive bibliography. With regard to the issues that concern us here, see especially: M. D. Knowles, *Cistercians and Cluniacs: The Controversy between St. Bernard and Peter the Venerable* (Oxford, 1955); A. H. Bredo, *Cluny et Cîteaux au douzième siècle: L'histoire d'une controverse monastique* (Amsterdam, 1986).

35. Bleaching with chlorine and chlorides did not exist before the end of the eighteenth century, as this substance was not discovered until 1774. Bleaching with a sulfur base was possible but unreliable, and it could ruin wool and silk. In effect, the cloth had to be immersed in a bath of diluted sulfurous acid; if there was too much water, the bleaching was ineffective, and if there was too much acid, the material was damaged.

36. We must not confuse actual sheets dyed white (even if this was a difficult operation with disappointing results) with the many "white" sheets mentioned in merchant and accounting documents. These "white" sheets were luxury fabrics, undyed, exported great distances from their place of production. They were dyed at their place of destination. See H. Laurant, *Un grand commerce d'exportation au Moyen Âge: La draperie des Pays-Bas en France et dans les pays méditerranéens (XIIᵉ–XVᵉ s.)* (Paris, 1935), 210–11. The precocious use of the adjective *white* in the sense of "not colored" is extremely interesting here. It prepares the way for the association modern science and sensibilities later made between "white" and "colorless."

37. On the origins, appearance, and spread of the first coats of arms, M. Pastoureau, *Traité d'héraldique*, 2nd ed. (Paris, 1993), 20–58 and 298–309.

38. The first five colors are encountered everywhere and with very great frequency in the coats of arms of all periods and all regions. The sixth, green, is rarer, but the reasons for this rarity remain unknown. Moreover, a seventh color can be found even less frequently: *pourpre* (purple); it was used only occasionally and does not really constitute a full-fledged heraldic color.

39. In the contemporary period, this absolute, almost abstract quality of heraldic colors was taken up again in the code of flags. No constitutional text defined, for example, the blue and red of the French flag. These were emblematic, and thus absolute colors. They could be produced using all sorts of shades (which, moreover, were changed by the weather) without altering the meaning of the flag in the least.

40. On the heraldic colors and the various questions they raise, Pastoureau, *Traité d'héraldique*, 100–121.

41. On all these figures, ibid., 115–21.

42. H. E. Korn, *Adler und Doppeladler: Ein Zeichen im Wandel der Geschichte* (Marburg, 1976).

43. R. Delort, *Le Commerce des fourrures en Occident à la fin du Moyen Âge, vers 1300–vers 1450* (Rome, 1978).

44. A. Ott, *Étude sur les couleurs en vieux français* (Paris, 1900), 31–32.

45. G. J. Brault, *Early Blazon: Heraldic Terminology in the XIIth and XIIIth Centuries, with Special Reference to Arthurian Literature* (Oxford, 1972), 271; Pastoureau, *Traité d'héraldique*, 101–5. Let us remember that the word *aigle* (eagle) is feminine in heraldry.

46. Not only the knight's shield but also his tunic, banner, and horse's cover were monochromatic, and seen as such from a long way off. That is why the texts speak of a red knight, a white knight, a black knight, and so on.

47. The choice of the word that qualifies the color red sometimes offers additional precision: a *vermeil* (vermilion) knight is thus of high birth (even while remaining a disturbing character); an *affoué* (from the Latin *affocatus*) knight is quick-tempered; a *sanglant* (bloody) knight is cruel and brings death; a *roux* (auburn) knight is treacherous and hypocritical.

48. In the fourteenth century, on the other hand, certain white knights in literary texts become a bit disquieting and maintain ambiguous relationships with death and the world of ghosts. But that was unknown before 1320–40 (except perhaps in northern European literature).

49. See the complete inventory of these monochromatic Arthurian knights in Brault, *Early Blazon*, 31–35. Also see the examples cited by M. de Combarieu, "Les couleurs dans le cycle du *Lancelot-Graal*," *Senefiance* 24 (1988): 451–588.

50. Blue did not signify anything. Or at least it was still too impoverished in terms of heraldry and symbolism to be used as a narrative motif. In a story, the sudden appearance of a blue knight would not be meaningful to a reader or listener. It was still too early; the promotion of the color blue in the social codes and symbolic systems had not yet occurred, and the color code for knights encountered in the course of adventures was basically fixed before blue arrived. See Pastoureau, *Bleu*, 59–60.

51. W. Scott, *Ivanhoe*, chap. 12. See M. Pastoureau, "Le Moyen Âge d'Ivanhoé: A best-seller à l'époque romantique," in *Une histoire symbolique*, 327–38.

A FASHIONABLE COLOR

1. For example, in Padua, in the famous frescos of the Scrovegni chapel painted by Giotto in 1303–5.

2. A list and critical study of these attributes can be found in the usual iconographical catalogues, notably L. Réau, *Iconographie de l'art chrétien*, vol. 2.2 (Paris, 1957), 406–10; G. Schiller, *Iconography of Christian Art*, vol. 2 (London, 1972), 29–30, 164–80, 494–501; E. Kirschbaum, ed., *Lexikon der christlichen Ikonographie*, vol. 2 (Freiburg, 1970), cols. 444–48. Also see M. Pastoureau, *Une histoire symbolique du Moyen Âge occidental* (Paris, 2004), 197–209.

3. S. Kantor, "*Blanc et noir* dans l'épique française et espagnole: Dénotation et connotation," *Studi medievali* 25 (1984): 145–99.

4. P. Bancourt, *Les Musulmans dans les chansons de geste du cycle du roi*, vol. 1 (Aix-en-Provence, 1882), 67–68.

5. *La Prise d'Orange*, ed. C. Regnier (Paris, 1966), verses 376–80 and 776–79.

6. Chrétien de Troyes, *Arthurian Romances*, trans. and introduced by William W. Kibler (Penguin, 1991), 298

7. Ibid., 382.

8. Chrétien de Troyes, *Le Conte du Graal*, vol. 1, ed. F. Lecoy (Paris, 1975), verses 4596–4608.

9. This example is the famous enameled pulpit of Klosterneuburg (Austria), completed about 1180–81 by the great silversmith Nicolas de Verdun.

10. L. Réau, *Iconographie de l'art chrétien*, vol. 2.1 (Paris, 1956), 296–97.

11. J. Pirenne, *La Légende du Prêtre Jean* (Strasbourg, 1992).

12. *Armorial du héraut Gelre*, ed. P. Adam-Even (Neuchâtel, 1971), 17, nos. 56, 57, 58.

13. See the beautiful book by G. Suckale-Redlefsen, *Mauritius, der heilige Mohr: The Black Saint Maurice* (Houston, 1987).

14. In seventeenth-century Paris the saint appeared on horseback: *de gueules à un saint Maurice à cheval d'argent*. But most frequently depicted (Nuremberg, Brussels, Milan) was a standing Saint Maurice, holding a shield *de gueules au rais d'escarboucle d'or*.

15. Paris, Nat. Arch. Y 6/5, fol. 98.

16. On the character and legend of Saint Maurice: J. Devisse and M. Mollat, *L'Image du noir dans l'art occidental: Des premiers siècles chrétiens aux grandes découvertes*, vol. 1 (Fribourg, 1979), 149–204, and Suckale-Redlefsen, *Mauritius, der heilige Mohr*.

17. Matt. 17:1–13; Mark 9:1–12; Luke 9:28–36.

18. E. Mâle, *L'Art religieux du XIIe siècle en France* (Paris, 1992), 93–96; Réau, *Iconographie de l'art chrétien*, 2.2:574–78.

19. Réau, *Iconographie de l'art chrétien*, 2.2:288, is wrong in claiming that the episode of Jesus with the dyer gives rise only to a single iconographical piece of evidence. This iconography is relatively abundant, but it is not the subject of recent studies. See E. Kirschbaum, ed., *Lexikon der christlichen Ikonographie*, vol. 3 (Freiburg im Brisgau, 1971), cols. 39–85 (*Leben Jesu*).

20. On this legend, allow me to cite my study *Jésus chez le teinturier: Couleurs et teintures dans l'Occident médiéval* (Paris, 1998).

21. In many thirteenth- and fourteenth-century manuscripts, the miracle involving the dyer of Tiberias is presented as the first one performed by Jesus upon returning from Egypt. That is an indication of the importance it was given in this period.

22. Much blame, real or imagined, was laid on dyers: they officiated in mysterious cavernous workshops, similar to the abyss of hell; they dirtied the waters of the river and fouled the city air; they were in constant conflict with one another and everyone else. These were creatures of the devil.

23. On the chromatic evolution of the different versions and, more generally, on the important case constituted by this episode drawn from the gospels of the childhood, Pastoureau, *Jésus chez le teinturier: Couleurs et teintures dans l'Occident médiéval* (Paris, 1998).

24. The oldest statutes we have regulating the dyeing trade are from Venice. They date from the year 1243, but it is likely that as early as the late twelfth century, these dyers had already assembled into a *confraternità*. See F. Brunellow, *L'arte della tintura nella storia dell'umanita* (Vicenza, 1968), 140–41. In the enormous compendium by G. Monticolo, *I capitolari delle arti veneziane . . .* , 4 vols. (Rome, 1896–1914), there is a great quantity of information regarding the dyers' trades in Venice from the thirteenth to eighteenth centuries. In the Middle Ages, Venetian dyers seemed to have been much freer than those who worked in other Italian cities, notably Florence and Lucca. For the latter city, we have statutes from 1255, nearly as old as those from Venice. See P. Guerra, *Statuto dell'arte dei tintori di Lucca del 1255* (Lucca, 1864).

25. Isidore de Séville, *Etymologiae*, book 17, chap. 7, § 21, ed. J. André (Paris, 1986), 101.

26. On the bad reputation of the walnut, J. Brosse, *Les Arbres de France: Histoire et légende* (Paris, 1987), 137–38; Pastoureau, *Une Histoire symbolique*, 96–97.

27. Let us note that, as they appear in images, judges, doctors, and university professors long remained dressed in red when they were represented as actively performing their functions.

28. Despite a few monographs on one city or another, these sumptuary laws are still awaiting their historians. Among the older works, see especially F. E. Baldwin, *Sumptuary Legislation and Personal Relation in England* (Baltimore, 1926); L. C. Eisenhard, *Kleiderordnungen der deutschen Städte zwischen 1350–1700* (Göttingen, 1962) (probably the best work ever devoted to the dress laws); V. Baur, *Kleiderordnungen in Bayern vom 14. Bis 19. Jahrhundert* (Munich, 1975); D. O. Hugues, "Sumptuary Laws and Social Relations in Renaissance Italy," in *Disputes and Settlements: Law and Human Relations in the West*, ed. J. Bossy (Cambridge, 1983), 69–99; D. O. Hugues, "La moda proibita," in *Memoria: Rivista di storia delle donne* 11–12 (1986): 82–105.

29. Actually, the phenomenon was not new. Already in ancient Greece and Rome fortunes were spent for clothing and for dyeing cloth. Many sumptuary laws attempted in vain to remedy that situation (for Rome, for example, see the thesis by D. Miles, *Forbidden Pleasures: Sumptuary Laws and the Ideology of Moral Decline in Ancient Rome* (London, 1987). In his Art of Love (3, 171–72), Ovid mocks the wives of Roman magistrates and patricians who wear clothes, the colors of which cost a fortune: "Cum tot prodierunt pretio levore colores / Quis furor est census corpore ferre suos!" (When one finds so many colors at an inexpensive price / What madness to wear upon oneself all one's fortune!).

30. See with regard to marriages and funerals in Siena in the fourteenth century, the examples cited by M. A. Crepari Ridolfi and P. Turrini, *Il mulino delle vanità: Lusso e cerimonie nella Siena medievale* (Siena, 1996), 31–75. More generally, on the madness of numbers in the late Middle Ages, see J. Chiffoleau, *La Compatabilité de l'au-delà: Les hommes, la mort et la religion dans la région d'Avignon à la fin du Moyen Âge (vers 1320–vers 1480)* (Rome, 1981).

31. M. Pastoureau, *L'Étoffe du Diable: Une histoire des rayures et des tissus rayés* (Paris, 1991), 17–37.

32. New works on all the discriminatory marks and signs of infamy would be welcome. While awaiting a comprehensive study, we are forced to return, once again, to the mediocre work of Ulysse Robert, "Les signes d'infamie au Moyen Âge: Juifs, sarrasins, hérétiques, lépreux, cagots et filles publiques," *Mémoires de la Société nationale des Antiquaires de France* 49 (1888): 57–172. This work, now outdated in many regards, can be supplemented with the bits of new information published in recent articles and works on prostitutes, lepers, outcasts, Jews, heretics, and all those excluded from and condemned by medieval society.

33. S. Grayzel, *The Church and the Jews in the XIIIth Century*, 2nd ed. (New York, 1966), 60–70 and 308–9. Let us note, however, that this same Fourth Lateran Council also required prostitutes to wear marks or specific articles of clothing.

34. Is that because at the end of the Middle Ages it represented a color that was too highly valued or that bestowed too much value to participate in such a sign system? Or, rather, was it henceforth too commonly used in clothing to constitute a divergence, a distinctive mark visible from a distance? Or again, as I am most inclined to believe, was it because the beginnings of these chromatic marks—which remain to be studied—took place before the social promotion of the color blue, even before the Fourth Lateran Council (1215), when blue was still too poor symbolically to have any real meaning in terms of dress or identification? See M. Pastoureau, *Bleu: Histoire d'une couleur*, 2nd ed. (Paris, 2006), 73–85.

35. In Scotland a dress regulation dated from 1457 prescribed that peasants wear gray clothes for ordinary days and reserve blue, red, and green for holidays. *Acts of Parliament of Scotland*, vol. 2 (London, 1966), 49, § 13. See A. Hunt, *Governance of the Consuming Passions: A History of Sumptuary Law* (London, 1966), 129.

36. I use the word *patrician* here intentionally, a word that however convenient (too convenient) is now avoided or rejected by some historians. This term has the advantage nevertheless of encompassing various realities and of being as applicable to Italian cities as to those in Germany and Holland. On the contested use of this word: P. Monnet, "Doit-on encore parler de patriciat dans les villes allemandes à la fin du Moyen Âge?" in *Mission historique française en Allemagne. Bulletin* 32 (June 1996): 54–66.

37. On the prices of various fabrics according to the colors they were dyed, see the very instructive tables published by A. Doren, *Studien aus der Florentiner Wirtschaftsgeschichte*, vol. 1, *Die Florentiner Wollentuchindustrie* (Stuttgart, 1901), 506–17. For Venice, see also the old study by B. Cechetti, *La via dei Veneziani nel 1300. Le veste* (Venice, 1886).

38. I would like to thank Claire Boudreau for sending me the edition of the text that she is preparing of the Sicilian herald. This passage comes from the fifth chapter. I adapted it here into modern French.

39. Numerous detailed archival sources have made it possible for many authors to study the color fashions in the fourteenth- and fifteenth-century Savoy court; it would be nice to have such sources available for other courts. See L. Costa de Beauregard, "Souvenirs du règne d'Amédée VIII . . . : Trousseau de Marie de Savoie," *Mémoires de l'Académie impériale de Savoie,* ser. 2, no. 4 (1861): 169–203; M. Bruchet, *Le Château de Ripaille* (Paris, 1907), 361–62; N. Pollini, *La Mort du prince: Les rituels funèbres de la Maison de Savoie (1343–1451)* (Lausanne, 1993), 40–43; and especially A. Page, *Vêtir le prince: Tissus et couleurs à la cour de Savoie (1427–1457)* (Lausanne, 1993), 59–104 and passim.

40. On Philip the Good and the color black: E. L. Lory, "Les obsèques de Philippe le Bon . . . ," *Mémoires de la Commission des Antiquités du département de la Côte d'Or* 7 (1865–69): 215–46; O. Cartellieri, *La Cour des ducs de Bourgogne* (Paris, 1946), 71–99; M. Beaulieu and J. Baylé, *Le Costume en Bourgogne de Philippe le Hardi à Charles le Téméraire* (Paris, 1956), 23–26 and 119–21; A. Grunzweig, "Le grand duc du Ponant," *Moyen Âge* 62 (1956): 119–65; R. Vaughan, *Philip the Good: The Apogee of Burgundy* (London, 1970).

41. See, for example, the explanations of Georges Chastellain, who in his chronicle devotes lengthy detail to the Montereau murder (it is even the point of departure for his account) and to the way in which Philip the Good devotes himself to black. G. Chastellain, *Oeuvres,* vol. 3, ed. E. Kervyn de Lettenhove (Brussels, 1865), 213–36.

42. R. Vaughan, *John the Fearless: The Growth of Burgundian Power* (London, 1966).

43. A few decades later, in South America, Europeans found different tropical trees that provided wood with the same tinctorial properties as *brasileum,* but to an even greater extent. They named this land of plenty, possessing such trees in abundance, "Brazil."

44. L. Hablot, "La Devise, mise en signe du prince, mise en scène du pouvoir," thesis (Poitiers, 2001), *Deviser,* vol. 2, 460, 480, and passim.

45. Sicile, héraut d'armes du XVe siècle, *Le Blason des couleurs en armes, livrées et devises,* ed. H. Cocheris (Paris, 1860), 64.

46. On gray as the symbol of hope at the end of the Middle Ages, see the fine article by A. Planche, "Le gris de l'espoir," *Romania* 94 (1973): 289–302.

47. Charles d'Orléans, *Poésies,* ed. P. Champion, 2 vols. (Paris, 1966–71), song 81, 5–8.

48. Ibid., ballad 82, 28–31.

49. Planche, "Le gris de l'espoir," 292.

50. C. de Mérindol, *Les Fêtes de chevalerie à la cour du roi René: Emblématique, art et histoire* (Paris, 1993).

THE BIRTH OF THE WORLD IN BLACK AND WHITE

1. A. Ott, *Étude sur les couleurs en vieux français* (Paris, 1900), 19–33. See also A. Mollard-Desfour, *Le Dictionnaire des mots et expressions de couleur: Le noir* (Paris, 2005), passim.

2. On the origins of printing, again and as ever: L. Febvre and H.-J. Martin, *L'Apparition du livre,* 2nd ed. (Paris, 1971).

3. M. Zerdoun, *Les Encres noires au Moyen Âge* (Paris, 1983).

4. On paper and its role in the appearance of printing: A. Blanchet, *Essai sur l'histoire du papier* (Paris, 1900); A. Blum, *Les Origines du papier, de l'imprimerie et de la gravure,* 2nd ed. (Paris, 1935); Febvre and Martin, *L'Apparition du livre.*

5. On Newton's discoveries and their consequences, M. Blay, *Les Figures de l'arc-en-ciel* (Paris, 1995), 60–77. See also, of course, Newton's texts themselves, especially *Opticks or a Treatise of the Reflexions, Refractions, Inflexions and Colours of Light* (London, 1704) (French translation by Pierre Coste published in Amsterdam in 1720 and in Paris in 1722; reprinted Paris 1955).

6. The first printed book to include engraved images from woodcuts was a collection of fables, from the presses of Albrecht Pfister in Bamburg in 1460.

7. For the information they have provided me on this subject, I would like to thank Danièle Sansy and my team of students who worked on the inventory of woodcuts appearing in the Parisian incunabla housed in the Réserve des Imprimés of the Bibliothèque Nationale de France.

8. A few timid attempts nonetheless in W. M. Ivins, *How Prints Look: Photographs with Commentary,* new ed. (Boston, 1987), and in S. Lambert, *The Image Multiplied: Five Centuries of Printed Reproductions of Paintings and Drawings* (London, 1987), 87–106.

9. H. Hymans, *Histoire de la gravure dans l'école de Rubens* (Brussels, 1879), 451–53; H. Hymans, *Lucas Vorsterman* (Brussels, 1893), 123 and following.

10. I want to thank my friend Maxime Préaud for drawing my attention to the relationship between Rubens and Vorsterman. The controversies between these two artists with regard to rendering colors in engravings warrant detailed study. On Rubens and the issues of color in the first half of the seventeenth century, see the suggestive study by M. Jaffé, "Rubens and Optics: Some Fresh Evidence," *Journal of the Warburg and Courtauld Institute* 34 (1971): 362–66, as well as the work by W. Jaeger, *Die Illustrationen des Peter Paul Rubens zum Lehrbuch der Optik des Franciscus Aguilonius* (Berlin, 1976).

11. See on this subject M.-T. Gousset and P. Stirnemann, "Indications de couleur dans les manuscrits médiévaux," in *Pigments et colorants de l'Antiquité et du Moyen Âge,* ed. B. Guineau (Paris, 1990), 189–99.

12. See the table of these correspondences that I published in my *Traité d'héraldique* (Paris, 1993), 112. See also A. C. Fox-Davies, *The Art of Heraldry* (London, 1904), 48–49.

13. As some maps are not dated, scholars do not agree about how to determine the oldest example of the use of a system of hachures to code heraldic colors on maps. See *Annales de bibliophilie belge et hollandaise* (1865), 23 and following; *Revue de la Société française des collectionneurs d'ex-libris* (1903), 6–8; D. L. Galbreath, *Manuel du blason* (Lausanne, 1942), 84–85 and 323; J. K. von Schroeder, "Über Alter und Herkunft der heraldischen Schaffierungen," in *Der Herold* (1969), 67–68. According to this last author, the system of heraldic hachures appeared as early as 1578–80 on a few geography maps, but his arguments seem shaky.

14. No map historians seem to be interested in these questions. Father F. de Dainville does not mention them in his *Langage des géographes*

(Paris, 1964). On the other hand, he speaks at length about the washes on maps and the conventional coding system of the colors used for them (329 and following) and refers to the eighteenth-century work most frequently cited on this subject, by G. Buchotte, *Les Règles du dessin et du lavis* (Paris, 1721, 2nd ed. 1754).

15. G. Seyler, *Geschichte der Heraldik* (Nuremberg, 1890), 591–93, lists the works published in the first half of the seventeenth century in which engravers tried to code the colors of heraldry using a system of hachures and guilloche. These works nearly all come from Flemish or Rhenish presses, and the systems can be grouped into three large categories, according to whether or not they use dots in addition to lines.

16. *Tesserae gentilitiae a Silvestro Pietra Sancta, romano, Societatis Jesu, ex legibus fecialium descriptae* (Rome, F. Corbelletti, 1638), 59–60. See the long note that Joannis Guigard devotes to this work in his *Armorial du bibliophile* (Paris, 1895).

17. To code black (sable), the line engraver always used horizontal and vertical lines crossing perpendicularly, but the woodcut engraver, who also followed this practice, could sometimes use a simple application of black ink, which was obviously impossible to obtain with intaglio engraving.

18. Notably on a map of Brabant designed and drawn by Rincvelt, and engraved in 1600 by Zangrius. Seyler, *Geschichte der Heraldik*, 592 n. 15, believed he saw Pietra Santa's system used as early as 1623 in Brussels in the work of the architect Jacques Francquaert, *Pompa funebris optimi potentissimique principis Alberti Pii archiducis Austriae* I have unfortunately not been able to consult this work.

19. By 1640, the author, painter, and heraldist Marc Wulson of La Colombière recommended that engravers no longer use letters or small figures to represent heraldic colors, but rather adopt a new, simpler, and more readable procedure: the system of dots and hachures that he himself used in a collection with commentary of seventy-five engraved plates of coats of arms, published by Melchior Tavernier. The name of Father Pietra Santa was not mentioned, but it was very much a matter of the same procedure. Wulson used it again in his subsequent works, notably his *Science héroïque* of 1644 and his *Vray théatre d'honneur et de chevalerie* of 1648. In doing so, he helped to ensure the success of this system of hachures in France. Most of the treatises on coats of arms and works on heraldry published in Paris and Lyon in the second half of the seventeenth century, especially the prolific opus of Father Claude-François Menestrier, resorted to it.

20. Sculpted coats of arms on fronts of seventeenth- and eighteenth-century buildings adorned, as is frequently the case, with heraldic hachures are particularly appalling. And when it is a matter of medieval or Renaissance buildings on which the coats of arms have been restored and provided with hachures—that is what Viollet-le-Duc and his followers usually do—an anachronism is added to the ugliness and absurdity. Today, heraldists continue to use this conventional system of dots and hachures, but they do so with a certain parsimoniousness; not only does this graphic code harmonize poorly with the contemporary heraldic style, which is spare and abstract, but it is not always legible when the coats of arms are small in size (bookplates, stationery, stamps), or when the engraving or printing is carelessly done.

21. The Reformation's "chromoclasm" still awaits its historians. On iconoclasm, on the other hand, excellent recent works exist: J. Philips, *The Reformation of Images: Destruction of Art in England (1553–1660)* (Berkeley, 1973); M. Warnke, *Bildersturm: Die Zerstörung des Kunstwerks* (Munich, 1973); M. Stirm, *Die Bildergrage in der Reformation*, Forschungen zur Reformationgeschicte, 45 (Gütersloh, 1977); C. Christensen, *Art and the Reformation in Germany* (Athens, Ga., 1979); S. Deyon and P. Lottin, *Les Casseurs de l'été 1566: L'iconoclasme dans le Nord* (Paris, 1981); G. Scavizzi, *Arte e architettura sacra: Cronache e documenti sulla controversia tra riformati e cattolici (1500–1550)* (Rome, 1981); H. D. Altendorf and P. Jezler, eds., *Bilderstreit: Kulturwandel in Zwinglis Reformation* (Zurich, 1984); D. Freedburg, *Iconoclasts and Their Motives* (Maarsen, Holland, 1985); C. M. Eire, *War against the Idols: The Reformation of Worship from Erasmus to Calvin* (Cambridge, Mass., 1986); D. Crouzet, *Les Guerriers de Dieu: La violence au temps des guerres de Religion*, 2 vols. (Paris, 1990); O. Christin, *Une révolution symbolique: L'Iconoclasme huguenot et la reconstruction catholique* (Paris, 1991). To these individual or collective works must be added the scholarly and voluminous catalogue of the *Iconoclasme* exposition (Bern and Strasbourg, 2001).

22. Among the great reformers, Luther actually seems to be the one to show the greatest tolerance toward the presence of color in the church, worship, art, and daily life. It is true that his essential concerns lay elsewhere, and that for him the Old Testament prohibitions against images were no longer truly valid under the regime of grace. Thus, for iconography, there sometimes arises a distinctive Lutherian attitude toward the arts and the uses of color. With regard to the general issue of the image for Luther (no study focusing particularly on color exists), see the fine article by Jean Wirth, "Le Dogme en image: Luther et l'iconography," in *Revue de l'art* 52 (1981): 9–21. See also the studies cited in the previous note, especially Christensen, *Art and the Reformation*, 50–56; Scavizzi, *Arte e architettura sacra*, 69–73; Eire, *War against the Idols*, 69–72.

23. Jer. 22:13–14; Ezek. 8:10.

24. Andreas Bodenstein von Karlstadt, *Von Abtung de Bylder . . .* (Wittenberg, 1522), 23 and 39. See also the passages cited by H. Barge, *Andreas Bodenstein von Karlstadt*, vol. 1 (Leipzig, 1905), 386–91, and C. Garside, *Zwingli and the Arts* (New Haven, 1966), 110–11.

25. M. Pastoureau, "L'incolore n'existe pas," in *Mélanges Philippe Junod* (Paris, 2003), 11–20.

26. Garside, *Zwingli and the Arts*, 155–56. See also the fine study by F. Schmidt-Claussing, *Zwingli als Liturgist* (Berlin, 1952).

27. Barge, *Andreas Bodenstein von Karlstadt*, 386; Stirm, *Die Bilderfrage in der Reformation*, 24.

28. Typical in this regard was the case of Luther. See Wirth, "Le Dogme en image," 9–21.

29. Garside, *Zwingli and the Arts*, chaps. 4 and 5.

30. *Institution de la religion christienne* (1560 text), 3.10:2.

31. This resonant quality of color in Rembrandt's painting, in combination with the power of the light, gives a religious dimension to most of his works, including the most secular of them. Within the vast bibliography,

see the Berlin conference (1970) volume by O. von Simson and J. Kelch, eds., *Neue Beiträge zur Rembrandt-Forschung* (Berlin, 1973).

32. Louis Martin, "Signe et representation: Philippe de Champaigne et Port-Royal," *Annales ESC* 25 (1970): 1–13.

33. Naked in earthly paradise, Adam and Eve receive clothing at the moment of their expulsion, intended to hide their nudity. This clothing is the symbol of their sin.

34. Calvin especially considered men who disguised themselves as women or animals an abomination. Hence the problem with theater.

35. The violent sermon *Oratio contra affectationem novitatis in vestitu* (1527), in which he recommends that all honest Christians wear clothing of dark and sober colors and not "distinctus a variis coloribus velut pavo." *Corpus reformatorum*, vol. 11, 139–49. See also vol. 2, 331–38.

36. On the revolution in dress recommended by the Anabaptists of Münster, R. Strupperich, *Das münsterische Täufertum* (Münster, 1958), 30–59.

37. F. Gaiffe, *L'Envers du Grand Siècle* (Paris, 1924).

38. See the table reproduced by D. Roche, *La Culture des apparences: Une histoire du vêtement (XVIIe–XVIIIe siècles)* (Paris, 1989), 127.

39. Cited by A. Gazier, "Racine and Port-Royal," *Revu d'histoire littéraire de la France* (January 1900), 1–27; see 14. See also R. Vincent, *L'Enfant de Port-Royal: Le roman de Jean Racine* (Paris, 1991).

40. J. Boulton, *Neighborhood and Society: A London Suburb in the Seventeenth Century* (Cambridge, 1987), 123.

41. L. Taylor, *Mourning Dress: A Costume and Social History* (London, 1983); J. Balsamo, ed., *Les Funérailles à la Renaissance* (Geneva, 2002).

42. N. Pellegrin and C. Winn, eds., *Veufs, veuves et veuvages dans la France d'Ancien Régime* (Paris, 2003), especially 219–46.

43. On the demonology of Jean Bodin: S. Houdard, *Les Sciences du Diable: Quatre discours sur la sorcellerie (XVe–XVIIe siècle)* (Paris, 1992); S. Clark, *Thinking with Demons: The Idea of Witchcraft in Early Modern Europe* (Oxford, 1997).

44. Within a vast bibliography, see especially, for the beginning of the modern era, J. B. Russel, *The Devil in the Modern World* (Ithaca, N.Y., 1986); M. Carmona, *Les Diables de Loudun* (Paris, 1988); B. P. Levack, *La Chasssse aux sorcières en Europe au début des temps modernes* (Seyssel, 1991); R. Muchembled, *Magie et sorcellerie du Moyen Âge à nos jours* (Paris, 1994); P. Stanford, *The Devil: A Biography* (London, 1996); Clark, *Thinking with Demons*.

45. Accounts and descriptions of sabbats in E. Delcambre, *Le Concept de sorcelleries dans le duché de Lorraine au XVIe et au XVIIe siècle*, 3 vols. (Nancy, 1949–52); P. Villette, *La Sorcellerie dans le nord de la France du XVe au XVIIe siècle* (Lille, 1956); L. Caro Baroja, *Les Sorcières et leur monde* (Paris, 1978); C. Ginzburg, *Le Sabbat des sorcières* (Paris, 1992); N. Jacques-Chaquin et M. Préaud, eds., *Le Sabbat des sorcieres en Europe (XVe–XVIIIe s.)* (Grenoble, 1993).

46. An overview of a multitude of negative beliefs involving black animals during the ancien régime is found in the work by the abbot J.-B. Thiers, *Traité des superstitions . . .* , 4 vols. (Paris, 1697–1704). See also the works of E. Rolland, *Faune populaire de France,* 13 vols. (Paris,

1877–1915), and by P. Sébillot, *Le Folklore de France*, new ed., 8 vols. (Paris, 1982–86).

47. In addition to the work by J.-B. Thiers cited in the previous note, see the various works by Robert Muchembled, notably *Culture populaire et culture des élites dans la France moderne (XVe–XVIIIe siècle)* (Paris, 1978).

48. On the relationship between the research of painters and of scholars in the seventeenth century, see especially A. E. Shapiro, "Artists' Colors and Newton's Colors," *Isis* 85 (1994): 600–630.

49. On the medieval history of theories involving vision: D. C. Lindberg, *Theories of Vision from Al-Kindi to Kepler* (Chicago, 1976); K. Tachau, *Vision and Certitude in the Age of Ockham: Optics, Epistemology and the Foundations of Semantics* (1250–1345) (Leiden, 1988).

50. Lindberg, *Theories of Vision*.

51. J. Kepler, *Astronomiae pars optica . . . De Modo visionis . . .* (Frankfurt am Main, 1604).

52. L. Savot, *Nova seu verius nova-antiqua de causis colorum sententia* (Paris, 1609).

53. A. De Boodt, *Gemmarum et lapidum historia* (Hanau, 1609).

54. F. d'Aguilon, *Opticorum libri sex* (Antwerp, 1613).

55. Kepler, *Astronomiae pars optica*.

56. R. Fludd, *Medicina catholica . . .* , 2 vols. (London 1629–31); what concerns colors is mostly found in volume 2.

57. The terminology and some of the "genealogical" classifications proposed by A. Kircher seem to be borrowed from the work of François d'Aquilon, *Opticorum libri sex* (Antwerp, 1613).

58. A. Kircher, *Ars magna lucis et umbrae* (Rome, 1646), 67 (*De multiplici varietate colorum*).

59. Robert Grosseteste, *De iride seu de iride et speculo*, vol. 9 of *Beiträge zur Geschichte der Philosophie des Mittelalters*, ed. L. Baur (Münster, 1912), 72–78; see also C. B. Boyer, "Robert Grosseteste on the Rainbow," *Osiris* 11 (1954): 247–58; B. S. Eastwood, "Robert Grosseteste's Theory of the Rainbow: A Chapter in the History of Non-Experimental Science," *Archives internationales d'histoire des sciences* 19 (1966): 313–32.

60. John Pecham, *De iride*, in *John Pecham and the Science of Optics: Perspectiva communis*, ed. D. C. Lindberg (Madison, Wis., 1970), 114–23.

61. Roger Bacon, *Opus majus*, ed. J. H. Bridges (Oxford, 1900), pt. 6, chaps. 2–11; see also D. C. Lindberg, "Roger Bacon's Theory of the Rainbow: Progress or Regress?" *Isis* 17 (1968): 235–48.

62. Thierry de Freiberg, *Tractatus de iride et radialibus impressionibus*, ed. M. R. Pagnoni-Sturlese and L. Sturlese, in *Opera omnia*, vol. 4 (Hamburg, 1985), 95–268 (replaces the old edition, often cited, by J. Würschmidt, constituting vol. 12 of *Beiträge zur Geschichte der Philosophie des Mittelalters* (Münster, 1914).

63. Witelo, *Perspectiva*, ed. S. Unguru (Warsaw, 1991).

64. On the history of theories devoted to the rainbow: C. B. Boyer, *The Rainbow: From Myth to Mathematics* (New York, 1959); Blay, *Les Figures de l'arc-en-ciel*.

65. G. B. della Porta, *De refractione* (Naples, 1588). For this author, colors arose from the weakening of the white light crossing through the

prism: yellow and red were only slightly weakened; green, blue, and purple were to a greater extent because, close to the base of the prism, they crossed through a greater quantity of glass.

66. Marco Antonio de Dominis, *De radiis visus et lucis in vitris perspectivis et iride tractatus* (Venice, 1611), and then as a last response, just before Newton, Robert Boyle, *Experiments and Considerations Touching Colours* (London, 1664).

67. A few authors proposed only three colors (red, yellow, and "dark"). A single author—Roger Bacon—argued for the number six: blue, green, red, gray, pink, white (*Perspectiva communis*, 114).

68. R. Descartes, *Discours de la méthode . . . Plus la dioptrique* (Leiden, 1637).

69. See A. I. Sabra, *Theories of Light from Descartes to Newton*, 2nd ed. (Cambridge, 1981).

70. On Newton's discoveries and the development of the spectrum, M. Blay, *La Conception newtonienne des phénomènes de la couleur* (Paris, 1983).

71. Newton, *Opticks*.

72. C. Huyghens, *Traité de la lumière . . .* (Paris, 1690).

73. *Optice sive de relectionibus, refractionibus et inflectionibus et coloribus lucis . . .* (London, 1707). Translated by Samuel Clarke, republished in Geneva in 1740.

74. That was the case with Father Louis-Bertrand Castel, who reproached Newton for having conceived his theories before doing the experiments and not the other way around: *L'Optique des couleurs . . .* (Paris, 1740) and *Le Vrai Système de physique générale de M. Isaac Newton* (Paris, 1743).

ALL THE COLORS OF BLACK

1. See J. Gage, *Colour and Culture: Practice and Meaning from Antiquity to Abstraction* (London, 1993), 153–76 and 227–36.

2. On grisaille, T. Dittelbach, *Das monochrome Wandgemälde: Untersuchungen zum Kolorit des frühen 15. Jahrhunderts in Italien* (Hildesheim, 1993); M. Krieger, *Grisaille als Metaphor: Zum Entstehen der Peinture en Camaieu im frühen 14. Jahrhundert* (Vienna, 1995).

3. M. Brusatin, *Storia dei colori* (Turin, 1983), 47–69; Gage, *Colour and Culture*, 117–38; T. Puttfarken, "The Dispute about Disegno and Colorito in Venice: Paolo Pino, Lodovico Dolce and Titian," in *Kunst und Kunsttheorie, 1400–1900* (Wiesbaden, 1991), 75–99. See also the impassioned texts compiled by P. Barocchi, *Trattati d'arte del cinquecento: Fra Manierismo e Controriforma* (Bari, 1960).

4. For the history of the debates in France, see the catalogue from the fine exhibition *Rubens contre Poussin: La querelle du coloris dans la peinture française à la fin du XVIIe siècle* (Arras and Épinal, 2004). See also the studies cited in the following note.

5. On these issues, see the fine book by Jacqueline Lichtenstein, *La Couleur éloquente: Rhétorique et peinture à l'âge classique* (Paris, 1989). See also E. Heuck, *Die Farbe in der französischen Kunsttheorie des XVII. Jahrhunderts* (Strasbourg, 1929), and B. Tesseydre, *Roger de Piles et les débats sur le coloris au siècle de Louis XIV* (Paris, 1965).

6. Notably in his *Vorlesungen über die Aesthetik* (Berlin, 1832, new ed. Leipzig, 1931), 128–29 and passim. See D. William, *Art and the Absolute: A Study of Hegel's Aesthetics* (Albany, 1986); G. Bras, *Hegel et l'art* (Paris, 1989).

7. See those considered most significant ("la balance des peintres") as listed by Roger de Piles in his *Cours de peinture par principes*, new ed. (Paris, 1989), 236–41. See also Brusatin, *Storia dei colori*, 47–69.

8. On this invention, see the catalogue from the exhibition, *Anatomie de la couleur* (Paris: Bibliothèque Nationale de France, 1995), organized by Florian Rodari and Maxime Préaud. See also the treatise by J. C. Le Blon, *Colorito, or Harmony of Colouring in Painting reduced to Mechanical Practice* (London, 1725), who acknowledged his debt to Newton and affirmed the primacy of three basic colors: red, blue, yellow (6 and following). On the history of color engraving from a long-term perspective, see the study by J. M. Friedman, *Color Printing in England, 1486–1870* (New Haven, 1978).

9. Definitive formulation had to wait for the turn of the nineteenth century. Let us note, however, that by the early seventeenth century, a few authors had made red, blue, and yellow the "principal" colors, and green, crimson, and gold (!) colors derived from combinations of principal colors. The pioneering work in this area was by François d'Aguilon, *Opticorum Libri VI* (Antwerp, 1613), who proposed many "tables of harmony" in which green appeared as the product of yellow and blue.

10. In France, in the war of cockades at the beginning of the Revolution, supporters of the alliance with the House of Austria displayed the black cockade. It was aligned with the white cockade worn by the king's supporters against the tricolored cockade.

11. J. Harvey, *Des hommes en noir: Du costume masculin à travers les siècles* (Abbeville, 1998), 142–45.

12. M. Pastoureau, *Bleu: Histoire d'une couleur* (Paris, 2000), 123–41.

13. For a long time, Dippel kept his discovery secret, but in 1724, the English chemist Woodward solved the mystery and published the composition of the new pigment.

14. J. W. Goethe, *Zur Farbenlehre* (Tübingen, 1810), 4, § 696–99.

15. D. Roche, *La Culture des apparences: Une histoire du vêtement (XVIIe–XVIIIe siècles)* (Paris, 1989), 127–37 and tables 11 and 15.

16. M. Pinault, "Savants et teinturiers," in *Sublime indigo* (exhibition, Marseilles, 1987) (Fribourg, 1987), 135–41.

17. Let us note that even today, mustard or greenish yellow tones remain the most disagreeable to European eyes. See M. Pastoureau, *Dictionnaire des couleurs de notre temps* (Paris, 1992), 127–29.

18. Harvey, *Des hommes en noir*, 146–47.

19. In France, a regental decree in late 1716 reduced by half the mourning period in the court and among princes of royal blood. See A. Mollard-Desfour, *Le Dictionnaire des mots et expressions de couleur: Le noir* (Paris, 2005), 84.

20. See the figures included in my *Traité d'héraldique*, 2nd ed. (Paris, 1993), 116–21 and passim. Within the French realm, however, variations did exist: sable appears below 15 percent in all the "provinces" except two: Brittany and Flanders.

21. Madame de Staël seems to be the first writer to make use of this expression in her correspondences (as early as 1794). See the *Trésor de la langue française*, art. "Couleur," B:1.a and *Etym*.

22. See the various tables published by S. Dagat, *La Traite des noirs* (Rennes, 1990) and by O. Pétré-Grenouilleau, *Les Traites négrières: Essai d'histoire globale* (Paris, 2004).

23. E. Noël, *Être noir en France au XVIIIe siècle* (Paris, 2006), passim.

24. His *Voyage à l'Ile de France, à l'Ile Bourbon, au Cap de Bonne-Espérance par un officier du roi*, published in Amsterdam in 1773, is much more interesting with regard to the descriptions of the inhabitants of Africa and the islands of the Indian Ocean.

25. His *Rêveries du promeneur solitaire*, written between 1776 and 1778 and left unfinished, were published after his death (July 1778) in London in 1782.

26. Unfinished, this novel was published by Ludwig Tieck, Novalis's friend, in 1802. The book opens with the account of a dream, minstrel Heinrich's dream: he sees himself crossing marvelous countrysides and discovering near a spring the strange blue flower that offers a glimpse, between its petals, of a young woman's face. When he wakes, Heinrich decides to go in search of that flower and that woman. This quest, a merging of dream and reality, constitutes the principal theme of German romanticism.

27. Pastoureau, *Bleu*, 134–41.

28. Text reproduced from Gérard de Nerval, *The Chimeras*; translated by Peter Jay, with an essay by Richard Holmes (London, 1984). 15.

29. M. Pastoureau, *Une histoire symbolique du Moyen Âge occidental* (Paris, 2004), 317–26 ("Nerval lecteur des images médiévales").

30. C. Baudelaire, *Les Fleurs du mal* (Paris, 1857), 92 ("Les litanies de Satan").

31. In his story "Smarra ou Les démons de la nuit" (1821), Charles Nodier seems to be the first French author to use the term *fantastic* as a noun and to give it the meaning it still has today. Before that it only existed as an adjective; it characterized what did not exist in reality, what was a matter of the imagination, and the "black" aspect of it was absent.

32. J. K. Huysmans, *Against Nature*; translated by Margaret Mauldon, edited with an introduction and notes by Nicholas White (Oxford, 1998), 11–12. This "meal of mourning" is the "announcement dinner for a virility momentarily dead" offered by the hero, Des Esseintes.

33. On Hamlet as Romantic hero: Harvey, *Des hommes en noir*, 105–16.

34. On this long-standing clothing phenomenon, ibid., 133–230.

35. The proportion is greater still in France: 4 million tons in 1850, 28 million in 1885, and 40 million in 1913.

36. On the relationship of miners to the color black, see the catalogue from the exhibition *Couleur travail et société* (Lille, Archives Départementales du Nord, 2004), 152–63.

37. Moreover, more recently, in a Europe that has become multiethnic and faced with the problem of racism, less worthy motives may also have contributed to reversing the trend in tanning in certain social and professional circles.

38. C. Dickens, *Great Expectations* (1861), cited by Harvey, *Des hommes en noir*, 190–91.

39. Some workers wore a black suit on Sunday, the same one all their lives, but that was the exception. Indeed, black clothes could not be dyed another color when they were worn or soiled. That was why in general only the affluent classes could afford clothes of this color, at the same time as they owned others, dyed in other colors.

40. A. de Musset, *Confession of a Child of the Century*; with a preface by Henri de Bornier (New York: Howard Fertig, 1977), 11.

41. Cited by Harvey, *Des hommes en noir*, 271.

42. J. Giraudoux, *Plays*, vol. II, translated by Roger Gellert (London, 1967), 119.

43. See above, 124–29.

44. M. Weber, *Die protestantische Ethik und der Geist des Kapitalismus*, 8th ed. (Tübingen, 1986). This work was initially published in the form of two articles in 1905 and 1906.

45. I. Thorner, "Ascetic Protestantism and the Development of Science and Technology," *American Journal of Sociology* 58 (1952–53): 25–38; Joachim Bodamer, *Der Weg zur Askese als Ueberwindung der technischen Welt* (Hamburg, 1957).

46. C. Sorenson, *My Forty Years with Ford* (Chicago, 1956); R. Lacey, *Ford: The Man and the Machine* (New York, 1968); J. Barry, *Henry Ford and Mass Production* (New York, 1973).

47. E. Chevreul, *De la loi du contraste simultané des couleurs et de l'assortiment des objets colorés considéré d'après cette loi dans ses rapports avec la peinture* (Paris, 1839).

48. E. Chevreul, *Des couleurs et de leur application aux arts industriels à l'aide des cercles chromatiques* (Paris, 1864). On Chevreul's discoveries and influence on the work of painters: Gage, *Colour and Culture*, 173–76; G. Rogue, *Art et science de la couleur: Chevreul et les peintres, de Delacroix à l'abstraction* (Paris, 1997), 169–332.

49. Leonardo da Vinci, *Traité de la peinture* (*Trattato della pittura*), trans. A. Chastel (Paris, 1987), 82.

50. P. Gauguin, *Oviri: Écrits d'un sauvage: Textes choisis (1892–1903)*, ed. D. Guérin (Paris, 1974), 123.

51. On the beginning of color cinema: G. Koshofer, *Color: Die Farben des Films* (Berlin, 1988); B. Noël, *L'Histoire du cinéma couleur* (Croissy-sur-Seine, 1995).

52. See especially the catalogue for the exhibition, *Paris-Moscou* (Paris, Centre Georges-Pompidou, 1979), and K. S. Malevich, *La Lumière et la Couleur: Textes inédits de 1915 à 1926* (Laussanne, 1981). See also G. Rickey, *Constructivisme: Origine et évolution* (New York, 1967); K. Passuth, *Les Avant-gardes de l'Europe centrale, 1907–1927* (Paris, 1988); S. Lemoine, *Mondrian et De Stijl* (Paris, 1987).

53. On Pierre Soulages and his work: M. Ragon, *Les Ateliers de Soulages* (Paris, 1990); P. Encrevé, *Soulages: Noir lumière* (Paris, 1996); P. Encrevé, *Soulages: Les peintures (1946–2006)* (Paris, 2007).

54. I am thinking here of true "design," which seeks to adapt form, color, and function, and which is meant for mass consumption. See M. Pastoureau, "Color, *Design* and consommation de masse. Histoire d'une rencontre difficile (1880–1960)," in *Design, miroir du siècle: Exposition (Paris, Grand Palais, 1993)* (Paris, 1993), 337–42.

55. Marcel Proust, *Swann's Way,* translated by C. K. Scott Moncrieff (New York, 1957).

56. Some fashion historians have dubbed this famous and always fashionable black dress the Model T of the house of Chanel. See E. Charles-Roux, *Le Temps Chanel* (Paris, 1979); A. Mackrell, *Coco Chanel* (New York, 1992); H. Gidel, *Coco Chanel* (Paris, 1999).

57. J. Robinson, *Fashion in the Thirties* (London, 1978); M. Constantino, *Fashions of a Decade: 1930s* (New York, 1992).

58. This image has remained to the present the Corsican coat of arms. The oldest example of it is found in the *Armorial universel du héraut Gelre* (about 1370–95) (Brussels, Bibliothèque Royale), ms. 15652-15656, fol. 62 verso.

59. The history of the black flag remains to be written. On the red flag, however, the historian has an excellent study at his disposal: M. Dommanget, *Histoire du drapeau rouge des origines à la guerre de 1939* (Paris, 1966).

60. M. Pastoureau, *L'Étoffe du Diable: Une histoire des rayures et des tissus rayés* (Paris, 1991), 102–11.

61. I. A. Opie, *A Dictionary of Superstitions* (Oxford, 1989), 64; D. Laclotte, *Le Livre des symboles et des superstitions* (Bordeaux, 2007), 123.

62. In Europe, the great period of black dress associated with mourning occurred during World War I and in the years 1918–25.

63. F. Birren, *Color: A Survey in Words and Pictures* (New York, 1961), 64–68; E. Heller, *Wie Farben wirken: Farbpsychologie, Farbsymbolik, kreative Farbgestaltung* (Hamburg, 1989), 20 and passim; M. Pastoureau, *Dictionnaire des couleurs de notre temps*, 2nd ed. (Paris, 1999), 178–84.

BIBLIOGRAPHY

Many books and articles have been cited in the notes; all of them do not reappear in this bibliography. Regarding the general or particular history of colors, I have only included a few works from the vast bibliography, omitting publications that are nonhistorical, superficial, esoteric, or psychologizing. These publications are without interest. Similarly, among the many works on the history of clothing and dress practices, I have only mentioned those that actually focus on the issues of color, the subject of the present work. Contrary to what one might think, there are not very many of them.

The same is true for the history of pigments, colorants, and dyeing practices. The bibliography offered can only be a selection based on my readings and experience; I have only cited work that I know can be useful to the historian of social phenomena, leaving out specialized studies on the physics and chemistry of colors as well as the results of laboratory analyses of artworks or textile samples, despite their great value.

Finally, regarding the history of art, the selection is even more limited. Under this heading, I would have had to mention several hundreds of books and articles; I have only listed a few publications, ones that have as their primary theme the relationship between colors, theories of art, and social practices. This choice seems legitimate to me because the present work is primarily concerned with the social history of the color black, and not its pictorial history. The reader interested in the more artistic and scientific history of colors will find an extensive bibliography in the excellent work by John Gage, *Colour and Culture* (London, 1993), which has just been translated into French under the title *Couleur et culture. Usages et significations de la couleur de l'Antiquité à l'abstraction* (Paris, 2008).

HISTORY OF COLORS

GENERAL

Berlin, Brent, and Paul Kay. *Basic Color Terms: Their Universality and Evolution.* Berkeley, Calif., 1969.

Birren, Faber. *Color: A Survey in Words and Pictures.* New York, 1961.

Brusatin, Manlio. *Storia dei colori.* 2nd ed. Turin, 1983. Translated as *Histoire des couleurs* (Paris, 1986).

Conklin, Harold C. "Color Categorization." *American Anthropologist* 75, no. 4 (1973): 931–42.

Eco, Renate, ed. "Colore: Divietti, decreti, discute." Special number of *Rassegna* (Milan) 23 (September 1985).

Gage, John. *Colour and Culture: Practice and Meaning from Antiquity to Abstraction.* London, 1993. Translated as *Couleur et culture. Usages et significations de la couleur de l'Antiquité à l'abstraction* (Paris, 2008).

Heller, Eva. *Wie Farben wirken: Farbpsychologie, Farbsymbolik, Kreative Farbgestaltung.* Hamburg, 1989.

Indergand, Michel, and Philippe Fagot. *Bibliographie de la couleur.* 2 vols. Paris, 1984–88.

Meyerson, Ignace, ed. *Problèmes de la couleur.* Paris, 1957.

Pastoureau, Michel. *Bleu: Histoire d'une couleur.* Paris, 2000.

———. *Couleurs, images, symboles: Études d'histoire et d'anthropologie.* Paris, 1989.

———. *Dictionnaire des couleurs de notre temps: Symbolique et société.* 4th ed. Paris, 2007.

Portmann, Adolf, and Rudolf Ritsema, eds. *The Realms of Colour. Die Welt der Farben.* Leiden, 1974.

Pouchelle, Marie-Christine, ed. "Paradoxes de la couleur." Special number of *Ethnologie française* (Paris) 20, no. 4 (1990).

Rzepinska, M. *Historia coloru u dziejach malatstwa europejskiego.* 3rd ed. Warsaw, 1989.

Tornay, Serge, ed. *Voir et nommer les couleurs.* Nanterre, 1978.

Vogt, Hans Heinrich. *Farben und ihre Geschichte.* Stuttgart, 1973.

Zahan, Dominique. "L'homme et la couleur." In *Histoire des mœurs*, ed. Jean Poirier, vol. 1, *Les Coordonnées de l'homme et la culture matérielle*, 115–80. Paris, 1990.

ANTIQUITY AND THE MIDDLE AGES

Beta, S., and M. M. Sassi, eds. *I colori nel mondo antiquo: Esperienze linguistiche e quadri simbolici.* Siena, 2003.

Brinkmann, V., and R. Wünsche, eds. *Bunte Götter: Die Farbigkeit antiker Skulptur.* Munich, 2003.

Brüggen, E. *Kleidung und Mode in der höfischen Epik.* Heidelberg, 1989.

Cechetti, B. *La vita dei Veneziani nel 1300: Le veste.* Venice, 1886.

Centre Universitaire d'Études et de Recherches Médiévales d'Aix-en-Provence. *Les Couleurs au Moyen Âge. Senefiance*, vol. 24. Aix-en-Provence, 1988.

Ceppari Ridolfi, Maria A., and Patrizia Turrini. *Il mulino delle vanità: Lusso e cerimonie nella Siena medievale.* Siena, 1996.

Descamps-Lequime, Sophie, ed. *Couleur et peinture dans le monde grec antique.* Paris, 2004.

Dumézil, Georges. "*Albati, russati, virides.*" In *Rituels indoeuropéens à Rome*, 45–61. Paris, 1954.

Frodl-Kraft, Eva. "Die Farbsprache der gotischen Malerei: Ein Entwurf." *Wiener Jahrbuch für Kunstgeschichte* 30–31 (1977–78): 89–178.

Haupt, Gottfried. *Die Farbensymbolik in der sakralen Kunst des abendländischen Mittelalters.* Leipzig, 1941.

Istituto Sorico Lucchese. *Il colore nel Medioevo: Arte, simbolo, tecnica: Atti delle Giornate di studi.* 2 vols. Lucca, 1996–98.

Luzzatto, Lia, and Renata Pompas. *Il significato dei colori nelle civiltà antiche.* Milan, 1988.

Pastoureau, Michel. "L'Église et la couleur des origines à la Réforme." *Bibliothèque de l'École des chartes* 147 (1989): 203–30.

——. *Figures et couleurs: Études sur la symbolique et la sensibilité médiévales.* Paris, 1986.

——. "Voir les couleurs au XIIIe siècle." In *View and Vision in the Middle Ages*, 2:147–65. *Micrologus: Nature, Science and Medieval Societies*, vol. 6. Florence, 1998.

Rouveret, Agnès. *Histoire et imaginaire de la peinture ancienne.* Paris, 1989.

Rouveret, Agnès, Sandrine Dubel, and Valérie Naas, eds. *Couleurs et matières dans l'Antiquité: Textes, techniques et pratiques.* Paris, 2006.

Sicile, héraut d'armes du XVe siècle. *Le Blason des couleurs en armes, livrées et devises.* Ed. H. Cocheris. Paris, 1857.

Tiverios, M. A., and D. Tsiafakis, eds. *The Role of Color in Ancient Greek Art and Architecture (700–31 B.C.).* Thessaloniki, 2002.

Villard, Laurence, ed. *Couleur et vision dans l'Antiquité classique.* Rouen, 2002.

MODERN AND CONTEMPORARY TIMES

Birren, Faber. *Selling Color to People.* New York, 1956.

Brino, Giovanni, and Franco Rosso. *Colore e città: Il piano del colore di Torino, 1800–1850.* Milan, 1980.

Laufer, Otto. *Farbensymbolik im deutschen Volsbrauch.* Hamburg, 1948.

Lenclos, Jean-Philippe, and Dominique Lenclos. *Les Couleurs de l'Europe: Géographie de la couleur.* Paris, 1995.

——. *Les Couleurs de la France: Maisons et paysage.* Paris, 1982.

Noël, Benoît. *L'Histoire du cinéma couleur.* Croissy-sur-Seine, 1995.

Pastoureau, Michel. "La couleur en noir et blanc (XVe–XVIIIe siècle)." In *Le Livre et l'Historien: Études offertes en l'honneur du Professeur Henri-Jean Martin*, 197–213. Geneva, 1997.

——. "La Réforme et la couleur." *Bulletin de la Société d'histoire du Protestantisme français* 138 (July–September 1992): 323–42.

PROBLEMS OF PHILOLOGY AND TERMINOLOGY

André, Jacques. *Étude sur les termes de couleurs dans la langue latine.* Paris, 1949.

Brault, Gerard J. *Early Blazon: Heraldic Terminology in the XIIth and XIIIth Centuries, with Special Reference to Arthurian Literature.* Oxford, 1972.

Crosland, M. P. *Historical Studies in the Language of Chemistry.* London, 1962.

Giacolone Ramat, Anna. "Colori germanici nel mondo romanzo." *Atti e memorie dell'Academia toscana di scienze e lettere La Colombaria* (Florence) 32 (1967): 105–211.

Gloth, H. *Das Spiel von den sieben Farben.* Königsberg, 1902.

Grossmann, Maria. *Colori e lessico: Studi sulla struttura semantica degli aggettivi di colore in catalano, castigliano, italiano, romano, latino ed ungherese.* Tübingen, 1988.

Jacobson-Widding, Anita. *Red-White-Black, as a Mode of Thought.* Stockholm, 1979.

Kantor, Sofia. "Blanc et noir dans l'épique française et espagnole: Dénotation et connotation." *Studi medievali* 25 (1984): 145–99.

Kristol, Andres M. *Color: Les Langues romanes devant le phénomène de la couleur.* Bern, 1978.

Magnus, Hugo. *Histoire de l'évolution du sens des couleurs.* Paris, 1878.

Meunier, Annie. "Quelques remarques sur les adjectifs de couleur." *Annales de l'Université de Toulouse* 11, no. 5 (1975): 37–62.

Mollard-Desfour, Annie. *Le Dictionnaire des mots et expressions de couleur: Le noir.* Paris, 2005.

Ott, André. *Études sur les couleurs en vieux français.* Paris, 1899.

Schäfer, Barbara. *Die Semantik der Farbadjektive im Altfranzösischen.* Tübingen, 1987.

Wackernagel, Wilhelm. "Die Farben- und Blumensprache des Mittelalter." In *Abhandlungen zur deutschen Altertumskunde und Kunstgeschichte*, 143–240. Leipzig, 1872.

Wierzbicka, Anna. "The Meaning of Color Terms: Cromatology and Culture." *Cognitive Linguistics* 1, no. 1 (1990): 99–150.

THE HISTORY OF DYES AND DYERS

Brunello, Franco. *L'arte della tintura nella storia dell'umanita.* Vicenza, 1968.

——. *Arti e mestieri a Venezia nel medioevo e nel Rinascimento.* Vicenza, 1980.

Cardon, Dominique, and Gaëtan Du Châtenet. *Guide des teintures naturelles.* Paris, 1990.

Chevreul, Michel Eugène. *Leçons de chimie appliquée à la teinture.* Paris, 1829.

Edelstein, S. M., and H. C. Borghetty. *The "Plictho" of Giovan Ventura Rosetti.* London, 1969.

Gerschel, Lucien. "Couleurs et teintures chez divers peuples indo-européens." *Annales ESC* 21 (1966): 608–63.

Hellot, Jean. *L'Art de la teinture des laines et des étoffes de laine en grand et petit teint.* Paris, 1750.

Jaoul, Martine, ed. *Des teintes et des couleurs.* Exhibition catalogue. Paris, 1988.

Lauterbach, F. *Geschichte der in Deutschland bei der Färberei angewandten Farbstoffe, mit besonderer Berücksichtigung des mittelalterlichen Waidblaues.* Leipzig, 1905.

Legget, W. F. *Ancient and Medieval Dyes.* New York, 1944.

Lespinasse, René de. *Histoire générale de Paris: Les métiers et corporations de la ville de Paris.* Vol. 3, *Tissus, étoffes . . .* Paris, 1897.

Pastoureau, Michel. *Jésus chez le teinturier: Couleurs et teintures dans l'Occident médiéval.* Paris, 1998.

Ploss, Emil Ernst. *Ein Buch von alten Farben: Technologie der Textilfarben im Mittelalter.* 6th ed. Munich, 1989.

Rebora, Giovanni. *Un manuale di tintoria del Quattrocento*. Milan, 1970.

Varichon, Anne. *Couleurs, pigments et teintures dans les mains des peuples*. Paris, 2000.

THE HISTORY OF PIGMENTS

Bomford, David, et al. *Art in the Making: Impressionism*. London, 1990.

——. *Art in the Making: Italian Painting before 1400*. London, 1989.

Brunello, Franco. *"De arte illuminandi" e altri trattati sulla tecnica della miniatura medievale*. 2nd ed. Vicenza, 1992.

Feller, Robert L., and Ashok Roy. *Artists' Pigments: A Handbook of Their History and Characteristics*. 2 vols. Washington, D.C., 1985–86.

Guineau, Bernard, ed. *Pigments et colorants de l'Antiquité et du Moyen Âge*. Paris, 1990.

Harley, R. D. *Artists' Pigments (c. 1600–1835)*. 2nd ed. London, 1982.

Kittel, H., ed. *Pigmente*. Stuttgart, 1960.

Laurie, A. P. *The Pigments and Mediums of Old Masters*. London, 1914.

Loumyer, Georges. *Les Traditions techniques de la peinture médiévale*. Brussels, 1920.

Merrifield, Mary P. *Original Treatises Dating from the XIIth to the XVIIIth Centuries on the Art of Painting*. 2 vols. London, 1849.

Montagna, Giovanni. *I pigmenti: Prontuario per l'arte e il restauro*. Florence, 1993.

Reclams Handbuch der künstlerischen Techniken. Vol. 1, *Farbmittel, Buchmalerei, Tafel- und Leinwandmalerei*. Stuttgart, 1988.

Roosen-Runge, Heinz. *Farbgebung und Technik frühmittelalterlicher Buchmalerei*. 2 vols. Munich, 1967.

Smith, C. S., and J. G. Hawthorne, eds. *Mappae clavicula: A Little Key to the World of Medieval Techniques*. Philadelphia, 1974.

Technè: La science au service de l'art et des civilisations. Vol. 4, *La Couleur et ses pigments*. Paris, 1996.

Thompson, Daniel V. *The Material of Medieval Painting*. London, 1936.

Zerdoun, Monique. *Les Encres noires au Moyen Âge*. Paris, 1983.

THE HISTORY OF CLOTHING

Baldwin, Frances E. *Sumptuary Legislation and Personal Regulation in England*. Baltimore, 1926.

Baur, Veronika. *Kleiderordnungen in Bayern von 14. bis 19. Jahrhundert*. Munich, 1975.

Boehn, Max von. *Die Mode. Menschen und Moden vom Untergang der alten Welt bis zum Beginn des zwanzigsten Jahrhunderts*. 8 vols. Munich, 1907–25.

Boucher, François. *Histoire du costume en Occident de l'Antiquité à nos jours*. Paris, 1965.

Bridbury, A. R. *Medieval English Clothmaking: An Economic Survey*. London, 1982.

Eisenbart, Liselotte C. *Kleiderordnungen der deutschen Städte zwischen 1350–1700*. Göttingen, 1962.

Friedman, Daniel. *Une histoire du Blue Jean*. Paris, 1987.

Harte, N. B., and K. G. Ponting, eds. *Cloth and Clothing in Medieval Europe: Essays in Memory of E. M. Carus-Wilson*. London, 1982.

Harvey, John. *Men in Black*. London, 1995. Translated as *Des hommes en noir. Du costume masculin à travers les âges*. Abbeville, 1998.

Hunt, Alan. *Governance of the Consuming Passions: A History of Sumptuary Law*. London, 1996.

Lurie, Alison. *The Language of Clothes*. London, 1982.

Madou, Mireille. *Le Costume civil*. Typologie des sources du Moyen Âge occidental, vol. 47. Turnhout, 1986.

Mayo, Janet. *A History of Ecclesiastical Dress*. London, 1984.

Nathan, H. *Levi Strauss & Co.: Tailors to the World*. Berkeley, Calif., 1976.

Nixdorff, Heide, and Heidi Müller, eds. *Weisse Vesten, roten Roben: Von den Farbordnungen des Mittelalters zum individuellen Farbgeschmak*. Exhibition catalogue. Berlin, 1983.

Page, Agnès. *Vêtir le prince: Tissus et couleurs à la cour de Savoie (1427–1447)*. Lausanne, 1993.

Pellegrin, Nicole. *Les Vêtements de la liberté: Abécédaires des pratiques vestimentaires françaises de 1780 à 1800*. Paris, 1989.

Piponnier, Françoise. *Costume et vie sociale. La cour d'Anjou, XIVe–XVe siècles*. Paris, 1970.

Piponnier, Françoise, and Perrine Mane. *Se vêtir au Moyen Âge*. Paris, 1995.

Quicherat, Jules. *Histoire du costume en France depuis les temps les plus reculés jusqu'à la fin du XVIIIe siècle*. Paris, 1875.

Roche, Daniel. *La Culture des apparences: Une histoire du vêtement (XVIIe–XVIIIe siècles)*. Paris, 1989.

Roche-Bernard, Geneviève, and Alain Ferdière. *Costumes et textiles en Gaule romaine*. Paris, 1993.

Vincent, John M. *Costume and Conduct in the Laws of Basel, Bern, and Zurich*. Baltimore, 1935.

THE PHILOSOPHY AND HISTORY OF SCIENCE

Blay, Michel. *La Conceptualisation newtonienne des phénomènes de la couleur*. Paris, 1983.

——. *Les Figures de l'arc-en-ciel*. Paris, 1995.

Boyer, Carl B. *The Rainbow from Myth to Mathematics*. New York, 1959.

Goethe, Johann Wolfgang von. *Materialen zur Geschichte der Farbenlehre*. 2 vols. Munich, 1971.

——. *Zur Farbenlehre*. 2 vols. Tübingen, 1810.

Halbertsma, K.J.A. *A History of the Theory of Colour*. Amsterdam, 1949.

Lindberg, David C. *Theories of Vision from Al-Kindi to Kepler*. Chicago, 1976.

Newton, Isaac. *Opticks or a Treatise of the Reflexions, Refractions, Inflexions and Colours of Light*. London, 1704.

Pastore, Nicholas. *Selective History of Theories of Visual Perception, 1650–1950*. Oxford, 1971.

Sepper, Dennis L. *Goethe contra Newton: Polemics and the Project of a New Science of Color*. Cambridge, 1988.

Sherman, Paul D. *Colour Vision in the Nineteenth Century: The Young-Helmholtz-Maxwell Theory*. Cambridge, 1981.

Westphal, John. *Colour: A Philosophical Introduction*. 2nd ed. London, 1991.

Wittgenstein, Ludwig. *Bemerkungen über die Farben*. Frankfurt am Main, 1979.

THE HISTORY AND THEORIES OF ART

Aumont, Jacques. *Introduction à la couleur: Des discours aux images*. Paris, 1994.

Barasch, Moshe. *Light and Color in the Italian Renaissance Theory of Art*. New York, 1978.

Dittmann, L. *Farbgestaltung und Fartheorie in der abendländischen Malerei*. Stuttgart, October, 1987.

Gavel, Jonas. *Colour: A Study of Its Position in the Art Theory of the Quattro- and Cinquecento*. Stockholm, 1979.

Hall, Marcia B. *Color and Meaning: Practice and Theory in Renaissance Painting*. Cambridge, Mass., 1992.

Imdahl, Max. *Farbe: Kunsttheoretische Reflexionen in Frankreich*. Munich, 1987.

Kandinsky, Vassily. *Über das Geistige in der Kunst*. Munich, 1912.

Le Rider, Jacques. *Les Couleurs et les mots*. Paris, 1997.

Lichtenstein, Jacqueline. *La Couleur éloquente. Rhétorique et peinture à l'âge classique*. Paris, 1989.

Roque, Georges. *Art et science de la couleur: Chevreul et les peintres de Delacroix à l'abstraction*. Nîmes, 1997.

Shapiro, Alan E. "Artists' Colors and Newton's Colors." *Isis* 85 (1994): 600–630.

Teyssèdre, Bernard. *Roger de Piles et les débats sur le coloris au siècle de Louis XIV*. Paris, 1957.

PRELIMINARY STUDIES FOR THE PRESENT BOOK

"Les cisterciens et la couleur au XIIe siècle." In *L'ordre cistercien et le Berry*. Conference, Bourges, 1998. *Cahiers d'archéologie et d'histoire du Berry* 136 (1998): 21–30.

"La couleur en noir et blanc (XVe–XVIIIe siècle)." In *Le Livre et l'Historien. Études offertes en l'honneur du Professeur Henri-Jean Martin*, 197–213. Geneva, 1997.

"La couleur et l'historien." *Pour la Science* (April 2000): 112–16.

"Les couleurs de la mort." In *À réveiller les mort: La mort au quotidien dans l'Occident médiéval*, ed. Alexandre-Bidon, Danièle, and Cécile Treffort, 97–108. Lyons, 1994.

"Du bleu au noir: Éthiques et pratiques de la couleur à la fin du Moyen Âge." *Médiévales* 14 (1988): 9–22.

"L'Église et la couleur des origines à la Réforme." *Bibliothèque de l'École des chartes* 147 (1989): 203–30.

"Une histoire des couleurs est-elle possible?" *Ethnologie française* 20, no. 4 (1990): 368–77.

"Mensonges et vérités de la couleur à l'aube des Lumières." In *Anatomie de la couleur: L'invention de l'estampe en couleurs*, ed. Iorian Rodari, 91–93. Exhibition catalogue, Paris, Bibliothèque Nationale de France, 1996.

"Morales de la couleur: Le chromoclasme de la Réforme. *Cahiers du Léopard d'or* 4 (1995): 27–46.

"La Réforme et la couleur." *Bulletin de la Société d'histoire du Protestantisme français* 138 (July–September 1992): 323–42.

"Le temps mis en couleurs: Des couleurs liturgiques aux modes vestimentaires (XIIe–XIIIe siècles). *Bibliothèque de l'École des chartes* 157 (January–June 1999): 111–35.

"Voir les couleurs au XIIIe siècle." In *View and Vision in the Middle Ages*, 2:147–65. Micrologus: Nature, Science and Medieval Societies, vol. 6. Florence, 1998.

"Voir les couleurs du passé: Anachronismes, naïvetés, surlectures." In *Peut-on apprendre à voir*, ed. Laurent Gervereau, 232–44. Paris, 1999.

ACKNOWLEDGMENTS

Before taking the form of a book, this social and cultural history of the color black constituted the subject of my seminars for many years at the École Pratique des Hautes Études and the École des Hautes Études en Sciences Sociales. I thank all my students and listeners for the fruitful exchanges we had then.

I also want to thank all those close to me—friends, relatives, colleagues—whose comments, advice, and suggestions I have profited from: Pierre Bureua, Yvonne Cazal, Claude Coupry, Marina Escola, Phillippe Fagot, François Jacquesson, Phillippe Junod, Laurence Klejman, Maurice Olender, and Laure Pastoureau. Thanks also to Claude Hénard and his Éditions du Seuil team: Karine Benzaquin, Caroline Chambeau, Caroline Fuchs, and Frédéric Mazuy.

Finally, I offer immense, affectionate thanks to Claudia Rabel, whose advice, informed criticisms, and severe, efficient rereadings have benefited me once again.

Printed in Italy